D0984900

ISRAEL
AND THE
ARTS

Other books by Herbert A. Kenny

Newspaper Row: Journalism in the Pre-Television Era
Literary Dublin: A History
Cape Ann/Cape America
A Catholic Quiz Book
(With G. P. Keane)
The Secret of the Rocks
A Boston Picture Book
(With Barbara Westman)

Poetry

Suburban Man
Twelve Birds
Sonnets to the Virgin Mary

For Younger Readers

Dear Dolphin
Alistare Owl

ISRAEL
AND THE
ARTS

Herbert A. Kenny

Quinlan Press
Boston

Published by Quinlan Press
131 Beverly Street
Boston, MA 02114

Library of Congress Cataloging-in-Publication Data
Kenny, Herbert A.
 Israel and the arts.
 Includes index.
 1. Arts—Israel. 2. Israel—Intellectual life.
I. Title.
NX573.7.A1K46 1987 700' .95694 87-43032
ISBN 0-933341-11-3

Printed in the United States of America
April 1988

This book is dedicated affectionately to the memories of Ivan and Nancy Sandrof and Nat Kline.

Acknowledgements

I wish to thank the many people who helped me during the compilation of this book, among them, Milton Hindus of Brandeis University; Jerri Liberman now in Hawaii; The Rev. Felix Talbot, S.J., of Boston College; the several Consuls General of Israel who have served in Boston during the past twenty years; Joel and Bea Kerensky; the late Ivan Sandrof; the late Joseph Weisberg of the *Jewish Advocate;* Nika Rosovsky and the Rev. Carney Gavin, both of the Semitic Museum at Harvard University; Katherine Higgins at the Boston Public Library; Y. T. Feng of the Widener Library; Herman Woerner; Herbert Fromm; Dr. Martin Robbins; Rodney Armstrong and the staff of the Boston Athenaeum; the many officials and artists in Israel whom I interviewed, and who extended me so many courtesies; and to the Rev. Gerald Bucke of St. Joseph's Church, Boston, the best of company when traveling in Israel. As usual, this book like all I have done could not have been done without the editorial collaboration and patience of my wife. I owe special thanks to my editor, Kevin Stevens, and Henry Quinlan, my publisher. I apologize to all who helped and whose names do not appear here.

Special thanks to Robert Levenson for photographic help.

CONTENTS

Photographs follow page 86

INTRODUCTION

This book is a journalist's sketch or summary of a cultural aspect of life in the State of Israel that has, in an overall view, been neglected. It is not so much a book as an appeal for understanding. In 1988 Israel celebrates the fortieth anniversary of its establishment. In those forty years, and indeed, for as many years or more before 1948, the concern of the people of Israel for the aesthetic side of life has been obscured or overlooked because of the emphasis on the country's struggle for survival and the mere recognition of its right to exist. The response of Israelis to the aesthetic impulse has been extraordinary, both for the place that the arts hold in their lives and the place they have made for beauty. This book is an attempt by a Christian journalist whose career has been associated with the arts to recognize that dedication.

To understand why this aspect of Israeli life has not been duly publicized is not too difficult. From the moment of the State of Israel's conception in 1948 until today, the country has either been at war or under attack. The incredible military achievement that the country has made withstanding the might of all the Arab powers, and the economic miracle of making the desert bloom, has engrossed journalists and scholars alike. The noise and news have overrun the niceties.

To have raised from scratch, so to speak, an independent, modern, democratic state of any sort on the ancient sands of Palestine, where so many attempts at economic development have foundered, is a masterwork worthy of all the books that have been written about it. To have made yield, to have brought to harvest, the barren stretches of Levantine desert, is a miracle of modern engineering and human aspiration. Any person must salute it.

Nor are these actions greater than the translation of hundreds of thousands of polyglot Jews from scores of disparate countries and the melding of them into a new nation, giving them a common language and breeding into them the dynamism of a national pride rooted in the ancient Hebrew tradition, the same tradition that centuries ago came to the land of Canaan under divine inspiration to found the ancient kingdoms of Israel and Judea and first brought civilization and monotheistic culture to the area. All that is unique in the history of man.

In the modern age, the Jews of the world have not been known as a militaristic people. In the dawn of history, having escaped the slavery of Egypt, they engaged in defensive wars against foreign oppressors (as well as dynastic quarrels on occasion) to establish their claim to the land of Canaan. They withstood the Assyrians, the Philistines, the Greeks and the Romans for a while and then died bloodily as a nation before the Roman legions, isolated in the bleakest regions of the Holy Land. Throughout the Diaspora, without a homeland, as citizens of various nations, they served as soldiers and sailors in many lands, but not as an identifiable people, not as they fought in Israel. In Israel they have stood alone, and as themselves.

For many, it came as a surprise when Israel effected a brilliant record of warfare, beginning with the repulsion of the initial attempts of the Arabs to drive them into the sea, even before the British occupation forces under the League of Nations mandate had sailed from Palestine. History will forever record the military genius that came to the fore, the heroism displayed, the perduring courage which, day after day, kept the besieged Jewish colony in Jerusalem alive and marked the struggle to protect the peaceful Jewish farming communities. One war followed another and terroristic attacks by fanatical foes have never ceased, but Israel holds on.

Twice, Egypt, Syria and their allies mustered (at the command of bellicose dictators) to strike down the Israelis. The Arab armed forces outnumbered the Israelis by fifty to one. Twice those combinations of boastful armies were defeated by the dedication and ingenuity of the people of Israel. Such defensive warfare is expensive in dollars and man hours that could be put to productive labor. Despite such recurrent warfare, despite unrelenting terrorism by disaffected Palestinians and Muslim zealots, Israel has given her people, Christian, Muslim and Jew alike, a higher standard of living than obtains in any of the countries around it. Throughout all that it has maintained a democratic freedom of speech and of the ballot that seems at times witlessly incompatible with her survival.

All this should win the kudos of the Western world, where democratic freedoms are revered. Each of these aspects of life in Israel has been given its due. The arts are a major aspect of the Israeli achievement that has gone without due notice and needs a focus of attention.

2

During the forty years of its existence, when it could be described as a nation under siege, Israel has maintained as advanced a program of the arts — all the arts — as can be found in many an affluent nation with ten to twenty to thirty times its population. No one is surprised that ancient Sparta contributed little if anything to the arts. It was a nation pledged to war, a nation constantly girding itself for battle, and whatever the righteousness of its cause or the absence of righteousness, the nature of its polity was such that the arts were neglected if not abolished. The United States of America and its citizens will remember that during World War II the arts were either pushed from the stage, deprived of popular support or made to serve the purposes of propaganda. A nation under siege, unless peculiarly dedicated, doesn't encourage the arts.

Israel in the forty years of its existence has never been as safe from attack as the United States was in World War II, and indeed, it has always lived under a psychological threat that would justify not merely abandonment of democratic procedures in the national interest, but a cessation of investment in the arts if not a formal ukase against their consumption of goods, materials, man hours and the imaginative power of the human spirit, all of which could be used to advance the military might of the state and its economic strength.

The young republic has never succumbed to that temptation but has maintained the arts in a manner that should be an embarrassment to more affluent nations. This fostering of the arts in Israel has not been an easy matter for its people. First of all, there was and is much else to do. Second, the religious tradition of the nation, while celebrating the arts in some regards — say literature and music — honored a commandment against the plastic arts with a severity that even today has its impact on the artistic life of the nation. With its harsh landscape, the Holy Land itself is not one conducive to the creation of art, any more than were the circumstances that attended the formative years of the republic. Yet it can be said with some assurance that Israel has done as well with the arts as most nations living in tranquility.

The essence of the matter is this: the strength of any civilization lies in its religious convictions and its religious traditions, even if they are not patent but latent and little more than a dim diapason under the symphonic thunder of a nation. Israel has for its tradition, of course, one of the great religions of the world, a tradition from which has sprung two other great religions, Christianity and Islam.

A 1965 publication entitled, "The Performing Arts: Rockefeller Panel Report on the Future of the Theater, Dance, Music in America: Prospects and Problems," put the case with powerful particularity:

> Through the centuries, the governments of most great states and cities have participated in promoting the arts, and enriching the lives of their

3

citizens. It has been generally recognized that societies are ultimately judg-
ed the quality of their cultural life; that the worlds of the artist, the
dramatist and the poet outlive more transient victories and defeats. It has
been known too that the happiness of the citizens is related to the variety
and depth of the cultural experiences open to them.

Two years before that, the late President John F. Kennedy, speaking at the
dedication of a library in Amherst, Massachusetts, said:

> I see little of more importance to the future of our country and our
> civilization than full recognition of the place of the artist. If art is to nourish
> the roots of our culture society must set the artist free to follow his vision
> wherever it takes him ... art is not a form of propaganda, it is a form of
> truth ... art established the basic human truths which must serve as the
> touchstones of our judgment.

Israel has not forgotten that.

We turn to Christopher Dawson for a letter of marque to take our tour of
the arts in Israel, using the word in the broadest sense so that not merely
literature and the plastic arts, not merely the graphic arts, not merely the
lively arts, the dance, the theater and music will be our areas of examination,
but the museums themselves, the maintainence of national monuments, the
national passion for archaeology, the production of films, the concern for
ecology and nature, the intense language study, and indeed, remembering
Jacob Burckhardt's reflection on the city-states of the Renaissance, the state
itself as a work of art.

Dawson wrote:

> To understand the art of a society is to understand the vital activity of
> that society in its most intimate and creative moments. We can learn more
> about medieval culture from a cathedral than from the most exhaustive
> study of constitutional law, and the churches of Ravenna are a better
> introduction to the Byzantine world than all the volumes of Gibbon.

That statement points the direction of our sketch. We can learn more about
Israel and the Israelis from an examination of what that country has done
in the arts and for the arts than any scholarly study of the Six Day War, the
stubborn intricacies of Israel's foreign policy, the achievements of the
kibbutzim, the agricultural triumphs that made the Negev bloom or the
democratic wrangles in the Knesset.

The temptation to write history in terms of battles, in the grisly arenas
of open warfare, in the debates of the parliaments of the world or in the Byzan-
tine maneuvers of diplomacy is all but overwhelming. But in the long reaches

of history, as President Kennedy said, what is remembered are the carved stone, the illuminated manuscript, the coruscating mosaics, the crumbling fresco, the songs, the stories or what the Irish poet Oliver St. John Gogarty called "the blithe hexameters."

Whatever happens to the State of Israel, people of the future will assess among its preeminent gestures the concern that the state and its people showed for the arts, which can be seen as deriving from the contemplation of their ancient wisdom.

If Israelis are more likely to apologize for what they deem a neglect of the arts than boast of them, the reason is readily adjudged. For every artist, the artifact never matches in splendor the perfection of the concept that propelled it into matter, and it never will, because the concept draws its virtue from the perfection of the Transcendent, a transcendence that becomes immanent in art, which is, in the case of Israel, the God of Israel.

This is why art is irrepressible. Tyrannies and some theologies may try to stamp it out or restrict it or shackle it to the plow, but it springs up in the cavity made by the iron heel and flourishes where the spittle of hatred is spewed against it. The harshest landscapes cannot eliminate it, nor can internecine war wither its aspirations. In the slow erosion of time, it has the last word, and when one regards the cruelest of civilizations, it is only their arts we cherish. The condition of the arts must be understood not merely as a measure of a nation's vitality but as an index of its respect for the dignity of the individual. The totalitarian state cannot accept this principle but must hold the nose of the artist to a grindstone. Is a man free? To know this we have only to ask, "Can he paint as he likes?" "Can he sing the songs he chooses?" In Israel, as in the United States and in Western Europe, the core of our culture, he can and does, as he cannot in so many countries today from the Soviet Union to the Union of South Africa.

Although the Israelis themselves may not reflect on it, their devotion to the arts, their consuming interest, is of deeper order than their deeds of battle or their techniques of planting, for their devotion to the arts roots in the very spirit that invigorates the nation, that gives it its strength and determination, the very spirit for which the Hebrew word *ruakh* tells us all, the word that meant and means at once the Spirit of the Creator and the creative afflatus of the artist. Every language should have such a word.

The author of this book on the arts in Israel is an American Catholic of Irish ancestry, sympathetic to Israel, but more interested in the theme of the centrality of the arts to the Good Society and the necessity to recognize their roots as feeding from the religious impulses of man than in the political progress of Israel. The book is not concerned with the international rights or wrongs that keep the Near East in ferment. It offers no attempt to penetrate

5

the mists of the future, and it is not concerned with the anti-Zionist discussions that are too often simply masks for a recrudescence of anti-Semitism. He sees no comparable case to be made for any of the other countries of the Middle East or Eastern Europe, but he is not interested in comparisons except perhaps where they serve to illustrate a particular point.

He does believe that the attention that Israel and its citizens have given to the arts — not without immediate danger to the state, for it is often strength absent from the parapets — deserves the admiration of the world. He believes that Christians particularly — indeed, they above others — in a world where materialism moves like a poisonous miasma over too many countries, should salute the aesthetic and artistic achievements of Israel. All true art is a religious manifestation. Franz Werfel put it very neatly. "Religion," he said, "is a dialogue between God and men; art is the soliloquy."

An examination of the arts of any country is an act of bridge-building from that country to other lands. The arts remain, as always, a universal ground of mutual understanding, a common currency that readily measures the substance and soul of the country of origin, or in turn, the sensitivity of perception in its neighbors.

BACKGROUND

The artistic history of the Jewish people is unique, and that uniqueness has a bearing on what is happening in Israel today. Even before Moses led them out of the land of Egypt, the Jews were artisans. One can assume that they were makers of statues to the point of idolatry since the proper worship of the one God — He of the Ineffable Name — demanded that they make them no longer. Polytheism carved pagan gods in wood, stone and clay, and many of them such as Astarte, the goddess of fertility, had an obscene inflection. For the understanding and growth of monotheism, it was necessary that there be no idols that could be worshipped or thought to have the divine powers of the Only God. No other people at that time were so possessed, so inspired.

The command, set forth in the book of Deuteronomy, was a cruel command:

> Take care what you do, therefore, since you saw no shape on that day at Horeb when Yahweh spoke to you from the midst of the fire, see that you do not act perversely, making yourselves a carved image in the shape of anything at all: whether it be in the likeness of man or of woman, or of any beast on the earth, or of any kind of bird that flies in the heavens, or of any reptile that crawls on the ground, or of any fish in the water under the earth.

Later, Moses gave them the commandment:

> I am the Lord your God, who brought you out of the land of Egypt, out of the house of slavery.

> You shall have no gods except me. You shall not make yourself a carved image or any likeness of anything in heaven or earth beneath or in the waters under the earth. You shall not bow down to them or serve them.

The commandment was given to raise them to monotheism, to raise us all, to distinguish them from their neighbors, a distinction that would cost them dearly in the centuries ahead. The God of the Jews was a jealous god and a just god, but he was not the cruel god the outlanders sought to placate. He had dismissed human sacrifice through Abraham. He was not a god to be represented by a bull or a serpent or a falcon. He was not to be represented anthropomorphically or theriomorphically. He was Pure Spirit, He was alone, He was the Lord, He was the One.

Whatever we may think of this prohibition today, it must have been devilishly difficult for the Jews to obey. Opposed to it was the powerful natural human impulse to model something in clay other than a pot; the desire of children to have toys and dolls (even the Puritans had their poppets); the Jewish envy of those other tribes that had solid material idols to stimulate their imaginations; the fact that God Himself had molded the world; that He had made Adam from clay and that he had carved Eve from a rib bone. The sexual drive of man lusted to make enticing phallic objects, or mammiferous, callipygian Astartes that would palliate or arouse his desire. No wonder the commandment was occasionally broken. Small wonder the Israelites set up the Golden Calf in the desert; small wonder the House of Dan would later slip from grace and present the bull as venerable. The miracle is that the commandment was so well honored — not for decades, not for centuries, but for millennia. The archaeology of the Middle East has shown that the area abounds in figurines of ancient gods, but none has ever been found that was intended to represent the Adonai, the God of Israel. Difficult the commandment may have been, but in that holy instance it was kept.

Art, however, is such a natural instinct in man, such a religious instinct, that it cannot be quiescent. The Lord proved Himself an artist in His creation. On one occasion he ordered Moses to model a snake and put it on a staff and hold it up, and all that gazed upon it would be well. Above all, he had designated the artist who was to construct the Ark of God, the Ark of the Convenant, the Ark of the Testimony, and commissioned him. In the Book of Exodus, we read:

> God spoke to Moses and said, "See, I have singled out Bezalel, son of Uri, son of Hur, of the tribe of Judah. I have filled him with the spirit of God [ruakh] and endowed him with skill and perception and knowledge of

every kind of craft; for the art of designing and working in gold and silver and bronze; for cutting stones to be set, for carving in wood, for every kind of craft. Here and now I give him a partner, Oholiab, son of Ahisamach, of the tribe of Dan; and to all the men that have I have given more, for them to carry out all that I have commanded you: the Tent of the Meeting; the Ark of the Testimony; the throne of mercy that covers it, and all the furniture of the tent; the table and all its furnishings, the pure lampstand and all its accessories; the altar of incense; the altar of the holocaust with all its furnishings; the basin and its stand; the sumptuous vestments — sacred vestments for Aaron the priest, and vestments for his sons — for the priest functions; the chrism and the fragrant incense for the sanctuary. In this they are to do exactly as I have directed you."

When the Hebrews had settled at last in Canaan and the long wandering was over, archaeological evidence shows they did indeed come to have graven images in their homes and in their temples. While an Israelite might not "make himself" any graven image, craftsmen from Tyre or Egypt or Crete were called on to make statues and mosaics for him, not for worship but for decoration. Even Solomon's Temple, the Book of Kings tells us, was decorated with four statues of oxen which supported a huge bronze laver used for ritual ablutions. Denied a tradition of their own by the ukase against the plastic arts, the Jews were influenced by their neighbors or their conquerors, and the influence of Greek and Roman art can be seen in the mosaics and statues uncovered by archaeologists. In periods of relaxation, the only sculptures banned were those of the human form; nor was its representation permitted on flat surfaces. The Lord, they were reminded by their prophets and their priests, could not be represented spatially.

The great Gamaliel II, a rabbi of liberal views, put his interpretation of the law simply: "What is treated as a deity is prohibited, what is not treated as a deity is permitted." His was a minority opinion, but it is the majority view today. His liberal admonition and foreign influences had their effect.

In Tiberias, extensive digging, begun in 1921, disclosed among many other things the remains of a synagogue with a beautiful mosaic pavement in fourth-century Hellenistic-Roman style with human figures. In 1939 archaeologists uncovered the Beit-Alpha Synagogue, built in the fifth century C.E., with a splendid mosaic in the floor. Here the sun is represented, after the Apollonian tradition, as a chariot with a human rider. Other human figures, including women, represent the four seasons. Still earlier is the work in the Dura-Europus synagogue in Syria with a decided Hellenic style. Other examples abound of paintings and carvings in early Jewish life in Palestine. Gamaliel's liberal view had its devotees.

For the first two hundred years of the Christian Church, the Jewish commandment against graven images held back Christian artist until the full implication

of the Incarnation of Jesus was appreciated. In turn, the Christian emphasis on art was to influence Jewish practice. During the Middle Ages, for example, *The Book of Hours*, a Christian prayer book, reached an apogee of artistic creation. The Limbourg brothers in France and other artists decorated such books with elaborate miniature paintings to follow the sequence of the Christian liturgical calendar, illuminating the pages with exquisite scenes of daily life as well as scenes from the Old and New Testaments. Jews followed suit in their Haggadah, a book of rabbinical stories and legends recounted with didactic intent. The word itself means "narration" or "telling" and is distinguished from "halacha," the legal writing. The Haggadah popularly refers to the material read at the annual Seder, the family feast on the first night of Pesach or Passover, and centers on the story of Exodus. The Haggadah has attracted Jewish artists for at least the past five hundred years as a book where depiction of Old Testament themes is welcomed. To this day it remains a book wherein Jewish artists can exercise an exuberance that might not be welcome in other Judaic literature. In this country two exceptional Haggadot with English texts have been illustrated by Ben Shahn and Leonard Baskin. Israeli artists have produced many there, of course, with Hebrew texts.

Long before Jewish artists were turning their attention to the Haggadah, they exercised their talents in the construction and decoration of synagogues and in ceremonial art. The sixteenth-century Jewish scholar Isaac Profiat Duran wrote that "looking on beautiful shapes and pleasing sculpture in a synagogue enlarges the soul, quickens the heart and increases the power of the mind." Unfortunately, very little Jewish art produced before the sixteenth century remains because of the recurring persecutions Jews suffered.

Throughout the centuries, from the days of Bezalel down to the most modern temple in Israel or New York or Buenos Aires or Australia, there was a lofty tradition of ceremonial art of the most exquisite workmanship going on in Jewry. Not merely the Haggadot with their graceful illuminations, books meant for the home, but the sacred scrolls before the book was devised. In the synagogues, a tradition of high architectural accomplishment obtained. The same Judaism that would have every man, woman and child offer a prayer as they lift a cup to their lips or when they enter or leave their homes, prayed too for the accomplishment of the work at hand, that *ruakh* might blow through it. Jewish museums are filled with ritual objects, too seldom seen by Christians. Among these are Torah scrolls, the arks or tabernacles in which the scrolls are sequestered and the woven curtains that adorn the tabernacles as well as various liturgical artifacts.

In the Western world, and wherever the industrial revolution is dominant, art has become a very specialized activity, quite apart from ordinary life. Ceremony has been rooted out of the home, and to see great works of art we must travel to galleries or be admitted to private collections. The objects that we use in our daily lives, our domestic tools, are for the most part without aesthetic charm.

Throughout the centuries, whether in the ghetto or wandering, the Jewish home did not suffer in this way. Within it a tradition of ceremony has persisted; a liturgical calendar, caught up in religious gestures, has been kept with enthusiasm or indifference, depending on the family. The calendar is akin to the Christian calendar that centers on Easter, but the Christian calendar brings little ceremony into the home. Except for the Advent wreath and the lighting of advent candles to prepare for the birth of the Saviour, and the recitation of the rosary, little Christian ceremony has been performed in the home, particularly in recent decades. Christian liturgy centers in the church. For the Jews, however, there is a saying that after the Temple fell the center of Jewish life was the table. There, regularly, great literature was read, poetic prayers recited, wine drunk, the good things of nature honored, and vessels of artistic beauty brought into use: Kiddish cups and other goblets, menorahs, Sabbath plates, Sabbath lamps, hallah covers that go over the bread, tablecloths of exquisite design. Prayer books were beautifully bound, beautifully illustrated, beautifully decorated. The humblest of items of religious practice were often intricately and exquisitely worked, even the yarmulke, the little skull cap worn by a man.

Because such ceremonial art was rarely seen by non-Jews, the Jewish tradition never impinged on the majority of citizens in the lands to which the Jews emigrated or in which they held citizenship. The point is that the love of beauty is inherent in Judaism. Dancing and singing are an intimate part of Jewish life. Indeed, dancing has been encouraged in a way it never was among Christians, albeit with all the modest sexual restraint of the American square dance.

Never, however, did the Jewish religion encourage painters and sculptors in the manner of the Catholic Church. With the abandonment of the ghettos and shtetls of Europe during the eighteenth and nineteenth centuries, the Jews entered the public life of Europe with a presence and an emphasis they never lent Europe previously. They began to figure more and more in the artistic life of the Western world. In Germany and elsewhere was this true, and the first Jewish painters to come to Israel came from Europe to set up a teaching school of painting out of which grew the national museum. The name they chose for their school was Bezalel, after the man into whom the Lord breathed His *ruakh*, the craftsman of multiple gifts who had designed the Ark of the Covenant. From those painters and sculptors who arrived in the Holy Land in 1906, almost half a century before the State of Israel was established, we mark the beginning of modern painting in Israel. The first among these immigrant painters was Boris Schatz, from Bulgaria, who was bent on founding a Jewish museum and a school of painting. When he came to Jerusalem, it was still under the control of the Ottoman Empire, and it is not without significance that Schatz established his humble museum in a building that had been used as a Turkish harem. From the arrival of Schatz

11

in Jerusalem, the Israeli artist has never looked back. Lean days there have been in abundance; the struggle against poverty; the struggle against the climate, as severe for the artist as for the farmer (very often the two were one). Nevertheless, the artist in Israel has from the earliest days and certainly from the formation of the state been a respected figure. He is conscious of many things, an artist in Israel. First, he is conscious that he is one of a new breed, always an intoxicating thought, a new breed making a new world. Second, he is conscious of being respected, of living among a people who regards the artist as indeed having within him a *ruakh*, the very breath of God. Third, he is conscious that around him is a network of museums dedicated to honoring the work of such persons as he. Lastly, he is conscious that his government seeks as best it can to encourage the arts and to honor the artist. All that is stimulating.

The Israeli artist has one other advantage: in Israel starting off, there were no oleographs or other dreadful reproductions of past masters to cover wall space in the new homes multiplying on all sides. Consequently, the works of Israeli artists have sold comparatively well. Still the country was impoverished, and remains pressed, so that there are vital priorities that stand before art.

The artist in the kibbutz had an advantage that the artist elsewhere might not find. He knew his living was secure. He worked as a member of the kibbutz, he clerked, he farmed, he taught, he stood guard, but on his free time he painted as he wished, he carved as he would, he created, he had subjects that were fresh, important and inspiring. Moreover, he had a sympathetic audience, and his work was more likely than not to be honored. Some of the best exhibits of art in Israel to this day are to be found in the kibbutzim or the moshavim.

This is not to imply that the Israeli artist has not had a struggle, that he has not gone cold, that he has not hungered, that he does not feel oppressed or neglected. He has. He has had to form his own organizations not merely to further the lofty purpose of art, but to insure fair dealing for himself and his colleagues and to see them properly presented to the nation.

The country into which he came is unique — and not alone for its religious history. First of all, it lies at the crossroads of three continents, Asia, Europe and Africa. In time, its artistic tradition would catch up strains from all three. The comparison with Venice is inevitable. That state also stood at the crossroads of the world, between north and south, between east and west. Given the 1,376 years that an independent Venice existed, what might not Israel produce in so many centuries, having produced in forty years what we can see today?

While the location of Israel is of paramount importance in its history, the geography has had a preeminent effect on the area's history. The geography of Israel is forbidding. The coastline of the Mediterranean runs four hundred miles without once offering a major harbor. A narrow coastal plain slopes to

a cruel ridge of mountains, a chain unblessed by a single major peak that might with the snow-capped dignity of a majestic cone suggest a sense of serenity. Dominating the land are rocky, rough, ugly formations of limestone and chalk, pitted with caves, gullies and wadis. Beyond the green valley of the holy river Jordan lies the desert, the hot breath of which scorches the summer air. To the south the desert is all but supreme. The aspect is one of violence. The heat of summer is violent; the winter rains are violent; the colors are violent. From such a land a living comes hard; it is a land that has discouraged all its conquerors, even at length the Romans, those remarkable engineers with the power of an empire behind them. The overriding concern is the lack of water, and one might recognize in the Dead Sea, with its somber stillness and intense salinity, a symbol of the ever-present threat of the desert to drown all in rocks and sand. That mysterious sea is unique, the lowest point on the earth. This landscape has affected the history of the area as few civilized regions have affected their inhabitants.

The conquerors have been many, but what must be seized is this: all previous conquerors have either quit the area or surrendered to the sterility of the landscape. What has lured them there, what has caused them to spill blood to hold it, has not been natural resources but the strategic location between the continents and, theologians would say, between heaven and earth. From before the dawn of history it has been a busy trade route, and consequently a perpetual battleground. For more than three thousand years it has been something much more important — it has been a Holy Land, sacred first to the Jews, then to Christians and then to Muslims. To this day it is the Holy Land to them all.

Because it was a constant trade route, it had the misfortune to be a crossroads in history, to stand on the pathway of the world powers and their need for petroleum, a resource cruelly denied Israel but abundant in adjacent lands inhabited by peoples inimical to Israel and bent on her destruction. From early in this century until today, the Jews have done more to tame the wild topography, to cultivate and civilize the land, to make the desert bloom, than was done by any conqueror since the Romans with their engineering genius and slave labor. The Israelis have done more in forty years in Israel than the Turks and Arabs accomplished in six hundred. It is not unreasonable to say that the land belongs to those who are worthy of it.

All that the people of Israel have accomplished has been accomplished while being harassed. Despite war, terrorist attacks, interminable economic difficulties, the arts in Israel have been developed with depth and brilliance, suffusing the society to an unusual degree. From the first, the arts were a consolation amid deprivation, a promise of communal achievement beyond personal achievement, an assurance of the civilization of the Jewish people, a mark of conviction of their inner worth, a mark of their identity and an earnest

13

symbol of their appreciation of Eretz Israel and their return to its sacred soil.

Writing of the Italian city-states of the Renaissance in *The Civilization of the Renaissance in Italy*, Jacob Burckhardt wrote words that may well be applied to Israel in the Middle East: "In them for the first time we detect the modern political spirit of Europe...often displaying the worst features of unbridled egotism...But wherever this vicious tendency is overcome or in any way compensated, a new fact appears in history...the state as the outcome of reflection and calculation, the state as a work of art." Israel remains the only truly democratic state in the Middle East.

On a spring day, when the Asian sun burned relentlessly on the Israeli shore, a Catholic nun, Sister Katherine Hargrove, walked into a war memorial and saw a vision of peace. The memorial is a ruined battleship, a tangle of rusted wreckage thrown up on a beach and there turned into a monument of found sculpture into which a man or woman may walk erect as if into a dream or a nightmare and stand in the midst of a tangled horror. Mounted on that memorial is the word *Shalom* in Hebrew and in English characters, but there is no peace in that hideous skeleton, she told me, until one looks through the aperture in the bent and jagged steel and sees the serene empyrean, the eternal blue of the waters of the Mediterranean. That woman of dedication standing in the ruins of war, looking westward and seeing peace, is a paradigm of the artist in Israel. As he works as best he can in Israel's struggle for survival, he knows that somewhere sometime, the God who holds the keys of peace may permit Israel to find it.

The incident of the nun in the destroyed weapon of war may also be taken as a symbol of Eretz Israel itself, a republic, a phoenix risen from the ashes of murdered millions, the sufferings of millions more, and the dreams of the remaining millions who are striving to build not a utopia where a man can live forever but a very human democracy where men can live their generations in peace.

In the forty years since Israel was founded, the books written about the country are legion. The catalogue is extensive and even forbidding. To encompass it could take a lifetime. Besides annual tourist guidebooks, there are extensive and intensive historical studies, sociological treatises, biographies of founders and leaders, their own autobiographies, histories of every major aspect of every major event and chronologies of just about every week (since they can crowd a war into six days) in the eventful years of the country's embattled existence.

So charged with burning emotion have those years been, the books written about Israel have concentrated on the sociological, military, political and international aspects of the aspirations and accomplishments of the indigenous Jews, the Yishuv, the pioneers, the refugees, the stalwarts of the aliyah, all

14

these and their descendants, the sabras — those native-born — a generation that has come to maturity as citizens of the indomitable little democracy. Too little has been written about the arts, perhaps because a healthy man rarely talks about his symptoms. But they have turned the tragedy preceding their return to Eretz Israel into art; they have made statues of their ashes. They have turned to art as a lesson to the world, for all true art is an act of brotherhood.

Art in Israel draws strength from three elements. First, the Hebrew language, primitive and powerful, and the great literature written in it. The second is something the world has never seen before, the treasure that lies in the hearts and minds that the people of the aliyahs have brought to the Yishuvim and Israel, the racial and religious traditions of a hundred lands, the insights of a variety of civilizations, the skills and crafts of those cultures, and the benefit of years of interplay and exchange between the Hebrew mind and the cultures in which it found itself. The third element is Israel's alliance with the West, its fraternal link with Western civilization, not merely the scientific and political expertise developed in the West but the common spiritual heritage of the West: the acceptance of the world, and the things of this world, on which the rest of the East turns its back, with the result that the arts stand in those countries, truncated, magnificent in concept but limited, unable to embrace the image of man. Thus from the Torah, Israel draws its spirituality; from the Hebrew language and the aliyahs, its nationalism; and from the Western scientific and humanistic traditions, its military and economic strength and a major element in its artistic tradition.

ARCHAEOLOGY

Archaeology has a unique intensity in Israel. There, if anywhere, it is an art as well as a science, an imaginative discipline that is helping to extend and refine the definition of the Jewish people. Nowhere can all the emotional resonances of that work be felt more than in the Shrine of the Book, one of the simplest and most beautiful buildings in the world, an ornament to the grounds of the Israel Museum in Jerusalem, and a religious mecca in Israel.

In it is displayed as a holy object — which indeed it is — an ancient leather scroll on which is inscribed the complete text of the Book of Isaiah. Composed of seventeen leather sheets, 7.34 meters long, the scroll is displayed under glass on a projecting drum on a pillar in the center of a raised platform in a circular room. Above the drum as an ornament and a symbol, and perhaps a philosophical conclusion, is an elongated knob, a gigantic representation of a simple handle of a Torah scroll.

What makes the manuscript unique is its age. More than two thousand years old, it is in an excellent state of preservation, having been sequestered in a forgotten cave in the eroded mountains near the Dead Sea at the bottom of the world since 70 C.E. during the First Jewish Revolt against the Romans, who had destroyed Jerusalem and forbade the teaching of Torah. The manuscript is a thousand years older than any other Hebrew manuscript extant. The Roman empire is gone; the Torah remains.

The book is the chief but far from the only treasure in the Shrine of the Book, which in turn holds but a small part of the manuscripts unearthed in the Holy Land. Standing before that holy book, moving around it, seeing what it is, sensing what it can mean to Jew and Christian alike, a visitor can realize why archaeology is a national passion and a sacred science in Israel.

17

The Department of Antiquities and Museums, now part of the Ministry of Education and Culture, was established in 1948. Among its duties are the safeguarding of antiquities, the preservation of ancient monuments and sites, the supervision of excavations and surveys, the inspection of ancient sites, the care of the state collection of antiquities and scientific archives relating to excavations, all scientific publications, services to scholars and students, and concern for the multiplex of museums throughout the country. A recent survey showed that, besides the Israel Museum with its magnificent collection, there are thirty museums of archaeology in the country plus half a hundred local collections, most in kibbutzim. The thirty museums are not chance or amateur gatherings; they qualify as museums under international definition.

The digging goes on. Among the foreign institutions excavating in Israel under license from the government and with the happy cooperation of Israeli authorities are Carnegie Museum; Mission Archaeologique Francaise; the Ecole Biblique et Archaeologique Francaise; the University of Cambridge, England; the University of Missouri; Hebrew Union College; and the Albright Institute of Archaeological Research. All in all more than thirty sites are being probed by foreign groups. Government maps designate more than a hundred archaeological sites where work continues.

All this work is reported in publications of the Department of Antiquities, its *Archaeological News*, a quarterly in Hebrew, and *Antiqot*, ongoing reports in Hebrew and English. The department puts at the service of the public a library of more than five thousand volumes. It has also organized a Society of Friends of Antiquities, an organization of knowledgeable dilettantes who report immediately on any of their finds.

Of all the sciences, archaeology, one may say, most closely approaches the arts. As we have said, in Israel it is an art. The dictionary defines archaeology as the "systematic recovery by scientific methods of material evidence remaining from man's life and culture in past ages and the detailed study of this evidence." It can also be defined as "the scientific study of the material remains of antiquity." Generally, archaeology confines itself to the study of artifacts dating from time out of mind to the Middle Ages. The *Encyclopedia Britannica* acknowledges that it can be considered an art. In its strictly scientific methodology it is a twentieth-century discipline.

In the popular mind, perhaps, it finds its beginnings with Heinrich Schliemann, the amateur archaeologist who discovered the ruins of ancient Troy in 1873. His excavations there and at Mycenae made him internationally famous, and so far as archaeology is concerned, despite the corrections scholars have had to make on his work, immortal. It is interesting to reflect that because he innocently tipped the hall porter of an English club, the Atheneum, he was rejected for membership. From his day to this, archaeology has grown from a slovenly and enthusiastic hobby, often piratical, to a skilled, scholarly

and scientific discipline. In Israel it is well-nigh preeminent among all such disciples.

How does it relate to the arts? First, many of the artifacts resurrected from the dust and ashes of the centuries are things of beauty. A painter puts layers of paint, shellac and varnish on a canvas to create a work of art; experimental artists gather odds and ends from junkyards to mount found sculptures; others carry driftwood from tidal reaches to buff and polish and present as wall-hangings to the acclaim of critics. With a hand as delicate as that of a surgeon, the archaeologist brushes away the accumulated dust of centuries to invent (in the antique sense of that powerful word) an art object, precious not only for its inherent beauty but for the historical value that attaches to it. Often the archaeologist is called upon in the reconstruction of an object to intuit the mind of the original creator, and re-creation becomes creation. At times, he must intuit the mind of an architect, millennia dead, in order to proceed without clumsy destruction. Archaeology, like art, imposes man's rational and artistic order on the chaos of decay. Like the artist, the archaeologist wills beauty and with his techniques brings it into being.

No country in the world, including Egypt, whose pyramids with their funereal and lovely contents have caught the imagination of the world, has had as much of its surface subject to the probing tools of archaeologists as has Israel. Nor has any other nation put as much of its substance into the science that is in the end a public service — a service to mankind. In Israel, Jews and Christians and nonbelievers work side by side to flash the light of archaeology on the story of man and on the literature of the Bible. For Jews the work gives additional knowledge of their national history. On the first score, Israel's archaeology has made basic contributions to our knowledge of prehistoric man. Again, archaeology has made no greater contribution to our knowledge of the Bible than the discovery of the Dead Sea Scrolls, their identification, preservation and interpretation; while Jewish national history has been accorded no greater monument, no more inspiring excavation than that uncovered at Masada, an ancient, incomparable fortress and now a universal monument for any who put the human spirit above the claws of armament.

We have the word itself from a Jew in the Holy Land, Flavius Josephus, soldier-historian, born 37/38 B.C.E., the year of Caligula's accession to the throne of the Roman emperors. One of Josephus's several works carried the title *Archaiologia*, which came over into English as *The Antiquities of the Jews*. But it gave us the word *archaeology*, and it is semantically fitting that the science today obtains so widely in Israel and there is so revered. Beyond the scholarly disembowelment of hundreds of sites in Israel, archaeology, with its unveiling of ancient glories, has become a national pastime in the land, for rich and poor alike. Digging a produce garden, preparing a new highway

19

or plowing a furrow can turn up sherds or an ancient coin or two—Jewish, Greek or Roman—or something better. The deserts themselves are more likely to produce a crop of informative sherds than a cluster of flowers or a thrust of perdurable weeds. A few years ago, a tourist visiting the Kibbutz Tirat Zvi in the Beit Shean area on the river Jordan south of Galilee turned up a bronze head of the emperor Hadrian, a rarity even among collections of Roman statuary, and workmen more recently turned up a marble head of Athene, the Greek goddess of arts, crafts and war.

Israelis more than any other people have been schooled not to dig recklessly and to report to the authorities any unusual find so that specialists may pursue the work. Not every citizen is conscientious, and even Moshe Dayan, familiar to American newspaper readers because of his black eye patch if not for his military exploits, was accused of cagily using his position as general and statesman to build his own collection of antiquities which on his death was appraised at more than a million dollars. Early in 1987 controversy over the illegal sale of antiquities and the smuggling of them out of the country erupted. Some, describing the practice as "historical rape," wanted to strengthen the Antiquities Law, but Mayor Teddy Kollek of Jerusalem argued that it might have the reverse effect. He suggested that the business be left to a small group of responsible dealers who would traffic in minor pieces but see that the major pieces remained in the country. Nor is everybody enthusiastic about the numerous digs. Orthodox rabbis are shocked at what they deem the desecration of graves.

Persons familiar with James Michener's novel *The Source*, dealing as it does so thoroughly with archaeology and the evolution of man in the Holy Land, have found it an excellent popular account of the way archaeological work proceeds. No nation has given more of its substance to this science than has Israel, whether encouraging or collaborating with foreign scholars or conducting its own digs sponsored by the Hebrew University, the Israel Exploration Society and the country's numerous museums. Archaeology plays such a major part of life in Israel that as a public service the government distributes a book, *Archaeology*, which summarizes all the work done or being done at scores of sites throughout the country.

Generally speaking, archaeology ends when written records begin, but there is no strict demarcation. The reading or deciphering of inscriptions, on whatever surfaces, must be left to specialists in epigraphy, paleography or numismatics, handmaidens to archaeology. Ancient written records, such as the Bible itself, can, or course, be supplemented as historical documents by the scrutiny and collation of man's material remains unearthed by archaeology.

Israel is a unique land for archaeological study because of its place at the crossroads of three great continents and many cultures—the world's oldest—and its unique religious role for thousands of years and millions of believers.

Babylonian, Assyrian, Persian and Egyptian horses and chariots harrowed the land. Greek phalanx and Roman legion reduced its strongholds and sacked its cities; Crusaders came and fought and built; and later, desert warriors on their swift horses destroyed temple and monastery. All such invaders imposed their architecture, handicrafts, their mores and their vengeance on the ancient cities of this oasis and surrounding wasteland. Jericho is deemed the oldest city in the world, and heaven alone knows how many layers of past lives spread beneath its green landscape. Over the centuries cities shift their centers, their very locations. An earthquake or a war razes in hours a city that man took years to build. With the crisis past, those inhabitants who remained, if any, and those who fled and crept back, built anew, a mile or two perhaps from the ruins they mourned or directly on the old. The new city is always near the old. For all sites in this arid country depend on the location of a water hole, a spring, a dependable water course, a continuing supply. As W. H. Auden wrote in his poem "First Things First," "Thousands have lived without love, not one without water." Thus, the Israelis, tracing the history of their ancestors, have a trail before them that gets lost in the mists of time, back to the very emergence of homo sapiens. Archaeologists in Israel have turned up remnants of Pithecanthropus Man, bones matched by discoveries in only one other part of the earth, Tanganyika. It was 300,000 to 500,000 years later but not very far away, the Torah tells us, that Abraham made his covenant with his God. Abraham and his family came out of the Sumerian lands, having infiltrated into Sumer about the twelfth century B.C.E., some time in the Middle Bronze Age. The oldest documents speak of the Habiru or Hapiru, nomads on the fringe of Sumerian society. Were they the original Hebrews? The question is debated. There is a stele – an upright stone with an incised surface – that dates from the thirteenth century B.C.E. and mentions Israel. It is the first mention of the name, but from it one might deduce that the Hebrews were in their Holy Land before the Canaanites, whom the Israelites, after the Exodus and led by Joshua, displaced.

Before he was anything else, man was an artist, an artisan making tools with beauty and beauty with tools, or painting pictures on the walls of caves. No cave paintings have been found in Israel, but traces of man's development as toolmaker, hunter, herder, food gatherer, domesticator of animals, and farmer, have been found. Man was in the Holy Land at least 500,000 years ago, when the Paleolithic Age began. The earliest clues to him were discovered in 1962 at Ubeydiya near the Kibbutz Afiqim in the Jordan Valley south of the Sea of Galilee (Lake Kinnereth). The bones found there were identified as belonging to Australopithecus, the first toolmaker, older than Java Man, older than Pekin Man and previously known only in Tanganyika. Archaeologists found bones and tools: pebble tools, a chopper and spheroid, for cutting, scraping and pounding. The Paleolithic period ends about 12,000

B.C.E., and the Neolithic period follows. These periods have yielded to scholars evidence of the growth of man, including circular dwellings found at Eynan in the Jordan Valley and tools indicating domestication of animals and production of food—in brief, a high standard of living. Mortars and pestles of the Neolithic period have been discovered along with flint blades and tools for reaping a harvest and a stone axe for felling trees. City life had become possible; Jericho came. Here was irrigation farming in the Neolithic period and here has been placed the arrival of pottery. Brick-work was found on defensive walls around Neolithic towns and watchtowers thirty feet high. Here was found the earliest known pottery in Israel. Wars and earthquakes destroyed Jericho again and again; seventeen times it was repaired and rebuilt. At one site, twenty-two layers of floor were excavated. The walls that Joshua brought down with his trumpets cannot be descried, but the curse that he put on anyone rebuilding the city may have taken effect, because no remains from the twelfth century B.C.E. have been found.

There is a sense in which Islamic rule of the Holy Land also became a curse. The Middle Ages had a saying that can give us some insight into the effect of centuries of Muslim rule in the Middle East: "The grass never grows where the Arab sets foot." The saying arose perhaps from the observation of the decline of Roman civilization along the African shore and the Levant following the Arabian conquests and the collapse there of Christendom. The Romans had come into Palestine (named for the non-Semitic Philistines) and built with stone. Herod the Great, a Hellenizing Jew who owed his years of rule to sycophancy paid Roman emperors, was an accomplished builder. Roman roads went everywhere to link the cities that pushed back the desert and so permit easy passage for the fast-moving Roman legions. Hundreds of years of European civilization ended when the Islamic horsemen came sweeping in from the desert to impose their language and beliefs. The sand shaken from their white robes silted over the Roman stone. The desert crept back. Islam conquered in 636 C.E., the Ottoman Empire in 1516. Palestine remained under Islamic rule until the Allies defeated the Turks in World War I and the League of Nations set up the British mandate. The sole interruption in Muslim rule between the seventh and twentieth centuries was a century in which the Crusaders built with stone before dying in their armor at the Horns of Hittin in 1187, harassed by Saladin's nimble horsemen.

Under Islamic rule, the Holy Land became not a frontier, as it had been under the Roman rule and under Jewish independence, but a backwater, an arena for sheep- and goat-herders, with a culture and economy shaped by the nomadic mind. Doomed by the sterility of the desert, Islamic culture achieved perdurance by sacrificing growth. The Arabs did bequeath Jerusalem one of its most beautiful buildings, the Great Mosque, but only in the nineteenth century were the Western powers able to make arrangements with the Turkish

government to permit scholars to explore the land. In 1839 Jews were allowed Turkish citizenship. In Western and East Europe they were permitted to return to the Holy Land and join the Jews who had remained throughout the turbulent and then the sleepy centuries, an impoverished people. We can sense their humiliations under Turkish rule from incidents recounted in the book *The Dead Sea and the Jordan*, by Lieutenant W. F. Lynch, U.S.N., which tells of his expedition to Palestine in 1850. The British mandate allowed the Jewish culture to express itself, and archaeological excavations developed far more briskly. Since then no land has given up such treasures for the stimulation of the mind and a better understanding of history.

Almost all the early leading archaeologists in the Middle East were non-Jews. Felicien de Calucy dug as early as 1863 and discovered some royal tombs, including that of the Persian queen, Helen of Adiabene. Charles Warren performed a daredevil feat of engineering to demonstrate that the Temple wall went down far deeper than supposed. Charles Clermont-Canneau found the first of the two surviving stones with inscriptions threatening death to any non-Jew to enter the Holy of Holies. William Flinders Petrie won more attention for his work in Egyptian tombs. L. Hugues Vincent, a Dominican priest, besides conducting his own excavations, correlated all excavations in Palestine. Gottlieb Schumacher excavated at Meggido and R. Stewart Macalister undertook at Gezer what is deemed the first major Palestinian excavation. William F. Albright probably did more for the furthering of archaeology in Palestine than any other man. Nelson Glueck, head of Hebrew Union College in Cincinnati, worked in Transjordan and the Negev. Roland DeVaux, another Dominican priest, headed all research activity on the Dead Sea Scrolls after the partition. Kathleen M. Kenyon was an exemplar of the leading women who have entered the field and a proponent of teaching archaeology as a distinct discipline. Bellarmino Bagatti led the archaeological work of the Franciscan Holy Land Custody. The first Israeli archaeologist was Eliezer Lipa Sukenin, father of Yigael Yadin, who led the work on Masada. Both of them are at the heart of the "immense boom in archaeological research fostered by the State of Israel." With them, the State of Israel became the major factor in archaeological excavation in the country. With them we come to the two major historical discoveries: the Dead Sea Scrolls and the Fortress Masada.

THE DEAD SEA SCROLLS

Yigael Yadin is one of the great heroes of Israel, a sound example of the Israeli artist who is required on occasion to be a man of action. Yadin is a sabra. Born in Jerusalem in 1917, he was only fourteen years of age when he became a revolutionary, joining the Haganah, the underground resistance army that, in the last days of the British occupation, fought both the British troops impeding Jewish immigration and the Arab incursions. He became chief

of planning and operations for the Haganah, and in 1948, when the State of Israel was established and the surrounding Arab countries sought to over-run the infant republic, Yadin became chief of staff of the Israeli defense forces and played a hero's role in Israel's victory. In one famous incident, he won a crucial engagement with his knowledge of archaeology, remembering an ancient Roman road across the desert that all but he had forgotten.

His story should best begin with his father, the late Eliezer Lipa Sukenin, professor of archaeology at Hebrew University in Jerusalem, who directed the dig at Bet Alpha to uncover a sixth-century B.C.E. synagogue built in the reign of the Emperor Justin. The synagogue is famous for the splendid mosaic floor that was found almost intact. The design demonstrates that the commandment against the depiction of man or beast was not always strictly kept. In its rectangle are three horizontal panels, each a prime example of Jewish folk art of the Persian period. The first panel depicts God's interrup-tion of Abraham's sacrifice of Isaac. God is depicted by a human hand beside the sun's rays. Four human figures are presented: Isaac bound to an altar, Abraham and two servents; there is also a ram. In the middle panel are the signs of the zodiac and a youth driving a chariot pulled by four seasons, perhaps Apollo. The top panel has the Ark, flanked by menorah and lions, along with swinging censers, palm branches and citron. The excavation, now with some government restoration, is at the foot of Mt. Gilboa, not far from Haifa.

This was not Professor Sukenin's only excavation but was perhaps his most satisfactory. He is also remembered for his contribution to the rescue, acquisi-tion and authentication of the Dead Sea Scrolls in 1947 and 1948, a most dramatic story.

The first Dead Sea Scrolls were found in an isolated cave by a Bedouin goatherd boy chasing a maverick black goat up a precipitous mountainside. The animal led him to a naturally concealed entrance to a cave, 254 feet deep and six feet wide, inside which he found a fractured jar holding something other than the gold and silver coins an imaginative youngster might hope for. When he opened the jar he saw folded pieces of leather incised with letter-ing and rolls with linen coverings. He had no way of knowing what scholars could later hardly believe: that the scrolls were two thousand years old. The boy told his sheikh of his discovery, and a man in his tribe brought the scrolls to a Muslim elder in Jerusalem. He in turn referred them to a dealer in antiq-uities, and four scrolls went into the possession of Mar (Lord) Athanasius Jesus Samuel, a bishop of a small, schismatic Christian sect in Jerusalem. According to the account of the Rev. J. Van Der Ploeg, a Dutch scholar, at first the bishop was not moved by a desire to bring the scrolls to international attention so much as by a hope to turn his purchase to a whopping profit (which he ultimately did). On his behalf, it must be said that, in the face of discouragement, his abiding conviction that the scrolls were very old never wavered, although a number

of scholars had remained unimpressed after cursory examination. If Mar Athanasius had been frank and told them all he knew about the scrolls, their judgments might have been different. He was reluctant to let the scrolls out of his hands for scientific examination at Hebrew University, where they would have been known for what they were.

The first scholar to see some of the scrolls and recognize them for their worth, to acquire some and work on them while continuing his pursuit of the others, was Professor Sukenin, Yadin's father. The scrolls he acquired were the first published to a waiting world, and this while Israel was at war. In 1948, invaded by six Arab armies, Israel was fighting for its life. The discoveries were made in territory that would become Jordan but was then under British mandate and which (since 1967) is now occupied by Israel.

The discovery of the scrolls is acknowledged the greatest manuscript discovery of modern times. By 1970, in eleven caves of the Dead Sea region, within an area, actually, about ten kilometers square, the remains of more than six hundred manuscripts were found, including ten complete scrolls and thousands of fragments. Of these, a little more than one quarter are Biblical texts. The remainder are the theological writings of the Qumran community, deemed Essenes, and commentaries of Biblical text, as well as hymns, psalms and secular writings. Seven of the scrolls from the first cave are in the Shrine of the Book on the Hebrew University campus. The majority of the manuscripts found, and certainly those from the first cave, were from the library of the Essenes, an ancient Jewish religious community coeval with the time of Christ and the beginnings of the Christian epoch.

The finds in the first cave, where the boy alighted, were the most important. The scrolls had been hidden in various caves to escape destruction by Roman soldiers in the First Roman War (The First Jewish Revolt) 67-70 C.E., in which Jerusalem was leveled ("not a stone left on a stone"). Jews were slaughtered by the thousands, and others were sold into slavery in greater numbers. What is almost impossible to realize or fully appreciate is that many of the manuscripts dating from the second century B.C.E. are one thousand years older than any Hebrew manuscript previously known. But the desert is a dry place, and where manuscripts are concerned, water is the danger. Many will recall Hamlet's exchange with the gravedigger in the last act of the play:

> Hamlet: How long will a man lie i' the' earth ere he rot?
> Clown: I' faith, if a be not rotten before a die—as e have many pocky corses now-a-days that will scarce hold the laying-in—a will last you some eight or nine year; a tanner will last you nine year.
> Hamlet: Why he more than another?
> Clown: Why, sir, his hide is so tann'd with his trade that a will keep out

water a great while; and your water is a sore decayer of your whoreson dead body.

Encased in jars, confined to a cave, in desert where moisture is rare, the Dead Sea Scrolls survived two thousand years. Startling as is their physical preservation, equally amazing is the accuracy and uniformity in which the texts they offer have persevered. The text of Isaiah copied over and over again throughout the centuries by exquisite Hebrew scribes varies only slightly from the text found in the Qumran cave! Even as that scholarship prevailed, threatened constantly by ignorance, Philistinism, Roman commerce, fire and sword, so it continues throughout the Diaspora, and so it obtains today in Israel, still threatened, still at work.

Toward the end of 1947, with the Holy Land in bloody turmoil, Professor Sukenin at last had an opportunity to examine some of the scrolls and recognize, certainly, if not precisely, their authenticity, age and pricelessness. On November 29, 1947, the United Nations voted to set up an Arab state and a Jewish state in Palestine and fixed their borders. The Jews accepted the plan, albeit reluctantly, but the Arabs rejected it out of hand and immediately attacked the Jewish communities throughout the Holy Land. In the next twelve days, seventy-nine Jews were killed in Arab attacks. Thirty-two Arabs died, some under British guns and some at the hands of Jews defending their land. In Jerusalem, a mob of Arabs looted Jewish shops. Seven Jews were murdered. Arab attacks on the Jews continued throughout the year. In circumstances such as these, Professor Sukenin labored to obtain such of the scrolls as he could. He purchased three from dealers in antiquities, conducting negotiations in turbulent Jerusalem and even riding in an Arab bus to Bethlehem at the risk of his life. Mar Athanasius, meanwhile, had fled the country with the four manuscripts that he had, including the magnificent Isaiah text. Taking such documents out of the country was illegal, but at least the scrolls were preserved, and who knows what might have happened if they had been left behind. The bishop sold them in New York for $250,000 to – of all people – Professor Sukenin's son.

This fascinating sale came about because Yigael Yadin happened to be in New York and saw the manuscripts offered for sale in an advertisement in the *Wall Street Journal*! Through a wealthy friend, D. Samuel Gottesman, Yadin was able to have the manuscripts purchased, and he took them to Hebrew University to sequester them there with the others procured by his father. They constitute today the core of the collection in the Shrine of the Book, the "book" being in this case not the Bible or the Torah, as one might presume, but the Book of Isaiah, singularly honored and deservedly so. The fighting between Jews and Arabs became open warfare and continued until early 1949. Six Arab armies invaded Israel and were repelled. The chief of

operations for Israeli armies was then Yadin. His greatest archaeological triumph was before him.

MASADA

In the bleak desert reaches that surround the Dead Sea, itself 1,230 feet below sea level, Masada rises like a massive petrified warship in an ocean of stone and sand, its bow pointed north and its stern south. Standing at the stern, one sees that the irregular sides bulge on the east, and that the plateau, while level enough, slopes upward to the north. The area on top measures 650 by 220 yards, approximately twenty-three acres. The sheer sides drop 1,300 feet to the valley below, excepting at the eastern bulge where the drop is somewhat less.

Nearby are other plateaus, not unlike the tepuis of Venezuela, but rocky without verdure and with sculptured lines of millennia of erosion. They are nowhere the size of Masada. Masada stands apart from the others, mammoth and austere, and inaccessible save by two paths, both perilous to travel. One of these is the so-called snake path up the eastern side of Masada over which men must go single file. The other is the sloping remains of the titanic ramp Roman engineers built so their legions could storm Masada to quell the last Jewish resistance after the fall of Jerusalem, which had occurred three years earlier in the First Roman War.

Herod had used Masada — the word means "fortress" — as a refuge before he decided to build there. What he built was incredible. On the very prow of that great stone lozenge-shaped mountain — for such it is — his engineers constructed, in three tiers, an enormous terrace, a covered pavilion above that and a palace at the top. The topmost tier was sixty feet above the one in the middle and one hundred and ten feet above the terrace.

Above them, on the top of Masada, was a great swimming pool and a very large bathhouse. Clever engineering insured a constant water supply from a capacious cistern carved in the solid rock at the southern tip.

The work was done sometime after 37 B.C.E., the year Herod, client-king to the Roman emperor, was named King of Judea. For all his notorious cruelty (which in his domestic life shocked even the Romans) he gave Judea thirty years of peace and never had to defend Masada against Cleopatra, whom he feared, his own disconsolate subjects, or the Romans. To fortify further what nature had so generously conceived, Herod built a double wall with watch-towers eighteen feet high all around the rim of Masada. In the twelve feet between the dual walls, soldiers could not only move expeditiously but live in barracks. On the top, within those walls, were storerooms, a huge palace and several smaller palaces or dwellings.

About 66 C.E., when the First Jewish Revolt against Roman rule was getting underway, some Zealots seized Masada from a Roman garrison and used it to wage guerrilla warfare against the Romans and their Jewish collaborators.

27

The Zealots were a Jewish sect that refused tribute to Caesar and remained in an ongoing state of rebellion. In Hebrew they were called *Kanna'im*, which translated into Greek as "zealots." The Romans besieged Masada at length; the Zealot defense and the tragic ending of their story is one of the most heart-rending episodes of early Jewish history.

The narrative comes to us solely from the works of Flavius Josephus, the soldier-historian who fought courageously against the Romans five years earlier at Jopatha, where the Jews withstood a Roman siege for forty-seven days of most savage fighting. Josephus recounts that struggle and the destruction of forty thousand Jews in detail. After it, he joined the Romans in a traitorous turnabout to fight in their ranks. If it had not been for him, the story of the resistance of the Zealots at Masada would never have been known to history, for the siege was a mere footnote in the history of the First Jewish Revolt, a mopping-up operation that the Romans seemed to have disdained to record, having already celebrated their victory with a traditional Roman triumph and the construction of an arch. On the arch are carved the details of the victory over the Jews. What it doesn't show is the heroism of the Jews at Jopatha, or at Masada. For that story we have only Josephus. For all the intervening centuries, Jews generally discounted the story. Since Josephus was a traitor, he was probably also a liar, but the Israeli exploration and excavation and restoration of Masada proved him right.

The Zealots who seized Masada numbered 960 men, women and children. From that bastion, they made forays against the Romans in the area, disrupting commerce, slaughtering soldiers and waging typical guerrilla warfare. After Jerusalem was reduced to rubble (and after the triumph had been celebrated in Rome) the Zealots still held Masada. The Roman general Silva, who was named governor of the province, personally undertook the siege. He had at his disposal ten thousand legionaries and five thousand prisoner-workers or slaves. One of his first acts, after cleverly locating his enormous camps, was to build a wall six feet high, with lofty lookout towers, completely surrounding Masada and the Zealots. The construction of the Roman wall itself was an incredible feat, and remnants of its two-mile length can still be seen. Silva built eight camps, two large, six smaller, for his soldiery. Then he began to pile a ramp to assail the western, shallower side of the fortress. All the implements of siege warfare were brought to bear. The Zealots, well armed from Herod's arsenal and well supplied with food and water, did all they could to disrupt the Roman preparations and to raid the Roman camps. The Romans, however, were experts at siege warfare; their soldiers were all professionals whose adult life was spent in arms, and they had inexhaustible resources, with captured Jews to work as slaves and the countryside to feed them. The band of Zealots, minuscule beside the Roman hordes, held out for seven months—an extraordinary achievement.

At length the Romans crashed the walls that Herod had built at the rim of Masada, but they were balked by a substitute wall the Zealots had built. But this wall was of wood and vulnerable to fire. That night the Zealots knew they were defeated and doomed, that the next day the Roman troops would breach the second wall, and that all of them would be taken and tortured — wives and children with them — and then killed. Their leader, Eleazer ben Yair, made a dramatic speech — reported in detail by Josephus and perhaps embellished by him — in which he urged mass suicide. Many resisted at first, but at last it was agreed. The men killed their own wives and children and then designated ten of their own number to kill the others. That done, one of the ten was chosen to dispatch the other nine. He at last set fire to all that was combustible and fell on his own sword.

When the Romans broke through the substitute wall and entered the citadel the next day, they were surprised at the absence of resistance and astonished by the stillness. Then they found all dead — all except two old women and five children who had hidden and survived the slaughter. Indeed, they came out to greet the Romans and tell them what had been done, but the incredulous Romans were not satisfied until they had made their way through the smoldering fire and found the bodies.

By 1960 Israel was no longer at war, but it was still subject to terrorist attack, particularly at the wasp-waist of the country where the West Bank of the Jordan bulged inward on the republic. The discovery of the Dead Sea Scrolls — all of which had been found in what became Jordanian territory — prompted the Israelis to explore caves in the region of the Dead Sea that lay in Israel. With others Yadin made a number of exhilarating discoveries in various locations. The chance trip of two mountaineers to the top of Masada centered attention once again on that stronghold, moldering under centuries of rubble and ruin.

In 1963 the Masada Archaeological Expedition, sponsored by the Hebrew University of Jerusalem, the Israel Exploration Society and the government's Department of Antiquities, was organized with Yadin as director. Scholars and volunteer workers, many of them drawn from foreign lands, worked for two years aided by Israeli army engineers who, approaching Masada, were faced with some problems not unlike those that faced the Roman general centuries before. One was to supply water to the hundreds of volunteers, all of whom were housed in tents on top of Masada or on the remains of the old Roman camps. At length a pipeline had to be laid. To transport workers and equipment from the base to the top, the engineers constructed an aerial tramway whose counterpart today takes tourists to the top.

The expedition, unmatched in the history of Israel, uncovered what are certainly some of the most extraordinary ruins in the Holy Land. For what was

discovered as well as archaeological treasure was the truth of the story told by Josephus to give Israel one of its most sacred shrines. The archaeological scrutiny of Masada unearthed numerous buildings, palaces, concealed staircases, terraces, storerooms and other material treasure. Workers found fourteen manuscripts, including a first-century text of the lost original of the Book of Ben Sira, called Ecclesiasticus, and articles of clothing, utensils and Roman and Jewish coins, which told how Roman troops garrisoned the citadel for many years after the siege lest Jews again fortify it against the will of the emperor. Among the entrancing discoveries on Masada were mosaic floors, painted walls and a small chapel with a mosaic floor that had been built by Christian monks who for a short while in the fifth century took themselves to Masada. Despite the monkish delight in hardship and isolation, the rigors of ruined Masada proved too much.

One can with easy effort empathize with Yadin, himself a soldier who had led an outnumbered Israeli army against the ranks of six Arab armies, when he saw emerge before his eyes the heroic dimensions of the Zealots' defense and was able to certify by his project the truth of the narrative Josephus had told of the last stand of the Jews against the might of Rome. One measure of the vitality and achievement of the Zealot guerrillas was the extent to which the Romans went to wipe them out. Neither men nor equipment nor expense was spared to destroy the heroic 960. From the story of Masada and the excavation of its ruins and what they tell of Jewish heroism, one can grasp an understanding of the part that archaeology plays in the hearts of the people of Israel, for it has become an art by which they are establishing for all time, after the passage of two thousand years, their full identity.

Today some Israeli conscripts, before serving their time in the armed forces, take their oath of allegiance at Masada in a solemn ceremony, standing amidst those ruins where the last defenders of their country more than two thousand years before had spilled their blood in defense of their freedom. With its aerial tramway, the mountain has become one of the most popular places for tourists visiting Israel, and certainly one of the most impressive.

Besides the leader of the Zealots at Masada, another Jewish hero has come to life under the spade and brush of the archaeologist and been given dimensions he did not have before. He has moved from myth or mystery into history. He is Simon bar Kosiba, otherwise known as Bar Kochba, who was the leader of the Second Jewish Revolt or Second Roman War. Yadin and other Israeli archaeologists turned up impressive relics of this kingly man in some of the desert caves. He was originally Shimon Bar Kosebah or Bar Koziba, who was given the name Bar Kochba (meaning Son of a Star) by a holy rabbi, Akiba, who may have thought him the Messiah. His revolt began under the reign of Hadrian, who had outraged the Jews by his strictures against Judaism, including a ban on circumcision (curiously enough, he was trying to enforce

a Roman law against mutilation). Not too much is known of the revolt, but in 132 C.E. the Jews rose up under Bar Kochba and mounted such a threat to Roman occupation that the general Julius Severus was brought all the way from Britain to reduce the Jewish strongholds one by one until finally Bar Kochba himself was killed at a site that is now called Bittir. The exploration of the desert caves by scholars in 1960 yielded a number of finds, none better than a trove located by Yadin in what is now called "The Cave of Letters." In it were found fifteen letters from Bar Kochba to subordinate commanders in the El-Gedi region as well as thirty-five other documents in Greek, Aramaic and Nabataean, a tongue spoken by the Arabs in the south. Also found were coins struck by Bar Kochba covering three years of his revolt. Unfortunately for Bar Kochba, he had no Josephus to tell his story.

For the Jew, the coins minted by Bar Kochba and unearthed by archaeologists have a sacred aspect. They glow with the symbols of Judaism, the nationalism of Israel, and the defiance of Roman rule. One silver coin shows the front of a synagogue, Torah scrolls of the law and the single word "Jerusalem"; while the obverse bears the legend, Second Year of the Freedom of Israel, with the lulav and etrog for design—lulav is palm shoots, myrtle and willow, and etrog is the citron tree; they are traditional Hebrew symbols.

Other coins bear the inscription, First Year of the Redemption of Israel, and another the inscription, For the Freedom of Jerusalem. These were the last words of Israel before it fell to silence under the Roman sword. Not until 1948 would the Jews again raise the menorah on high as an independent people in their own land for which Bar Kochba fought and died as the Zealots on Masada had before him.

If Herod lived well on Masada he prepared for his burial elsewhere, and another great archaeological project is unveiling the secrets of Herodion, a mammoth cone-shaped construction not far from Jerusalem where it is believed Herod was buried. There too the works of Josephus throw some light. There was one other discovery made on Masada that we did not mention. It was the ruins of the oldest synagogue in the Holy Land, dating from the first century. The story of synagogues excavated in Israel is another exciting chapter of Middle East archaeology.

ANCIENT SYNAGOGUES

Although it is not commonly reflected on, in those years of Roman domination, when the great Temple towered over Jerusalem, there were synagogues in the Holy Land. The Temple was central and held the Holy of Holies, the Ark of the Covenant. There and there alone animal sacrifice was offered to the Lord. No sacrifices were offered in the synagogues, but the Torah was read and discussed there. Little was known of the style of these synagogues until archaeology began to unearth them, disclose their beauties and preserve them for world scholarship.

After the destruction of the Temple and the wasting of Jerusalem, the Romans rebuilt the city, called it Aelia Capitolina (the proposal to rebuild was the immediate cause of the Bar Kochba revolt) and permitted no circumcised person to enter its precincts. After the Roman conquest and slaughter, what was left of the Jewish nation in the Holy Land was pretty much concentrated in Galilee, and in an ensuing two centuries of peace subject to Roman rule, the Jews spent their time in scholarship and the construction of synagogues for their worship.

Unearthing these has been absorbing work for Israeli archaeologists, and the number discovered has been astonishing. The most spectacular was found in Syria on the banks of the Euphrates when a British soldier's trench-spade hit stone. Scholarly expertise subsequently uncovered the famous synagogue at Dura-Europus, a masterpiece of the third century. The walls of the building were decorated with historic scenes from Hebrew history, with representations galore of historical personages. What it revealed among other things was that the Jewish aesthetic impulse from the earliest days broke out of the strictures of the Second Commandment.

Less elaborate, but for Israelis historically more important, has been the discovery in Israel of one ancient synagogue after another, dating from the third century to the sixth. The discoveries have been full of surprises. In these synagogues a common feature has been a mosaic flooring often decorated with the great ring of the zodiac accompanied by figurations of historic persons.

The best preserved of these is the synagogue at the kibbutz Beit Alpha in the Jezreel Valley, which, like that at Dura-Europus, was touched first by a workman's tool, in this case a farmer's spade. The round of the zodiac is almost untouched by time, and the center circle in perfect repair. In it the sun god Helios rides a chariot drawn by four horses. In a neighboring panel Abraham prepares to sacrifice Isaac. The drawings are charmingly primitive, in strong contrast to the sophistication of the paintings at Dura-Europus.

On the other hand, the drawings in the mosaic at Hammath-Tiberas on the shores of the Sea of Galilee match those of Dura-Europus in artistry. Here the presentation of Helios is spectacular. Unfortunately the center panel where he is depicted was in great part destroyed by a wall built across it. Happily, the upper part of the panel is clear, showing Helios with the sun's rays behind his head in an aureole, and a whip and a shield in his left hand. His right hand is held aloft. Equally interesting is the figure of a naked youth dancing in one of the panels of the ring of the zodiac. One wonders if the worshipers here were Hellenizing Jews as Herod had been, corrupted by the elegance brought into Israel by Greek artisans. In a panel above the zodiac are pictures of two menorahs and a house that presumably was to receive the Torah.

North of Masada on the shores of the Dead Sea is an oasis, Ein Gedi, a center of Judaism from the beginning of time. It was here that David fled to escape

the wrath of King Saul. It has become a favorite tourist spot, offering as it does a green miracle in the midst of the desert wilderness. Uncovered here was an ancient synagogue with a beautiful mosaic floor decorated with peacocks.

In the Rockefeller Museum is a handsome mosaic removed from a sixth-century synagogue at Beit Shean which depicts three wine-makers trampling grapes, another toting a basket of grapes and, in a center pane, a donkey bearing baskets of grapes.

In the Talmud, it is reported of a fourth-century rabbi: "In the days of Rabbi Abun, they began to display paintings on mosaics and he did not prevent them."

In the Jordan Valley, due West of Caesarea, is the town of Beit Shean whose history traces back to the nineteenth century B.C.E. and the book of Samuel. Its main street is named for King Saul, whose body was hung on its walls by his enemies. Few regions have been more productive. Here were found early Israelite, Canaanite and Egyptian relics, the remains of a Roman theater and a fifteenth-century Byzantine monastery with some unusual mosaics, including a circle similar to the zodiac but displaying the twelve months of the year instead. From 1921 to 1933 the University of Pennsylvania Museum conducted extensive excavations of the great tell where one city of Beit Shean after another left its level of ruins. Eighteen in all were determined.

The Israeli archaeologist Nehemiah Zuri discovered the synagogue in 1974 some distance from the tell. It dates from the fifth or sixth century but has a unique feature: the largest mosaic inscription found in any synagogue. The mosaic is twelve feet by nine and contains twenty-nine lines of Hebrew writing with a total of 365 words. The text refers to the variety of produce grown in the area and the duty of tithing.

The search for ancient synagogues goes on, each discovery asserting the Jewish claim to Ha'aretz, "The Land." The rather widespread assumption that all Jews left the Holy Land after the Destruction of the Temple is dispelled by the presence of such synagogues dated century by century. The Jewish nation was conquered and their land occupied by one foreigner after another, but the Jewish presence continued and, when permitted, built with beauty.

SCULPTURE

On a low hill in the northernmost reaches of Israel, not far from the border of Lebanon where Mt. Hermon lowers, there is a small cemetery and in that cemetery a stone lion. He is not rampant as if at war, nor does he crouch as if on the alert. Instead, he sits on his haunches with his head thrown back, roaring triumphant defiance to the world. The statue is the work of Aharon Malkinov, and although Boris Schatz, who founded the Bezalel School in 1906, was a sculptor, one can say that Israeli sculpture began with Malkinov's lion.

While the noble head with its stylized mane can be seen (and almost heard) roaring, one senses also a wail of mourning for the men and women who lie in the cemetery on the small hill, which is paradoxically called Tel-Hai, the Hill of Life. Statue and cemetery are a national shrine, a memorial to six men and two women, who, in 1920 when the territory was under French mandate, were attacked and slaughtered by marauding Arabs while defending their new-found homes. Incised on the base of the memorial are the words: "It is good to have a country to die for, it is good to die for that country." One of the men buried there was Joseph Trumpeldor, a hero of the Russo-Japanese war, an ardent Zionist who fought for the British in World War I, a heroic, romantic figure. The inscription on the statue is said to be his last words. Apart from all patriotic associations, Malkinov's *Lion of Judah* is magnificent.

Historically, there has been very little Jewish sculpture, having fallen under the centuries-old ban on images. Still there were the brazen bulls in the Temple of Solomon, which may well have been carved by Phoenician sculptors, and there were the lions at the synagogue in Syria, which in turn may have been done by foreign sculptors. We know, of course, that there were Jewish artists who modeled and carved, for there are tombs with incised lettering, or decorated with carvings of hands or menorahs. Ancient Jewish coins bear images, and those found in the caves where the followers of Bar Kochba hid

35

are excellent examples. No question, however, but when Boris Schatz, who sculpted for the royalty of Bulgaria, came to Jerusalem the attitude of the Yishuvim was antagonistic. They were accustomed, of course, to intricate carvings on the ceremonial objects of ritual, but representations of the human figure were an abomination. In brief, sculpture did not have an easy time establishing itself as an art in the Holy Land.

In 1906 the surge of abstract sculpture, which sits much better with the Orthodox, was half a century away. Israel began to take it up about 1940, no earlier. They have found it more acceptable for public monuments than the more representational. If we reflect on all the uninspired, gloomy and often aesthetically grotesque statues America raised commemorating the heroes of the Civil War or World War I, or the Pere Lachaise monuments in some of our cemeteries and the Saint Sulpice statuary in some of our churches, one can only account the Jewish antipathy to representational art as a happy thing for the State of Israel. Their war memorials are not to be ignored. They are artifacts to be admired. They move the viewer aesthetically even if he has only passing consideration of the reasons for their construction.

Not all the abstract and minimalist constructions have been successful, and many citizens have protested loudly at the public expense of mounting some monstrosity that seems to please only the sculptor and his friends. A stabile by the late Alexander Calder erected near Mt. Herzl has few admirers; not only is it not one of his best works, it is also unhappily located. The mayors of the major cities have artists to advise them, but artists are divided in their tastes and opinions. All in all, the monumental sculpture that Israel has mounted in public places is imposing and successful. One critic wisely suggested that when a city awards any commission for a public monument it should reserve the right to move it to a different site if on extended experience it is deemed not to be working.

This is not to say that in the second half of the century the sculptors of Israel have abandoned the figurative. Far from it. They have been slow to swing to the abstract, content for good reason with the traditional, but not with the flatly classical of the late nineteenth century. They have made a vibrant even ecstatic use of tension, brilliant distortion and stylization, and have made space an element of their work. The casual visitor to Israel will be more struck by the sculpture than by the painting because, unless he prowls the galleries and museums, the excitement of Israeli painting will escape him. Israeli sculpture he will meet in many public places.

Non-Jewish citizens of the Unites States are quite unfamiliar with Israeli painting, but they are even less acquainted with Israeli sculpture. Sculpture shows do not travel as easily as painting exhibitions, and the number of non-Jewish visitors to Israel is minuscule compared with our population. Of the number that has gone, how many have gone with a view of examining the

art treasures of Israel? Archaeological exhibits in the museums predominate and, I shouldn't be surprised, soon weary the museum-trotter. Christians in the Holy Land naturally want to spend as much time as possible in the places made sacred by the feet of Jesus Christ, and in visiting the magnificent and ancient Christian shrines that have been constructed there. The triumphs of Israeli sculpture more than likely get only casual inspection.

Israel is not without academic sculpture in the classical tradition honoring its heroes. In the Kibbutz Mordechai, founded in 1943, there is a statue of Mordechai Anilewitz, one of the outstanding heroes amid a legion of heroes—the people who died in the Warsaw ghetto—defying with stones the Nazi Wehrmacht. The heroic statue depicts him about to hurl a hand grenade, the sort of thing admired by social realists. This kibbutz was overrun by the Egyptians in 1948 but recaptured by the kibbutzniks six months later. They have since created a simulated battlefield to memorialize the heroic defense of their kibbutz and they have erected a museum to commemorate the Jews who died under the Nazis. Inscribed on the walls are the haunting words: "There were one and a half million children." The interior of the museum, apart from its statues, has the force of sculpture with its cobbled pavements. Each kibbutz has its sculpture and monuments.

What is astonishing is the large number of sculptors there are in Israel, in a population less than five million. And despite the extraordinary number of indigenous sculptors, the State of Israel has not ignored foreign sculptors either. The Billy Rose Sculpture Garden, said to have inspired a similar one in the city of Cork in Ireland, is an impressive conception. Some complain that the walks of crushed stone make it difficult for the handicapped to get around, impossible for persons in wheelchairs and wearisome to the elderly, but these technical difficulties aside, the Sculpture Garden is one of the most popular aspects of the Israel Museum. A dozen or more distinguished foreign sculptors are exhibited by typical and powerful works. Most suitable, Augustin Rodin is represented by a massive bronze figure of a man entitled *Adam*.

Not far away lies Henry Moore's *Reclining Woman*, which I somehow think of as Eve, an inchoate figure slowly achieving her primordial femininity. Here too is work by Pablo Picasso and others. The Garden itself was designed by an American sculptor of Japanese ancestry, Isamua Noguchi. Billy Rose, songwriter and entrepreneur, chose wisely when he created such a memorial for himself, much more likely to carry into the future the memory of a man than such songs as "Clap Hands Here Comes Charley." Noguchi had five acres on a Judean hill to transform with the touch of man, imposing on the inchoateness of nature the order of man's emotion.

The Sculpture Garden is confined to contemporary sculpture, but as one can guess from the presence of the Rodin that does not mean post-1948. In this Garden, with its gentle slope, its occasional scallop shell of a wall, and

37

its vistas running off to stunning infinity, massive stone and bronze statues stand each in singularity to contrast, as one reflects, with sculpture one has seen complementing various architectual constructions. Here too is space enough to mount constructions of size: for instance, a moblie-stabile by Alexander Calder, sculpture in motion responding to the soft Judean winds, its motion contrasting with the stolidity of its triangular base, its own shadows moving before it as if in a dance.

One of the most significant pieces in the Garden is a flat, three-dimensional piece by Menashe Kadishman painted a brilliant yellow, its geometrical shapes brought into a forceful arrangement of curves and straight lines but gathering tension from the balance of its top beam, pointing as if to the future, straining with anticipation. The whole stands magnificently against the soft purple of the Judean hills across the valley. The work was commissioned in 1966. Kadishman is an Israeli sculptor. Other Israeli sculptors in the Garden are Yehiel Shemai, Yitzhak Danziger and Shammai Haber.

For many years, realism dominated Israeli sculpture. It was the tradition brought by Schatz to the Bezalel school. Modified by Romanticism, it was thoroughly European in its conception and execution. Such experimental sculpture as came sprang from the enthusiasm of a few.

To an extent, the monuments that have been erected tell the history of the State of Israel, commemorating as they do the dead of the various wars that the Israelis have had to fight in defense of their country, as well as the happier events that have taken place. The dream of Boris Schatz has more than come true, and it has been his school, now able to grant university degrees, that has trained the majority of the Israeli sculptors or their teachers, heirs to Bezalel.

One of the first names to loom large in the story of sculpture in Israel is that of Ze'ev Ben Zvi, one of whose most impressive works stands in Mishmar-Ha'Emek on the road from Haifa to Meggido, a memorial to the children who died in the Holocaust. Mishmar-Ha'Emek is also the site of a victory of Israeli farmers over invading Arab forces. Besides doing many portrait busts, Ze'ev Ben Zvi was one of the first to bring distortion and vibrant exaggeration to Israeli sculpture and to train brilliant young students in such.

Among these latter was Yitzhak Danziger, an experimenter and trailblazer like his mentor, who groped his way to absolute abstraction and found his place in the Billy Rose Sculpture Garden. His work shifted to clay, wax, bronze, aluminum and welded iron as he moved from figuration to abstraction. Danziger was born in Berlin, Germany, in 1916 but was brought to the Holy Land when he was seven years of age. After study at Bezalel he went to London for further study and took the sculpture prize at London University in 1935. In 1951, when an international competition was held at Mt. Herzl in Jerusalem, Danziger took second prize. In 1958 he took first prize for a monument at Kiriat-

Ono and in 1967 first prize for a navy monument at Haifa. The next year he designed a monument in Haifa to the immigrants who made their way illegally to the Holy Land during the British mandate. In 1968 he was invited by Mexico to create a sculpture for the Olympic games. With Michael Gross and Yehiel Shemai, two other distinguished Israeli sculptors, his work was mounted in a three-man show at the Museum of Modern Art in Haifa, hailed as one of the most impressive Israeli sculpture shows in decades. One of the most impressive pieces in the show was *The Burning Bush*, which he did in 1959. The welded iron of the piece stands on three tapering legs, and an iron-pointed flame thrusts out of random flanges near the base, flame given the immortality of iron, the whole hinting at aspiration and inspiration, flame not petrified but ferrified.

The other two exhibiting with him on that occasion were both sabras. Shemai was born in Haifa in 1922; Gross in Tiberias in 1920. Like Danziger, both have exhibited abroad, including the United States, and both are mounted in collections in Europe and the United States. Like Danziger, both like to work in iron. All three exemplify the sacrifice made by the artist in Israel. As with writers in Ireland, the temptation is real and strong to leave their country and settle in Paris, London or New York, where more money and greater fame await people of talent. Most are restrained by patriotism and the sense that the strength of their art rises out of the very soil of Israel. While it may be debated that there is as yet no distinctive Israeli school of sculpture, no Haifa, Jerusalem or Tel Aviv style, nevertheless the spiritual strength these artists need is rooted in the Holy Land. They work assiduously knowing they have sacrificed in part the audience that might appraise and applaud them. They are not wholly denied an international audience, of course, because traveling exhibitions of Israeli artists have toured Europe and the United States, and such organizations as the America-Israel Cultural Foundation have worked not merely to help them but to spread the news of their talent.

Shemai first carved in stone and wood and took his inspiration from the stark landscape around the Dead Sea, where he was a member of the Kibbutz Beit-Ha'arave which was destroyed in the War of Independence in 1948. The kibbutz life maintained its appeal for him, and in 1949 he helped found the Kibbutz Kabri in Western Galilee and worked there. His study has often taken him abroad, and for two years he lived in Paris. In his latter years, iron — welded, chiseled, hammered — was his favorite medium. His technique gave to the inanimate metal a feeling of organic growth. His work can be seen in the Israel Museum in Jerusalem, the Tel Aviv Museum and the Ein Harod Museum.

Gross was reared on the shores of the Sea of Galilee, or Lake Kinnereth as it is called. He studied sculpture at the Technion in Haifa under Moshe

Ziffer, himself a distinguished sculptor. The year was 1943. Later, after the War of Independence, he studied in the Ecole des Beaux Arts in Paris and after winning several prizes came back to teach at the Bezalel and later at the Oranim, a teachers' seminary near Haifa. His foreign exhibitions began in Paris in 1952 and continued past the sixties. Among the collections that present his work are the Museum of Modern Art in New York, the Museum of the University of Iowa and the Museum Boymans VanBeuningen in Rotterdam. He is also represented in private collections in the United States, Israel, France, Great Britain, Switzerland, Italy, Argentina and Canada.

In 1974 the publication of the America-Israel Cultural Foundation *Tarbut* (the Hebrew word for culture) put on its cover a frightening sculpture entitled *Hands Up!* by Yigael Tumarkin which had been one of the outstanding pieces displayed at an exhibition called *War Impressions* at the Jewish Museum in New York. The exhibition and the subsequent photographs so prominently displayed helped no doubt to spread the reputation of a sculptor who, of all Israeli sculptors, is perhaps the best known in the United States. Tumarkin was born in Germany in 1933 and taken to the Holy Land at the age of two. He was to study under another exile from his native Germany, Rudolph Lehmann, who was born in Berlin in 1903 and fled to Eretz Israel in 1933, the year Tumarkin was born. Lehmann brought birds to life in wood and plaster and brought Tumarkin to life in his classes. The latter's initial trouble was that he was too versatile, adept at both painting and sculpture. Though he was entranced by stage designing, sculpture is evidently the metier that shows best his unique power. When his expressionism caught the postwar wave he was hailed in a succession of one-man shows in Germany, Holland, France, London and Stockholm, as well as Tel Aviv and Haifa. In 1963 and 1970 he had one-man shows in New York City. His work is now to be seen in museums in New York, Louisville, Kentucky, St. Louis and Philadelphia. In the past decades his sculpture has reached a new plateau in imaginative construction in metals.

Women in sculpture in Israel have also carved for themselves a notable place. One of the most memorable contributions to Israeli sculpture is the memorial to Dov Gruner located at Ramat Gan, once a garden suburb of Tel Aviv, founded like Tel Aviv on barren land and now an industrial center. In Ramat Gan the police station stands opposite a spacious public garden that displays a monument to heroism. Their juxtaposition is important.

The statue honors the memory of Dov Gruner, a member of the Irgun. During the British mandate, the Irgun Zevai Le'ummi was a defense organization that, in the complexity of the politics at the time, split off from the Haganah, the main Jewish armed force defending Eretz Israel. Gruner was captured during a daring raid on the police station and executed in 1947 in

the British prison at Acre. Chana Orloff, selected to make the memorial for him, chose to portray the Lion of Judah locked in combat with the larger British lion. The statue bears the Hebrew inscription, "A Few against Many." At that time, monuments were for the most part restricted to architectonic constructions, but some standing figures appeared, most of them the figures of animals. The Orloff lions are among the most vivid of the period — symbolic, even narrative, but first-rate and of powerful, lively conception.

Other celebrated women sculptors are Ruth Tsarfati and Shoshana Heimann, the former noted for her statues of children and portrait heads, the latter for her carvings of human figures in wood, giving the wood all the statement of its grain and softening or eliminating detail. Hava Nehuttan's province is human figures and portrait heads tending often toward the abstract but clinging nevertheless to figuration, sometimes with lively humor. Her work is at once strong and forceful, but with warmth that goes beyond her distortion and beyond her wit. Again, to select one name is to neglect many, but Lea Majaro-Mintz, who was born and resides in the old Jewish quarter of Jerusalem, has made her name with droll, charming ceramic female figures.

Like Tumarkin, whose canvases began to grow into sculptures, Yaacov Agam moves between painting and sculpture. He is a master of kinetic art. When he was awarded an honorary degree by Tel Aviv University, he was cited for "the originality of his artistic contribution to twentieth-century civilization." The citation mentions specifically his kinetic art, louvered paintings that move or alter with the change of perspective and metal sculpture that vibrates. Born in Israel in 1928, his most recent imposing work was mounted in 1987 on a building at the northern end of the plaza facing the Western Wall to honor the memory of the victims of the Holocaust. Made of metal and glass, six constructions stand like lanterns, each topped by a slanting Star of David and bearing within them both fire and flowing water, and on them the word *Yizkor* ("remember"). He is perhaps the only Israeli sculptor to be honored by the city of Washington, D.C., with a day named in his honor. He has lectured around the world on his theories of art and communication. The most recent of his one-man shows to tour the United States came in 1987.

In spite of the surge of popularity of iron, aluminum, stainless steel and other metals, stone has not been forgotten by the sculptors of Israel. One of its great exponents is Aharon Ashkenazi, who came from Sofia, Bulgaria, in 1932 at the age of nineteen and settled in the Kibbutz Kfar-Masaryk near Acre. Ashkenazi studied with the late Ze'ev Ben Zvi, studied in Europe and then turned teacher himself in Haifa. While he has worked in local limestone and cement, his favorite medium seems to be marble from Greece or Italy. His bulky abstract figures can be found in museums in Haifa, Tel Aviv and in

private collections in Israel and abroad. Their massiveness somehow maintains a sense of lightness.

Another versatile master is Dani Karavan, born in Tel Aviv in 1930, the son of a landscape architect. Interested in art from his childhood, he began formal study at the age of thirteen and came almost immediately under contemporary revolutionary concepts. In his twenties he went to Florence to further his studies, bent, we are told, on learning fresco painting and stage design. Since his return in 1958, painting, sculpture and stage design have absorbed him. One major commission has followed another: the Israeli Discount Bank of Fifth Avenue, New York, a Hilton Hotel, the El Al terminal at Kennedy Airport, a monument at Beer Sheva to honor the Palmach Negev Brigade, and a stone wall at the Knesset, called *Song to Jerusalem.*

Besides such commissions, there have been his stage settings. Israel's Cameri Theater and the Inbal Dance Troupe have both called on him, but above all Martha Graham, the famous dancer-choreographer, has had him design for several presentations: *Judith, Part Reel-Part Dream, Holy Jungle,* and *Dream.* At a Spoleto Festival in Italy, his set for *The Consul* by Gian-Carlo Menotti was one of the highlights. Besides his wall at the Knesset, Karavan's sculptures adorn other public buildings in Israel.

Perhaps the best known or the most observed piece of Jewish sculpture for visitors to Israel is the great menorah that stands before the Knesset, high above Jerusalem, the work of British sculptor Benno Elkan and the gift of the British Parliament, the mother of parliaments, to the most recent outstanding exponent of the traditional principles the British Parliament has given to the world. Although the six-pointed Star of David is centered on the Israeli flag, the menorah is the official symbol of the State of Israel. No Jewish symbol is older, and its creation was at the hands of Bezalel directed by Moses who in turn was inspired by God. Tradition has it that the menorah carried for centuries by the Israelites was in the Temple in 67 C.E. and hidden by the priests when the Temple was sacked. It has never been found. The menorah depicted on the Triumphant Arch of Titus in Rome is not the menorah of Bezalel but some other. The seven-branched menorah traditionally was never in use in a Jewish home because the law forbade domestic use of the holy vessels of the temple. Other candlesticks and a special nine-branched candelabrum were used in the home at Hanukah. The symbolism of the menorah has not been established with certainty, but authorities link it with the seven days of the week, with the central candle for the Sabbath, and so with the eras of creation.

The Elkan menorah at the Knesset is of bronze and depicts in panels on the branches the history of the Jews. It stands five meters high (sixteen feet) and four meters wide. On the seven branches there are twenty-seven panels,

some larger than others, and only one of them as much as a meter in height, and that one at the base. It depicts the labor of the pioneer settlers.

At the top of the center column Moses is shown with his arms held aloft by Aaron and Hur during Joshua's conquest of the attacking Amalkites. Beneath that is a panel with the tablets of the law. The next two panels present two women famous in Jewish history: Rachel weeping over he lost children, and Ruth, the mother of the dynasty of the House of David. The next panel, almost centered, from which rises the two bottom (and outermost) arms of the menorah, is the depiction of the siege of the Warsaw ghetto. Between that panel and the one at the base, depicting the pioneer settlers at work, is a circular seal bearing in Hebrew the worde, "Hear, O Israel, Yahweh, our God, is the One other quotation appears on the lowest arms: " 'Not by the might, nor by the power but by My Spirit,' said the Lord of Hosts." The various panels on the arms picture other Biblical scenes and historical scenes down to Bar Kochba in 135 C.E.

Female figures in wood and stone have been done by numerous sculptors, inclucing Moshe Ziffer, Moshe Sternchuss, Moshe Jana, Israel Rubenstein, as well as others mentioned, such as Chana Orloff and Shoshana Heimann, but none in public places such as one sees in Rome. The nonrepresentational is still preferred or beyond that figures of birds and animals. Very early on, Israeli sculpture came of age.

PAINTING

For a nation of four and a half million people, Israel abounds in painters. This is a curious thing in itself—or perhaps not so. For the Jew, to be in Israel is to be liberated. The distinction made for the Jews by Gamaliel between art for worship and art for decoration has become the consensus. Freed from the commandment against making images, or a narrow interpretation of that commandment, the Israeli, Westernized, secularized and liberated, has become a painter. There are thousands of them in Israel. A national artists association has more than seven hundred members. A recent catalogue of preeminent painters and sculptors listed over two hundred. The catalogue was published to encourage the market somehow, for to be a painter in Israel, while it has its advantages—to be one of a new breed, to share the intoxication of having one's own country—has one major disadvantage. The painter in Israel is separated from the rich markets of the West by an inconvenient distance. The market in Israel, while an enthusiastic one, is small, and not without those who like to boast possession of a foreign painting. Unfortunately, contiguous countries boycott Israeli products, including paintings. Nevertheless, the Israeli paints and paints and paints.

He has been at it for eighty years, and critics there constantly debate whether or not a distinctive Israeli style can or will emerge. It is a quarrel to be left to the experts. For the visitor from the West, those representational paintings that depict Israeli scenes—from the sands of the desert to the golden contours of Jerusalem—are Israeli painting, a charming regionalism. The abstract paintings, the abstract expressionism, the conceptualism, the op art, the polymorphs, the kinetic works, the dynamism, the lyric expressionism— all look to the amateur very much like those paintings or constructions seen in the galleries of New York or Boston or in the modern museums of Europe.

45

For above all, Israeli painting is Western painting; it shares the schools, the themes, the temptations and the achievements.

Art today is international. It strives to transcend barriers, it tries to speak across geographical boundaries, to move from one culture to another with a profound universality. Having said all that, one has to add that in much of Israeli art, there is a unique quality, ineffable perhaps, faint, but surely there. One might sense an Oriental flavor not found in Western art elsewhere, but the perceptive eye catches it, and the alert sensitivity knows that it is there. Another eighty years perhaps and it will become quite readily identifiable.

Whatever questions may attend the existence of a distinctly Israeli style or school, whatever debate may attend the consistency of the quality, there is no question about the quantity. Painting in Israel proliferates, and there are peaks of quality that demand international attention, and more critical attention than has been received to date. That is surely coming, however. Israeli exhibitions are traveling the world and winning more interest and acclaim, and Israeli artists are lecturing abroad.

From 1905 to 1945, the Jews in Palestine were becoming a vital cultural entity. The determinative factor was the influx of Eastern European Jews, stimulated by the traditional yearning for the Holy Land as well as the political impulse of burgeoning Zionism. Their impact on the Yishuv—the Jewish community that had remained in Palestine since the days of the Roman Empire—was galvanic, for they brought with them the arts. One of the major names in the history of the arts in Israel is Boris Schatz, the Latvian native who became the sculptor for the Bulgarian court and head of the Royal Academy of Sofia, a man of varied talents with a dream of founding a school of painting in Eretz Israel.

That painting is one of the liveliest arts in Israel today is due in great part to the vision of Schatz. He was inspired and assisted by Theodor Herzl, the father of Zionism, and in 1906 arrived in Jerusalem to found the Bezalel School of Art, now the Bezalel National Academy of Arts and Design, which took its name from the man chosen by God to build the Ark of the Covenant. Schatz persuaded some other painters from Eastern Europe to come and teach at his school, which included all sorts of crafts in its curriculum. Along with the school, he began a museum which was strong on local folk art. Although his project was wildly ambitious, he was a conservative man. He had turned his back on expressionism—objectifying the subjective—which was popular in Europe, and opted for academicism. He recognized that good painting, all good art, must be grounded in strong technique. His school emphasized handicrafts and was to bore to death one distinguished painter, but its graduates came to dominate the growing art scene.

In 1906 Tel Aviv did not exist. Jerusalem was a small and sleepy city. The Ottoman Empire had occupied the Holy Land since the sixteenth century and

run it with a sterile hand. Not until the nineteenth century did Turkey permit relatively easy access for pilgrims, let alone immigrants. Schatz's school had its ups and downs, but it survived. Early on, two of the country's most celebrated painters came to study there: Reuven Rubin and Nahum Gutman. A third master, Mordechai Ardon, came there to teach. From 1940 to 1952 he served as director, at the same time pursuing his own work. He was born Mordechai Eliezer Bronstein in Tuchow, Poland, a few years before the turn of the century. After a varied career he went to Berlin as an actor, left the stage for the atelier and was caught up by expressionism. A chance encounter got him to the Bauhaus in Weimar three years after it opened, when Paul Klee, Wassily Kandinsky and Lyonel Feinniger were teaching there. With the rise of Hitler, Ardon, then Bronstein, fled Germany in such haste that he arrived in Jerusalem without papers, his spirits and fortune at a low ebb. A kibbutz took him in as a beekeeper, but his true talents were soon recognized and he was invited to teach at the Bezalel. The school had just reopened after a doldrum, and his presence was invigorating. He extended his influence beyond Bezalel into the elementary schools and the Hebrew Teachers Seminary.

More important, he was painting again. The landscape of the Holy Land and the Biblical ambiance had seized him. Like many an immigrant to Israel, he decided on the spot to adopt a Hebrew name, hit on Ardon and for a time signed his paintings Ardon-Bronstein. Later he dropped the old surname, and Mordechai Ardon was reborn in Jerusalem. For him the Bezalel contrasted unhappily with the Bauhaus, a fact that whetted his determination, and he extended his efforts to educating the general public to the value of art, supervised primary and secondary art education programs and, as an advisor to the Israeli Ministry of Culture and to UNESCO, traveled the world. Seeing his paintings is to be conscious of a prodigious presence, a gemlike palette, mysterious and moving compositions, a Biblical symbolism, and an integrity that somehow rises out of the soil of Israel. He was one of the first in Israel to move away from figuration to abstraction. With Ardon, Schatz's academicism dwindled into the past.

Another titan of Israeli painting is Reuven Rubin, a native of Romania who, at the age of nineteen, made his way to Jerusalem on his own to study for a year at the Bezalel. It was Rubin who became bored with the school's emphasis on handicrafts and the manufacture of pious souvenirs, however skillfully wrought. He wandered away to Paris and had a one-man show in New York City before he returned to Palestine in 1922 and set up a studio on the sands of Tel Aviv. The intervening years read like the most extraordinary of romances. When he fled Bezalel, tired of making Holy Land souvenirs, he sailed on an ill-starred ship. Cholera struck the passengers and Rubin was

put ashore, penniless, in Egypt, and found himself in jail. A stranger, whom he hailed from the prison window, vouched for him and won his release. A chance meeting with a well-to-do friend got him back to Romania. Ardon had at one time sold scrap metal; Rubin took to selling grain, all the while aching to get to Paris. He made it at length, thrilled to its treasures, but suffered a devastating loneliness. Despite it, he made a mark but returned to Romania at the outbreak of World War I. The next year he got to Italy to study, tried his hand at poetry, met Arthur Steiglitz, and through the great man's patronage got a one-man show in New York. From 1922 until his death in Israel he went from one triumph to another. When the State of Israel was proclaimed in 1948 Rubin was its outstanding painter and of such reputation that he was named minister plenipotentiary to Romania, an honor that filled him with intense emotion, to serve in the land where he had been born (as had one of his eleven children) and spent his adolescence.

Behind him by that time were a series of one-man shows and any number of prizes and honors. In 1964 Tel Aviv gave him its major prize for lifetime achievement. His paintings are in Israel's major museums and museums throughout the world, as well as great private collections; his *Glory of Galilee* hangs in the cabinet chamber of the Knesset; his sets decorate theaters; his stained glass windows adorn the residence of the President of Israel. In 1969 his autobiography appeared, and in 1972 the Israeli critic Sarah Wilkinson brought out an excellent study of his works. Their joyful exuberance is in marked contrast to the lowering mysteries of Ardon. Redolent of the Biblical, they have some of the magic of Chagall and the excitement of Matisse.

A contemporary of Rubin and Ardon, Menahem Shemi came to the Bezalel school from Russia while still in his teens and found himself conscripted into the Turkish army. Later he fought for the allies in the Jewish battalion, and after the war he took up residence in Tiberias and taught art. In 1922 he settled in Haifa. Like many another painter he designed for the Habimah Theater. When World War II broke out he enlisted in the British Army and served in North Africa, still managing to exhibit. After the war he had a major one-man show at the Tel Aviv Museum and about that time founded the art colony in Safed. He died in 1951. His landscapes recreate the landscape and the towns of Israel. In Shemi, Rubin and Ardon, Israel has three painters whose bulk would fill any quarter of a century.

In these three men we have simply chosen three major figures, three disparate lives, to indicate the manner in which painters went to Israel, grew there, developed and arrived at fruition. We could have chosen a score of others. Nahum Gutman came from Russia as a child, studied at the Bezalel, and later in Germany and France, before returning to Tel Aviv to pursue his career. For although Schatz had founded his school and set up his museum

in Jerusalem, with the growth of Tel Aviv that city became the art center of Israel. Yossef Zaritsky also came from Russia, where he had studied at the Kiev Academy of Art. Linhas Litvinowsky came from the Ukraine in 1912 to study at Bezalel, and then returned to Russia for further study before settling in Jerusalem.

Others have come from Belgium, France, Romania, Poland, Argentina, Iran, Morocco, the United States of America, Canada and Turkey. That does not, of course, exhaust the list of places of origin. Then, most significantly, there are the sabras. One cannot say of them that they are the first generation. There were sabras who lived and died before many of the immigrants arrived. The name *sabra* may be new as applied to a native of the State of Israel (the word means "a bitter prickly pear"), but it must be remembered that there were Jews in Eretz Israel from the beginning of the Diaspora, who were not driven out, a community remnant, the Yishuvim. Some of Israel's leading artists are drawn from those ancient families. Yoshe Castel was born in Palestine in 1909, three years after Schatz founded his celebrated school. Castel's works can be seen in the Tel Aviv Museum (*The Festive Meal*) and his murals adorn the Presidential residence in Jerusalem as well as the El Al offices in New York City.

That point kept in mind, we can then salute the sabras born in the State of Israel who have distinguished themselves as painters to rival the celebrated men and women of those early aliyahs who brought genius and talent to the shores of the Levant. Many strains have contributed to the making of painting in Israel.

The first group exhibit of paintings by Israeli artists was held in Jerusalem in 1923 in the Tower of David within the Old Walls. About 1926 the first shows were held at Tel Aviv. In 1931 the Tel Aviv Museum was founded, and the city began to take on a modern look. Beginning in 1933, German refugees from Hitler's anti-Semitic pogroms came to Tel Aviv in huge numbers to make a vital impact on the artistic life of the city. However, from 1935 to 1949 the Israelis were under constant siege or openly at war. One Arab incursion after another was repulsed. In World War II the Jews of Palestine fought in the Allied forces against the Nazi Wehrmacht. No sooner was that war over than they found themselves at war with the Arabs and the British, and that done, again at war when Israel, having been declared a republic, was invaded by the Arabs from adjacent countries who fell upon the infant state to destroy it.

After the War of Independence, Marcel Janco, who had been a founder of the Dada movement in Europe, became a moving figure in the New Horizons group in Israel, a congeries of artists determined to open new doors. The New Horizons group, whose members had little in common artistically except a leaning toward abstraction and the urge for renewal, held its first exhibition

in 1949 to cause sensation. *Bellum breve, ars longa.* The group mounted its show at David's Citadel in Jerusalem. There were thirty artists in all and they would mount a dozen shows until their energy, as a group, was spent in 1963. From 1949 on, painting in Israel was, so to speak, wide open. A variety of styles won adherents: expressionism, subjectivism, abstract expressionism, constructivism and something rather distinctly Israeli, a lyrical abstractionism. The vitality of the work heightened. There was no common direction; foreign influences were as strong or stronger than ever.

To the extent that the tax-burdened Israelis can help their painters, they have. Not alone, the intellectuals frequent the galleries, the museums and the studios with the man in the street. It is an unusual home or apartment in Israel that does not have a painting on the wall or at least a display of graphics. In the early days there were few places where the painter might mount a show, and private homes were most frequently used. Now the growth of public buildings and the cooperation of museums provide ample exhibition space. Shows are frequent and well attended. Most recently, a museum was opened in 1987 in Ramat Gan with the express purpose of presenting only Israeli painters and sculptors.

One of the internationally famous centers in Israel is Ein Hod Artists Village situated on the slopes of Mt. Carmel outside Haifa. It is this that brings us back to the name of Janco. When the Dadaists drifted into surrealism, Janco's drift was geographical—to Israel. He arrived from Zurich in 1948, already an established painter. After World War II his influence on younger Israeli painters was major. It was Janco who saved Ein Hod from the bulldozer of urban renewal. He saw an integrity within the old Arab buildings and suggested that instead of demolishing them, the government turn them into an artist colony. The government acted on the suggestion and the city of Haifa, caught up itself in the enthusiasm, proffered its patronage to what was then a struggling project whose early pioneers endured unique hardships in primitive circumstances until the idea would burgeon into the success it is today: a center of creativity, a mecca for tourists and a marketplace as well.

In 1960 Joseph Zaritzky, an immigrant painter from Russia who had trained in Kiev, was awarded the Israel Prize for Art. He more than any man was responsible for the distinctive lyrical abstractionism that was strong in the Israeli painting schools during the 1950s. His influence has been immense, and still obtains. Twenty years later, in the year of her death, the Israel Prize for Art went to Anna Ticho, one of Israel's finest painters, who took Jerusalem for her special interest. Her charcoal drawings of Jerusalem are most impressive. Mrs. Ticho was a native of Austria who came to Israel with her physician husband.

Art is always a shifting scene. Neo-realism mounts its forces; pop art displaces abstract; new media are discovered; formalism comes and goes;

strange, even weird materials are employed; pictures move and talk. Painting in Israel is very much alive, kinetic in more ways than one, very experimental, but never one of a piece. All the styles are working side by side.

This is not to say that it rivals that of the United States, nor to say that the painters in Israel have no problems. There are innumerable problems. Ample space there may be but not ideal space, and to prevent young artists from leaving Jerusalem for Tel Aviv, Europe or New York, Dr. Yona Fischer of the Israel Museum persuaded the Jerusalem Foundation to turn the top floor of a large industrial building into an atelier. Many if not most of the painters persevere in unsatisfactory quarters and lack workshops; the mastery of techniques is far from universal, and opportunities for study, considering the demand, are limited. Then, also, a living does not come from brush and palette alone. As many painters as possible wisely try to spend some time and exhibit in the United States or Europe. The best measure of all this is the vitality that abounds, that must ever precede quality. What has been done in eighty years is astounding, and the best would grace the walls of any museum or hold place in the most catholic of collections. Basically, the market is small, and the Israeli artist must look abroad for buyers.

Art galleries devoted solely to local artists do prosper. An Israel Art Galleries Association guards the interests of artists and galleries both, as well as the interests of their clients. Not too long ago traffic in forgeries was brought to light, particularly of the works of Shalom Moskovitz of Safed, who died in 1980 in his eighties, but whose works, described as "naive but not primitive" and concerned with Biblical themes and Jewish history, made him the most popular painter in Israel. He displayed his enchanting folk art, paintings and lithographs in one-man exhibitions in a dozen of the world's leading museums. When he was on his deathbed, a thief stole thirty-four of his paintings but returned them when he found that the publicity given the theft disenabled him from selling them. In 1987 a conspiracy peddling forgeries of his work and those of some other artists was discovered. A number of arrests were made, and the incident helped increase the membership in the association as gallery-owners looked to their reputations.

The major museums show many foreign artists but try not to neglect the native painters. Israeli painters take part in international festivals, and the New York market has been kind to them. Despite the difficulties, the Israeli painters multiply. The Bezalel school still turns out its graduates and has been joined by the Avni Institute for Painting and Sculpture in Tel Aviv and at least two other art schools. In Israel, painting is a lively art.

51

Museums

Israel has more museums per capita than any country in the world. Some were there before the State of Israel was founded, or before the Jewish aliyahs began in earnest, but the majority of them were founded or came to fullness after 1948. So many burgeoned that it became necessary for efficiency and economy to combine several into one on more than one occasion, and later to offer a course in museology at Hebrew University to train directors and curators. All museums are international treasure houses — the patrimony of mankind — and the State of Israel at great expense to its economy takes its responsibility in this regard very seriously.

Of all the museums in Israel the largest in size, content and reputation is the Israel Museum in Jerusalem, a composite of the Bezalel Museum of Art, the Samuel Bronfman Biblical and Archaeological Museum, the Children's or Youth Museum and the Shrine of the Book, which is formally called the D. Samuel Gottesman and Jeane H. Gottesman Center for Biblical Manuscripts. Jerusalem is a city of museums, home also to the Herzl Museum, which honors the father of Zionism, the Museum of Musical Instruments, the Isaac Wolfson Museum with its specifically Jewish collection, the Pontifical Biblical Institute, the Museum of Islamic Antiquities, founded by the Moslem Supreme Council, and the Rockefeller Museum, founded by the Rockefeller family.

The last, one of the major museums in the country, has been under Israeli control since 1967, when the Israeli armies reunited all Jerusalem. The museum was built with a grant of two million dollars from John D. Rockefeller, Jr., the father of the late Nelson Rockefeller, in 1938 during the British mandate and received most of the archaeological finds of the years 1930 to 1948. In the latter year the partition of the city put the museum in Jordan and under Arab control. The new State of Israel found itself without an archaeological

53

museum. Such acquisitions as were then made were sent to the Department of Antiquities or into the collection at the Hebrew University. In 1965 these collections, along with private collections, were drawn on for the Israel Museum.

Unique among the museums of Israel or indeed the world is the famous Yad Vashem Memorial of the victims of the Holocaust, which opened in 1960, has since been enlarged, and is one of Israel's most celebrated shrines, visited daily by pilgrims from all parts of Israel and the far reaches of the world. This remarkable building is operated by the Martyrs and Heroes Remembrance Authority, a unique national body, established by a 1953 act of the Knesset. Its commission was to investigate, study and record the martyrdom and heroism of all those Jews who "laid down their lives, who fought and rebelled against the Nazi enemy and their collaborators." These are the victims of the Holocaust, the six million who died in the gas chambers of the Nazi horror or otherwise under the Nazi boot. The museum is approached through a mall of trees planted in honor of those non-Jews who, at the risk of their lives, worked to save the Jews of Europe, and is called the Avenue of the Righteous Gentiles.

In Hebrew Yad Vashem means "Hand and Name," but the connotation "Tomb and Monument" runs deep. Ancient Hebrew tombs often had a hand carved in relief, and the part came to stand for the whole (synechdoche); the name like the doors is a metaphor. The resonances in the world "shem" come from the Book of Isaiah (56.5): "I will give in my house and my walls, a monument and a name better than sons and daughters; I will give them an everlasting name that shall never be effaced."

No one with a sense of history can approach those doors or enter that memorial without being shaken. In 1974 a French magazine reported that Henry Kissinger, in many ways an imperturbable man, was "completely stunned" after an hour's visit to the shrine. Foreign minister Abba Eban, delving into the files, produced the names and pictures of twelve Kissingers who had been slaughtered by the Nazis. Kissinger escaped with his family in 1930.

The museum seeks to compile a complete file of the names and histories of the Nazi victims; relics from the dreadful period; books and articles about it; stenographic records of trials, commentaries and analyses—indeed, all written matter. It has published a number of pertinent tracts and volumes. Each year on the anniversary of the Warsaw uprising, Holocaust Remembrance Day is celebrated and ceremonies held at Yad Vashem. Curiously enough, it was in the Warsaw Ghetto that the work of making a record of the Nazi atrocities and the proposed destruction of the Jews began, and those incipient records, compiled under the bloodiest of sieges, were sequestered beneath the tumbling ruins. After the war they were dug up to damn the oppressors forever in the memory of man.

The museum has also a separate gallery which shows paintings, drawings, sketches and other artistic gestures done in the concentration camps and saved there. The museum stands on the western slope of Mt. Herzl, where Israel's military dead are buried, and near the Kennedy Memorial, honoring the young American President the people of Israel so admired. The view from the height is breathtaking.

The Israel Museum, not too far from Yad Vashem, has extensive archaeological exhibits with an emphasis on the prehistoric. The archaeological emphasis in the museum is easily understood: the prehistoric has millennia while the historic, only centuries.

In the exhibits, ranging from the Lower Paleolithic Age to the beginning of the Middle Ages, one can trace the evolution of society and catch a glimpse of the evolution of man. For here are fossilized human and animal bones found in the Jordan Valley and dating back hundreds of thousands of years, as well as the pebble tools of Pithecanthropus man, crudely shaped stones for pounding, cutting and scraping. Here are harvesting tools from the Natufian culture of the Mesolithic Age (75,000-12,000 B.C.E.) and from the Neolithic Period (7500-4000 B.C.E.), animal figures, artistically done, and at length, the Chalcolithic Age (4000-3150 B.C.E.), brief but brilliant, giving us carved ivories, amulets, storage jars and ossuaries (portable tombs for human bones), earrings and kingly crowns, one of them a majestic copper artifact redolent of the past's mystery. The displays take us through the Bronze Ages, early, middle and late, after which come the Iron Age and the Israelite conquest of Canaan, the reigns of Saul, David and Solomon, and the construction of the First Temple. The parade of history goes on, mirrored in the thousands of artifacts, some fascinatingly beautiful. The march of archaeology sweeps past the years of Babylon, Nineveh and Tyre, of Nebuchadnezzar, Cyrus and Alexander the Great with his Seleucid successors, the Roman conquest, the days of Jesus of Nazareth, the destruction of Jerusalem and the Herodian temple, the slaughter, enslavement and exile of the main body of the Jews from their Holy Land, and the centuries of the Yishuvim — the Jews who remained in the Holy Land all through the centuries.

In another section of the museum is a magnificent collection of Judaica, entrancing to Jew and non-Jew alike, so little of which is seen in the major museums of the Western world. Indeed, museum collections of Jewish ritual objects began only in the nineteenth century. Only the Lord knows how much art has been lost in the peripatetic history of the Jews and the repeated persecutions. Here are brass Hanukah lamps, illuminated Haggadah manuscripts, menorahs, spiceboxes, cases to hold Torah scrolls, psalters, amulets, marriage stones, sacerdotal breast-plates, scrolls, intricately carved doors of ancient synagogues and other liturgical objects from Europe and the East.

55

One of the most charming exhibits of the Israel Museum is a reconstructed synagogue. In 1964 the Jewish community in Venice and the Fine Arts Commission of Venice arranged the translation to Israel of a small synagogue from the village of Vittorio Veneto sixty kilometers north of Venice. The synagogue was constructed about 1700, but the Jewish community in the town had vanished in the latter part of the nineteenth century. A service might have been held there to celebrate the conclusion of World War I, but there is no certainty in the matter. The synagogue, a masterpiece of Baroque art, was shipped in seventy-two crates and reconstructed within the Israel Museum. The three-paneled gilt Ark of the Covenant that stands at the east end of the exquisite room opens in the center section to receive the Torah scrolls. The brass lamps, hanging from the ceiling, votive lamps before the ark, the wooden benches and the grilled clerestory (behind which the women sat) make up a beautiful room, a decorative masterpiece. The overhanging clerestory has been turned into a gallery displaying Jewish ritual treasures from many centuries and many lands. Such objects are rarer than they should be because of the recurring persecutions, flights and exiles endured by Jewish communities over the centuries, as well as the Nazi destruction of Europe's Jewish museums. A special feature is the extraordinary collection of ceremonial and dress clothes of Jewish communities from many lands, particularly the East: Yemenite, North African and Bokharan, containing superb embroidery and stitching, exquisite jewels, filigree and brocade.

In another wing of the museum are paintings and drawings by the European masters and, proud and worthy in their places beside them, the works of Israeli painters. Many of the paintings are gifts from alien well-wishers throughout the world. One of the major gifts is the Billy Rose collection of sculpture of the nineteenth and twentieth centuries which is mounted in the Billy Rose Sculpture Garden.

The Israel Museum was the result of a national effort in Israel, spurred by the dynamic mayor of Jerusalem, Teddy Kollek. It drew both resources and inspiration from the Bezalel Museum, founded by the visionary Boris Schatz. By the time of its twentieth anniversary in 1985, more than 60 percent of the population of Israel was reported to have visited it once, and more than 30 percent had been there more than once.

The Rockefeller Museum, now within the borders of Israel, was designed in a semi-Oriental style with a hexagonal tower on a ten-acre site on a promontory north of the Old City in a garden of olive trees. Its central courtyard, graced by a lily pond, has serenity and charm. In it are archaeological finds made in much of Palestine from 1920 to 1948, exhibits arranged chronologically from the Stone Age to the Turkish occupation. When the partition of the country came in 1948, the museum fell on the Jordanian side of the line and remained so until the Six Day War, when battle surged around the museum

until the Israeli forces expelled the Arabs and took over all Jerusalem. The Israeli Department of Antiquities now has the responsibility for the museum, and the staff of the Israel Museum administers the exhibitions.

For a panoramic view of Jews throughout the centuries, a visitor turns to the Beth Hatefutsoth, which stands of the campus of Tel Aviv University. Here, through films, dioramas, pictures, sculpture, audio-visual productions and paintings, Jewish communities throughout the world and the years are presented. The whole is the only such museum in the world. No museum ever before attempted to portray the history of a people, in this case, the Jews through the 2,500 years of the Jewish dispersion.

In Tel Aviv, the museums are bursting at the seams. Some of them badly need new quarters but are plagued, like museums everywhere today, by a lack of sufficient funding. The museums of Tel Aviv were founded by citizens of the city and supported by them, but like many they have had to turn to the national treasury for additional support. The Tel Aviv museums are an ornament to the nation, and would be to any country. They compare favorably with museums in the major cities of the United States and indeed, in variety, surpass most. The astonishing thing to remember is that Tel Aviv did not exist until 1909.

The Ha'aretz Museum of Tel Aviv, located in Ramat Aviv, is in great part an archaeological museum with many additional features. In effect it is half a dozen museums. The components are the Glass Museum, with specimens from the Bronze Age to the Islamic period; the Kadman Numismatic Museum, which presents the history of money from its beginning to the present; the Ceramics Museum, which does the same for ceramics; the Ethnography and Folklore Museum, which exhibits religious and secular Jewish art, crafts and costumes; the Science and Technology Museum, which has a special emphasis on the history of mathematics, transportation (including astronautics) and energy. The Lasky Planetarium is an outgrowth of the last. The Alphabet Museum is here, appropriately on the shore where the alphabet began. There is also the display of the Tel Qasile excavations. Acquisitions continue to pour in from friends and benefactors, from the excavations around Tel Aviv and Jaffa, and from other excavations under the direction of the staff of the Ha'aretz Museum. Another popular exhibit, allied in nature with the Museum of Science and Technology, is the Adma ve-Amalo, which had among its founders the Avshalom Institute of the General Federation of Labor and which exhibits the working tools of various trades, the materials that compose them, the processes that made them, and an open-air display of agricultural functions. All these institutions carry on the traditional research studies and arrange public lectures. Finally, separately located, are The Museum of Antiquities of Tel Aviv-Jaffa and the Museum of the History of Tel Aviv-Jaffa.

The Ha'aretz Museum owes its existence to Dr. Walter Moses, a Berlin businessman and inveterate collector who set up in business in Tel Aviv in 1925. A man of boundless energy and innumerable interests, he was possessed by the idea that Tel Aviv should have a museum drawing on his own collection of glass and coins. The city's art museum, one of the handsomest buildings in the city, was begun in 1932 by the celebrated Meir Dizengoff, founder and first mayor of Tel Aviv. In him was that spirit responsible for the efflorescence of the arts in Israel, a spirit that rode the conviction that any center of Jewish life is hollow and insipid without a center of cultural life. He donated his home for a museum and it is still so used, but its greatest moment of glory is behind it, for it was there, on May 15, 1948, that the State of Israel was officially proclaimed into existence with David Ben-Gurion, the first prime minister, presiding. Thirty-nine years before, the site had been a sand dune on which the first pioneers drew lots for the land they would have in Ahusat Boyit, as it was first called.

In his desire for a museum Mayor Dizengoff had the enthusiastic support of some distinguished friends. First among them was his neighbor, Chaim N. Bialik, Israel's most celebrated poet, Marc Chagall, the distinguished artist who made several trips to Israel and gave the first donation of a work to the museum, and Hermann Struk, who had been Chagall's teacher in Berlin and had settled permanently in Haifa. If Chagall honored Mayor Dizengoff, Israel and Beit Dizengoff with the presentation of *Jew with the Torah*, it was in Beit Dizengoff and Tel Aviv that he found new passion for his work in the heroism of his fellow Jews. About the same time a Belgian collector, Maurice Lewin of Antwerp, gave the museum a first-rate collection that included paintings by Ensor, Vlaminck, Utrillo and others. More gifts followed, overflowing Beit Dizengoff. In 1958 the generosity of Helena Rubenstein created a pavilion for art that bears her name, but in twenty years' time that too was crowded, and in 1971 the city and the friends of the museum built additional quarters in the heart of the city, now called the Tel Aviv Museum.

In the four main galleries of this new building the museum's magnificent collection is on revolving display. Exhibitions are also continued at Beit Dizengoff house and the pavilion. The permanent collection of the museum includes a collection of early canvases: Italian, Dutch and French of the sixteenth, seventeenth and eighteenth centuries; French paintings from the close of the nineteenth century to the present — the Barbizon school, the Impressionists, post-Impressionists, the Nabis, the Fauves, the Expressionists, Cubists and contemporary paintings. Dada and Surrealism are represented by half a hundred canvases, and there are sound collections of American and Latin American painters as well as Jewish painters and sculptors from North and South America. There is an outstanding selection of sculpture, and the print room boasts more than 8,000 prints and drawings.

Recurring exhibitions of shows brought from abroad and temporary exhibitions of Israeli artists are very popular with the people of Tel Aviv and all Israel. The avant garde receives warm attention from the museum and provokes stimulating conversations at the outdoor cafes of Tel Aviv. Exhibitions mounted by the museum are put on tour throughout the country, borne to kibbutzim and moshavim, local museums and rural settlements. The museum also carries on educational programs for the young, lectures and film showings, and provides weekly concerts of chamber music in the Leon Recanati Auditorium, which is decorated with pictures from the museum's collections. The library, of course, is one of the busiest rooms in the museum.

These cultural resources are worthy of any city in the world, but in considering them we must never lose sight of their youth and the overstrained economy on which they must draw. The museums of Europe are the slow accumulation of centuries. Those in the United States — the best of them — have a hundred years or more behind them. Those in Israel are the creation of the last few decades, yet they have international distinction. The oldest of them of course is the Bezalel section of the Israel Museum in Jerusalem. It must not be thought that the Israel Museum was born without punishing travail, nor conceived with angelic unanimity.

All agree that the Israel Museum in Jerusalem is the child of Mayor Kollek, whose energy and vision brought it into being. His energy was deemed by many to be misdirected, and his vision seen as a grandiose dream. What he saw was the need for a visual cultural center to attract the attention of the world, a world that could not visualize the achievements of Israel without some concrete symbol. His critics believed his museum would become an empty memorial to pride or a clumsy collection of the mediocre. The Bezalel Museum at the time had a rather slight collection, but Mayor Kollek saw also that a beautiful building would attract donations and bequests. He was right, his critics wrong, and their hostility had vanished by the tenth anniversary in 1975.

Other difficulties arose, as one might expect. Mayor Kollek having brought about the museum, it was a municipal institution at the time, and he sought to gain it national attention and support. The professionals had two advantages; they knew their business and they were young. Has any museum director survived without conflict? The chief curator appointed was Martin Wayl, who also acted as curator of sculpture; Yona Fischer was appointed curator of contemporary painting. The year of the first anniversary found them both in controversy with the newspapers burning with letters of protest and dissent. The protest centered on the museum's seeming preference for conceptual art at the expense of the more traditional forms.

Wayl came under first fire for his refusal to mount a one-man show for Yaakov Luchansky, a veteran of the Kibbutz Givat Brenner, who about the

time of the tenth anniversary marked his hundredth birthday. Luchansky sculptured in the classical tradition. He was in his seventies and a mature artist trained in Paris in the traditional French classical style, when he emigrated to Palestine and promptly found himself a place as one of the foremost representatives of the classical school in Israel. Curator Wayl said simply that the hundredth birthday of a man was not sufficient reason to mount a one-man show of his traditional work. The contretemps provided the occasion for a renewed row over the museum's "neglect" of the traditional. The Luchansky rejection was seen as symptomatic of the museum's attitude and used to attack Fischer for his preferences in the shows he mounted and his interpretation of "the very highest standards." All in all, a healthy reaction to a very healthy institution.

To quarrel with the success of the museum is not easy (except for those artists who believe they have been passed over). After all, the museum welcomes more than 800,000 visitors a year, more than twice the number clocked by the museums of Zurich or Copenhagen. The gate receipts are vital to the museum and keep it from extinction. Government subsidies amount to less than 12 percent of its upkeep. One must remember, however, that public funds account for less than 10 percent of the upkeep of the Museum of Fine Arts in Boston.

In the days of the museum's infancy, Mayor Kollek had to answer again and again the question, "How, in struggling Israel (then classified as an emerging nation) could he justify such an expenditure of resources?" Ronald Sheridan, a professional journalist and friend of the museum, said this in a special article distributed by the Jewish News Service:

> The answer lay in Israel's special character and origins. It was felt necessary to demonstrate the Jews' history and ancient connection with the country in terms more tangible than those provided by the Jewish religion and traditions. It was felt too that there would be a place where the objects of Jewish culture through the past centuries whether European or Oriental could be brought together and preserved before being lost and forgotten. A place, too, where the continuing development of Israeli cultural expressions in the field of the arts could have a point of focus and reference to the cultures of other parts of the world.
>
> There was probably another aspect, not explicitly stated but doubtless there. In this present age of the decline of religions, the contact of many Jews with their religion was weakening, so something was wanted with which people could continue to identify, something specifically related to national history...

How accurate such an analysis may be can be gauged from a poll taken at the Ha'aretz Museum of a sample of the people entering. The survey found that 92 percent of the visitors said they were without religious belief, 80 percent

acknowledged that they had had higher education (the remainder had had secondary). Ninety-eight percent said that "art was an essential part of their lives." Ninety-seven percent agreed (the question was presented) that they needed a tradition, and 76 percent said they were looking for a tradition to which they could relate.

That state of mind may be evident in the statistics issued by the Ha'aretz Museum on which of their units gets the most visits in a year. It is the Museum of the Antiquities of Tel Aviv-Jaffa, far ahead of the Glass Museum, its nearest rival. The number of visitors to the Museum of the Antiquities is four times that of visitors to the Museum of the History of Tel Aviv-Jaffa, suggesting that interest lies not merely in the local tradition but in its deepest roots.

The Museum of Antiquities of Tel Aviv-Jaffa (Yafo) was founded by Dr. Walter Moses in 1951 in one of the buildings of Tel Aviv University but soon had to move to more suitable quarters. An old Turkish bathhouse and administration center was acquired. The building itself is a museum piece, and in the renovation fastidious care was taken to preserve its vaulted ceilings, Oriental archways and other architectural features.

The museum is divided into five halls, each covering a long time-span, beginning with the fifth millennium B.C.E. and ending with the Arab period. The first hall displays the earliest finds from "the dawn of civilization." The second hall exhibits the various phases of the Canaanite period down to the settlement of the Israelite tribes. The third hall features the Israelite period until the destruction of the kingdom of Samaria. The fourth hall presents the Judaen period down to the destruction of the Second Temple, while the fifth and final hall exhibits the Roman-Byzantine era down to the Arab period. Plans call for Arab, Crusader, Mameluke and Ottoman periods.

Under the supervision of scholars connected with the museum, excavations have been carried out at thirty sites within the city, among them the ancient tel of Jaffa. The research connected with these has unfolded a long vista of centuries, from prehistoric times, when primitive tribes dwelt in the basin of the nearby Yarkon River, to the present. The remains of early tribal towns, forts, cemeteries and many tombs have been uncovered in the area. Simultaneously research was done on ancient documents connected with the history of Tel Aviv-Yafo that are found in various museums throughout the world. Replicas of these documents are exhibited in the collection. Jewish visitors can sense themselves standing on the very summit of a time sequence become palpable.

The archaeological exhibits are accompanied by photographs, drawings, plans, models and explanatory labels. The visitor can view in sequence the entire history of the city: from the burial cults of Neolithic hunters, the daily life of the Chalcolithic herdsmen, the remains of the early Canaanite period, the Hyksos remains at Ramat Aviv and at Jaffa and the Hyksos burial grounds

near the old harbor, the Egyptian domination of the country, until the latter's subjection by David, and then the Assyrian invasion and conquest of Jaffa. Then there is the return of the Exiles, the liberation of Jaffa by the Hasmoneans, the arrival of Alexander and the Seleucid kings, then Rome and the Jewish wars against Rome. In Bible history, Jaffa is remembered as the port from which Jonah sailed to meet his destiny within the stomach of a whale. In Greek mythology Jaffa is recalled as the home of Andromeda, and in the harbor is the rock from which Perseus freed her.

There are other minor museums in Tel Aviv. One that deserves mention is the Zahal Museum, which illustrates the history of the Israeli armed forces from 1921 to 1948 and stands in what was the home of Eliyahu Colomb (1893-1945), one-time commander of the Haganah, who as a young man became the spokesman for labor in the councils of the Jewish defense forces organizing against Arab terrorism and the British impositions.

The museums of Haifa are enchanting particularly for visitors to Israel who may not share Israel's passion for archaeology, although, true to the image of the typical Israeli city, it has its own archaeological Museum of Ancient Art and a Prehistoric Museum. But it also boasts the Museum of Modern Art, the National Maritime Museum, the Museum of Ethnology and Folklore, the Chagall Artist's House, showing in the main Haifa artists, the Museum of Music, the Museum of Nature and the Museum of Japanese Art. One small museum is devoted solely to the work of the painter Mane-Katz. The city has its own museums administrator.

The National Maritime Museum is supported by the city of Haifa, the Israel Maritime League and the friends of the N.M.M. Originally the property of the Israel Navy, it was taken over by the league and the city in 1954 and about fifteen years later was moved to spacious quarters made possible by a grant from the Jack and Michael Morrison Foundation. Besides these there is the Illegal Immigrants Museum, situated opposite the cave where Elijah is believed to have hidden from Ahab. On the grounds is the illegal immigrant ship Af-al-pi-khen, which ran the British blockade when the Jews were fleeing Hitler and were denied legal entrance to the Holy Land. The National Maritime Museum has come to rank among the best in the world, benefiting as it does not merely from the Israeli enthusiasm for the arts and education but from Israeli archaeological excavations, including submarine explorations along the coast. A few years ago these explorations turned up a marvelous specimen of an Attic helmet, which is exhibited along with a Corinthian helmet.

The museum displays coins and some ancient seals made of the hardest gems and expertly incised. In its new building it has been able to exhibit its undersea archaeological finds, which in its old quarters had to be hidden in storerooms. It also now has a lecture hall, workrooms for researchers and a growing library.

In the 1960s it began publication of a bulletin entitled *Sfunim*, Hebrew for "seafarers," with scholarly articles in English and Hebrew, not all related to the sea. One of the articles in a recent issue dealt with the history and making of sundials in the Holy Land, which says something about the broadness of the publication's appeal. Surveys of anchors, stone and metal, and lead plummets, as well as more intricate nautical equipment, can often make compelling reading, even for the landlubber. The museum deals not only with the past. Among the exhibits are materials taken from the Egyptian destroyer Ibrahim el Awal, a victim of the Six Day War. The museum is appropriately placed in Haifa, which is not only Israel's second largest city but its naval base and leading port.

The museum was founded in 1954 and consisted at that time of a small collection put together by Lieutenant Commander Aria Ben-Eli of the Israel Navy, who remained as curator. The collection has been greatly expanded, and precious acquisitions continue to arrive. In dealing with the long history of man's relationship to the sea, the museum specializes in the area of the Mediterranean, the Red Sea and the Persian Gulf.

The section "The Sea and Its Deities" introduces us to the attempts of ancient peoples to come to terms with the sea—provider of food, carrier of trading ships and unpredictable source of storm and tempest. A collection of large ship models includes old and new, many from archaeological discovery. A manned Egyptian craft dates from 2000 B.C.E. Not all exhibits are tied to the museum's area of specialization. Peruvian raft models each about a thousand years old are among the best items in the museum.

The "Sea and Ships in Art" exhibits prints, engravings, lithographs and paintings; the "Fish in Art and Ritual and Marine Ethnology" develops a vital aspect of the life of man and the sea with a broad range of fish-decorated artifacts. The "Coins and Seals" collections are an important source of knowledge of early ship types, many of them displaying artistry of a high order. The "Scientific Instruments, Charts and Maps" are mostly drawn, as one might suppose, from European sources but offer some very rare Islamic instruments including an extraordinary Islamic astrolabe. As one English journalist pointed out, "The collection brings home the point that Jewish craftsmen and mathematicians moving through both Islam and Christendom were often responsible for the transmission of scientific knowledge between them."

Like Jerusalem Haifa is a city built on a hill, and the inhabitants are conscious of the charm of their city compared with the brash growth and bustle of Tel Aviv. The citizens are even more museum-minded and more aesthetically concerned than the rest of the country. It is no surprise then when one finds that the grain silo on their wharves is a thing of beauty, an ideal observation tower for visitors, and offers at the top an exhibition of the history of grain in the Holy Land from Biblical times.

63

The Museum of Modern Art was founded in 1951, three years after independence, and exhibits paintings, sculpture, ceramics and graphics by Israeli and foreign artists. The exhibitions are thronged with visitors. The one-man shows of leading Israeli artists are not merely artistic successes but social events of distinction, and the occasion for the printing of excellent catalogues which have become collectors' items.

One of the first exhibitions of the museum, mounted in 1952, was a show of the the works of Menahem Shemi, one of Haifa's most distinguished painters. The memorial exhibition was held on the tenth anniversary of his death. In 1970 a show was held of the works of Batia Mokady, Moreno Pincas and David Ben-Shaoul. One of the major shows that stirred great attention was that of the "Aclim" group. In listing such exhibitions one is likely to numb the reader with mere enumeration.

Safed has its own museums, one of them unique in Israel, the Museum of the Art of Printing, for from Safed long ago, in the sixteenth century, came the first book ever printed in Hebrew. It was a commentary on the book of Queen Esther whose grave is said to be on the grounds of a synagogue called Biram, recognized as the oldest in Israel, located about five miles west of Safed. Safed is also a city on a hill, north of the Sea of Galilee with a climate that makes it an ideal summer resort. From it one sees beautiful vistas at all compass points. The town has a great Jewish tradition, for it was here in the nineteenth century that the Sephardic scholar Joseph Caro compiled a compendium of Jewish religious law that has become an orthodox standard. Here too the Cabbalists came with their magic and mystery and built their synagogues. Safed has several well worth a visit.

The Glicenstein Municipal Museum in Safed is a small museum begun in 1953 as a home for the works of the sculptor Henoch Glicenstein, an artist who had dreamed all his life about going to live in Safed—the second Jerusalem—but never made it. The museum is in the home of the former Turkish governor and was the historic headquarters in the War of Independence for the Jewish northern command. Under the scholarly eye of Isaac Lichtenstein, the collection of works by fellow artists have been added.

Besides the magnificent scenery and the ancient stone streets and stairs of this hilly town, the feature that most catches the attention of tourists is the artists' colony. This is the highest town in Israel and the most picturesque, and the artists' quarter, full of the marks of antiquity, helps make it so. Here painters, sculptors, ceramicists and metalworkers—artists all—work at their studios and their summer homes, behind painted walls and amid patios and lovely gardens where the visitors can roam at will. The very atmosphere of the colony has its effect on more than one resident, among them one of its most famous artists, Shalom of Safed as he was known, the painter whose

works were replicated in a forgery ring. He spent much of his life as a watchmaker and silversmith before he turned to painting after the style of the great medieval miniaturists. Shalom got caught up in the Safed atmosphere and in middle life turned from watchmaking to paints. September is Artist Month in Safed but since this is lofty and cool and a summer resort the month of July finds it the site of the annual Hasidic and Jewish Art Festival.

Rivaling Ein Hod in creativity and charm, the artist colony is preferred by many to the art colony in Jaffa, which, active and exciting, seems newly created compared to that in ancient Safed.

The Wilfrid Israel House in Hazorea would be extraordinary in any country, let alone a struggling new nation with intense problems of self-defense. It is a museum housing a superb collection of Oriental art, a museum with the specific task in Israel of helping to a "better understanding of the special values in the art and ancient cultures of the Far East."

The Wilfrid Israel House for Oriental Art and Studies was opened in Hazorea in 1951 in memory of the self-effacing, German-born, Jewish pacifist, who, after admirable resistance to Naziism, fled at last to England to engage in humanitarian work only to die with Leslie Howard, the actor, in a civilian plane shot down by the Nazis. Long before that, emigration to Palestine had engaged him, and he had helped thousands get there. His special interest in Kibbutz Hazorea led him to leave it his distinguished Oriental collection, now enlarged by other acquisitions, some from the government of Israel itself, recognizing as it does, the unique role of the Wilfrid Israel House.

In the house are three exhibition rooms, two with standing exhibitions from the museum's growing collection, and one room reserved for varying exhibitions, many featuring Israeli artists. The quarters are ideal for presenting exhibitions that delineate the contrasts between the art of the Far East and Western Art, with accompanying lectures. The collection has been supplemented by local archaeological finds.

Discussion of the museums of Israel could be extended into a book, and indeed several books have been done on individual museums. The variety of holdings in the State of Israel is extraordinary and in many instances unique, as in the case of the Dead Sea Scrolls. The responsibility that rests on the country to preserve and protect them is not Israel's alone, but a responsibility of the Western world. Israel's collections are an undying possession of mankind, for when it comes to the preservation of art, any nation is nothing more than a trustee.

The Jewish life truly lived is a life of prayer. The scribe prays before he takes up his brush or pen and the workman before he sharpens his tools. Louis Finkelstein, a former chancellor of the Jewish Theological Seminary of America, said, "Judaism is a way of life that is dedicated to the transformation of every

65

action into means of communion with God." The Talmud declares that should a man wish to donate a Sefer Torah to a synagogue he was to make sure that it was "written in his honor with the finest ink, with the best quills, by the most skillful scribe, and that it be wrapped in the purest of silk." Thus have the Jews over the centuries created in their liturgical vessels and ritual artifacts a great religious art.

Beautiful architectural elements and ritual objects have been traditional since Biblical times. Hebrew has ten words for "beautiful," and ceremonial paraphernalia used to enrich the religious service in the synagogue and the home are governed by the phrase *hidur mitzvah*, the glorification of a duty or the beautification of an object. In brief, if you are going to make something, make it well.

Driven from their land by the Romans, Jewish artisans were unable to make sculptures or paint pictures of any size, since the wandering life disenabled them from excessive luggage. Constant persecutions, in which their goods were plundered, also motivated against elaborate art works. During the Middle Ages they were debarred from membership in the guilds, which controlled crafts and art. Few trades were open to them. In the home, however, they could create as they would. Thus from the late Middle Ages through the Renaissance and down to the twentieth century, beautiful objects abound, and museums boast splendid collections of Jewish ceremonial art, objects created for the synagogue and for the home.

In excavations of ancient sites in Israel, various artistic artifacts have been found but none that can be confidently identified as ritual objects used in the home. Ancient synagogues have yielded much, including a sculptured menorah from the second century. But it was not until the Jews were settled in Europe in the Middle Ages, having survived the barbarousness of the Dark Ages in their wanderings, that they began to produce the magnificent array of art works we find in the Israel Museum and other museums in Israel. There is, of course, no way of knowing what was lost in the previous centuries or in later centuries. We are quick to forget that Martin Luther was eager to drive the Jews from Germany and in his seven-point program for ridding Germany of Jewry urged his followers to "burn their synagogues and bury or cover with dirt whatever will not burn." He also advised that their homes be burned. His persecution was not an isolated one. Much of their art was saved, however, including many marvelous examples now in the Israeli museums. There are outstanding collections of Judaica in the United States, England and Europe, but the museums of Israel are amassing the preeminent collections.

In 1958 Yehuda L. Bialer, a Polish scholar who settled in Jerusalem in 1949 after fleeing to Russia before the Nazi Wehrmacht, established the Museum of Religious Art at Hechal Shlomo, the rabbinical headquarters on King George

V Street, Jerusalem, where the Great Synagogue bulks. The museum is now called the Sir Isaac and Lady Edith Wolfson Museum, after the great collection donated by them to the museum to supplement its other holdings. Most often the museum is referred to simply as the Hechal Shlomo museum.

When Boris Schatz founded the Bezalel Museum, now a unit of the Israel Museum in Jerusalem, the Yishuvim—members of the centuries-old community—were not particularly happy that he did so. They were a poor and deprived group, victims of oppression, without the material culture of Europe. Schatz was intent on bringing into Jerusalem all the skills in the making of ritual objects and ceremonial art that had developed in the Western world. The tradition has grown and been refined.

Wandering through such collections in Israel's museums, one is struck by the universality of the urge to beautify. Not only from Germany, Poland, Holland and elsewhere but from all along the African littoral have come vessels of exquisite craftsmanship. From Morocco, Tunisia, Bukhara, Yemen, Egypt, Turkey and all those centers where the Jews lived in exile. Only in Palestine did the Roman heel and centuries of Muslim rule seem to have diminished the artistic spirit. The Yishuv was a depressed minority under Muslim rule, poor in fact, poor in spirit, rich only in endurance.

Today the situation is reversed. Israel is the greatest center in the world for the creation of Jewish liturgical art. The ritual artifacts for Judaism divide into those pertaining directly to the sacred Torah and its ceremonics and those pertaining to the ritual of the household which have sacramental overtones. Among the first are the Torah itself, the sheath that covers it, the cloths in which it is wrapped, the ark in which it is housed, called the *aron ha-kodesh*, the crown that sometimes adorns it, and the *rimonim*, which are similar adornments.

For the home there are candlesticks, the Hanukah candelabra, plates, silverware, flagons, decanters, the Kiddush cup, spiceboxes, the Elijah cup and the Elijah chair, plaques for the wall, amulets to be worn or displayed, sabbath rings, prayer shawls, and the mezuzot, which no Jewish house should be without. All these are made with grace and charm. The Elijah cup is set out at Passover and filled for the fifth glass of wine. It is a solemn moment, for at the same moment the door is opened for the hoped-for arrival of the Messiah. Consequently, the Elijah cup gets more attention than the others. The Elijah chair is set up at the time of the circumcision of the newborn, for he is seen in the mind's eye to be sitting there. It too is wrought as magnificently as possible. On Hanukah candelabra alone is there a religious stricture as to how it should be made. On the other objects the artist is free to exercise his creativity. The Hanukah candelabrum must have eight candle-holders (although some of the ancient ones have slight depressions for oil) and one more from which the others are lighted.

The craftsmen of Israel can be divided into those who take their inspiration from the historic vessels and utensils that fill the museums, and those who seek to swing clear of the old forms. That the rule on Hanukah candelabra has not impeded creativity can be seen in bronze by Kurt Fefferman, now in the Israel Museum, side by side with those taking their shape from the traditional menorah or architectural tropes.

The revival and mounting interest in such religious paraphernalia has resulted in the inevitable, a situation that has been called "the great Judaica rip-off." Forgers of fake antiques have been making hundreds of thousands of dollars selling reproductions of the real thing. So good is the workmanship that experts have difficulty detecting the reproduction. Professor Bezalel Narkiss, head of the Center for Jewish Art at Hebrew University, warned that in his estimate "60 to 70 percent of the items on sale in shops is fake. Frankly, I don't think there is much of the real stuff left." He said that the vast majority of the traders honestly represent their goods as reproductions. Too often, the aim is to mislead.

"The origins of these items are extremely hard to trace because, although some of them are made here, much of it is produced abroad," he has said in the *Jewish Advocate*. "Forgery is an international industry — worth millions of dollars." Daniela Luxembourg, who represents Sotheby's in Israel, believes the estimate of Professor Narkiss on the amount of fakes is exaggerated, but she agrees that the market is large. The prices are mounting as availability declines. The first Sotheby auction of Judaica held in 1985 produced more than a million dollars in sales.

The reproductions generally match the originals in beauty. The new creations of the Israeli artisans abound in their studios and shops from Haifa with its great diamond market, and from Safed with its own art colony to Eilat in the south with its sun-worshipping tourists. But the center for handicrafts and Judaica is Jerusalem. Tubal Cain in the Book of Genesis is the forefather of all metalworkers, and his descendants today congregate in the Holy City, which should be no surprise since the city is the center of the tourist trade.

The Old City harbors many workshops. Starting at Zahal Square, walking up Rehov Yohanan MiGush Halav to the left or Shivtei Israel Street to the right or down on Hevron Street near the railroad station and the Church of St. Andrew, one encounters the shops of the metalworkers, the carvers, the sculptors, the ceramists, the jewelers. While the city has a concentration of artisans, they are not necessarily concentrated. Near Zion square on Harav Kook Street is the Maskit, a headquarters for handicrafts for handwoven cloth, pottery, batik, oregami and jewelry.

Maskit is an organization founded to further the creativity of immigrants, to improve the quality of their work, and to provide markets for them. The

massive immigrations of the 1950s created almost insurmountable housing problems, but they also brought into the country amazingly diverse talents and the creative fruits of many cultures. Some of them, while primitive, claimed a most sophisticated craftsmanship. Ruth Dayan, a sabra and agricultural expert, was assigned to help place such people on the land and get them farming. She writes in her book *Crafts of Israel:*

> As it happened, my assignment did not work out as planned. We soon discovered that economically viable agricultural activity was not feasible at the moment... In my travels to the struggling settlements I discovered, to my delight, samples of the handicrafts that these immigrants had made and brought from their homes... such as jewelry, rugs, and garments made by hand and used in the home or worn. These handicrafts were part of everyday life. I was overjoyed by this discovery; these objects were, in fact, the start of Maksit.

For years the styles of Yemen jewelry and Yemen dress colored the making of jewelry and clothes in Israel, just as the Yemen dance group was so influential. Indeed, the vibrancy of colors and designs that came from the Jewish colonies in the Arab countries have lent a very special flavor to the handicrafts of Israel.

The line between handicrafts and the artistry of the liturgical artifacts is a fine one, if indeed it can be defined, and it is certain that they overlap. Not only Jewish liturgical items are made in Jerusalem but some startlingly lovely *objets de pietie* are sold in the Christian shops. In all cases, a lovely work of art transcends doctrinal boundaries and appeals to the aesthetic instinct of everyman.

The Jewish spiceboxes, where the artisans have free hand uninhibited by religious tenets, are popular with the general public. Although they can be made in any form, in the Renaissance and the centuries following it spiceboxes took on the form of filigreed towers with a banner waving from the top. True architectural details mark them, and the intricacy of the construction involves lapidarian work of a high order.

Israeli artists have exhibited their blown-glass work at Tiffany's in New York, and their ceramics are in museums throughout the world. More than one has won the DeBeers' Diamond International Award; the museums and universities of Europe have honored their silversmithing; and their own museums have bought and exhibit some of their finest work.

Among the most popular and numerous of religious objects made by Israeli artisans and sold in great numbers to natives and tourists alike are the mezuzot. The word means "doorpost," and the mezuzah should be attached to the right hand doorpost of every Jewish home — and indeed to each right-hand doorpost within the door. On the outside door it should be tipped slightly to indicate a welcome.

69

The mezuzah in its essence has inscribed on parchment the first two paragraphs of the Shema, which contain pledges of the Jewish faith. Also inscribed on the parchment is the word *Shaddai,* another name for the Deity. In time, the parchment came to be covered for protection. The origin of the mezuzah is lost in time, but it may have been a talisman to ward off evil. Jews on entering or leaving the house would touch it for luck. Today, all the mastery of the Israeli craftsmen is brought to bear on mezuzot, and they can be found in a thousand guises, some of the most exquisite metalwork. The interior parchment (and it is best that the name *Shaddai* be visible) must be done by a talented scribe.

We have mentioned the utensils and furniture used at the annual Seder supper. For Purim, a holiday that remembers and honors the escape of the Jewish people from the conspiracy of Haman to destroy them, there are other objects of semisacred intent. On this holiday, the Book of Esther is read in the home, since it was through her good offices that the Jews were saved and Haman hanged. That scroll demands its own tik or housing. Such tikim are beautifully carved, and the artistic attention is given to the humblest of objects used on the day. One of these is a noisemaker swung by the children to drown out the very name of Haman. These are ratchet affairs and usually made of metal. Sound metalworking and decoration are brought to the making of these.

The Esther scroll in turn should be done by an expert scribe, and without illustration. But in the Haggadah, the prayer book used at the Passover dinner, a good deal of liberty is allowed the scribe and artist, and traditionally beautiful illustrations are sought after. We have seen how from the days of the Duro-Syrian synagogue the commandment against the making of images was frequently broken. Again, from the end of the Middle Ages to the twentieth century manuscript illumination and book illustration were a fertile field for Jewish artists, as all ceremonial art has been.

HEBREW LANGUAGE

If we recall Jacob Burckhardt's phrase "the state as a work of art," considering the elements that might be necessary for a state to be so designated and thinking of Israel in those terms, then it must be acknowledged that the revival of Hebrew as an everyday mundane language was a stroke of genius. This is none the less so because of its apparent obviousness. The contemporary revival of the ancient tongue is generally recognized as the most "extraordinary example of a linguistic revival," quite different and far more difficult than the revival of Finnish and far more successful than the attempts of the Irish Republic to restore the use of Irish.

Hebrew in Israel is the country's first language, a normal living language, the common tongue for business, books, education, the home, the school, the theater, the press, and radio and television broadcasts. It is spoken and read and written by the overwhelming majority of Jews in the country, and spoken by a large fraction of the Arab population. Those who have not mastered the language, mostly recent immigrants, are given every opportunity to learn through the *Ulpanim*, a variety of schools for teaching citizenship as well as Hebrew. The native-born, of course, have it as their first language, and though many Israelis are polylingual, some speak no other. A common joke in Israel is that Hebrew is the only language that parents learn from their children. What Westerners do not realize is that the revival of Hebrew as an everyday language is a sociological and artistic triumph, an extraordinary achievement, profoundly significant for the Jewish people.

The Jews spoke Hebrew from the time of Abraham down to the Babylonian captivity—in reality more an exile than a captivity (586-538 B.C.E.)—but during the four hundred years after the return to the Holy Land, the areas in which Hebrew was the spoken language shrank markedly. Alexander the

Great conquered the region in the fourth century B.C.E., and the Greek language mingled with the Aramaic of the Persian empire as the chief local idioms. Jesus spoke Aramaic; the New Testament was written in Aramaic and Greek; and St. Paul, a master of Hebrew, wrote his letters to the early Christian churches in Greek. After the two wars against the Romans, in 70 C.E. and in 132 C.E., Hebrew disappeared as a spoken language. In the Diaspora, the Jews took up the languages of the lands of their exiles, and when the first Zionist aliyahs came to Palestine, the Yishuvim were speaking Turkish or Arabic.

From 200 C.E. to 1880 C.E Hebrew, while not a spoken language, continued as a written language, particularly for religious commentary. Pious Jews said their prayers aloud in Hebrew. On meeting, Jews from disparate countries might converse as best they could in Hebrew, as Catholic priests from different countries might use Latin. In Eastern Europe highly educated Jews might talk in Hebrew, but it was nowhere the language of a community or even the spoken language of the home. A Hebrew literature persisted and even flourished in certain areas—Hebrew poetry written in Italy and Spain in the Middle Ages and during the Renaissance for example.

In Europe during those centuries of exile, the Jews developed two lingua francas: Yiddish and Ladino. The latter was a Spanish dialect with a Hebrew admixture spoken in Spain and any number of Mediterranean ports by Sephardic Jews. Yiddish, a development of medieval German with some admixture of Slavic and Hebrew words, was spoken by the Askenazi Jews of Central and Eastern Europe, a far larger body than the Ladino speakers.

What was important for the revival of Hebrew in the past hundred years was this: both Ladino and Yiddish were written in characters of the Hebrew alphabet. Otherwise, except for borrowings, Ladino and Yiddish have nothing linguistically in common with Hebrew. Both have literatures of their own, and the names of Sholom Aleicham, from whose short stories we have "Fiddler on the Roof," and Isaac Bashevis Singer, a leading American author, are familiar to millions of readers of English. The late Sholem Asch, an American author of several best-selling narratives, also wrote in Yiddish. Yiddish newspapers flourished in New York, among them the *Jewish Daily Forward*, for the thousands of Yiddish speakers on the Lower East Side. Few foreign languages have put as many words into our current American speech as Yiddish. Through the Bible, of course, Hebrew has contributed more.

The first newspaper printed in Hebrew was the weekly *Ha'Maggid*, published in 1865. That was more than half a century after the French Revolution had given the Jews citizenship for the first time in Europe. That emancipation was also more than half a century before the birth of perhaps the key figure in the revival of Hebrew as a spoken language, Eliezer Ben-Yehuda.

Generally conceded the honorific title "the Father of Modern Hebrew," Ben-Yehuda was born near Vilna, Lithuania, then a leading center of Jewish scholarship. He would become an intense scholar even before he had to abandon his medical studies in Paris because of tuberculosis. In 1879, twenty years before Theodor Herzl, the Father of Zionism, called his historic congress in Basel, Ben-Yehuda urged the formation of a Jewish state in Palestine and the adoption of Hebrew as its native language in a memorable article. Not even Herzl envisioned such. The next year, caught up by the force of his own idea, he was on his way to Palestine with his bride, Devora. It was their honeymoon, and during the trip he told her that in Palestine he would address her only in Hebrew, a language she did not know. Their son, born in 1882, was reared hearing only Hebrew, which prevented him from conversing with the children of neighbors. Ben-Yehuda had a fanaticism to match that of the non-Hebrew-speaking Herzl, who had dreamed of a Jewish state where the language would be German! Ben-Yehuda was committed single-mindedly to the restoration of Hebrew and sensed that the most important step must be a generation reared speaking the language.

Despite opposition from Yiddish-speaking immigrants and more from the Orthodox Jews, and with no help from the Ottoman Empire, Ben-Yehuda pursued his goal. He started a newspaper, *Ha'haValzlet*, taught school, and began the compilation of a monumental thesaurus that would run to seventeen volumes. In 1888 one school in the Holy Land taught all subjects in the elementary grades in Hebrew, but by the first decade of the twentieth century several high schools were using only Hebrew, including the technical high school in Haifa where the students struck to have Hebrew as their language.

In 1921, a year before Ben-Yehuda died, the British mandate government recognized Hebrew as one of the official languages of the country, along with Arabic and English. By that time the overwhelming majority of the residents of Tel Aviv were Hebrew-speaking, and so were about half the Jews outside the major cities. Ben-Yehuda, with other scholars and enthusiasts, formed a Hebrew Language Committee, which, on the founding of the State of Israel, became the Academy of the Hebrew Language. When that day came in 1948, twenty-six years after the death of Ben-Yehuda, a census showed that 80 percent of the Jewish population could speak Hebrew and that more than 50 percent used Hebrew only. Such statistics in Israel were threatened by the continuing influx of immigrants who spoke a variety of languages—Russian, Ladino, German, Yiddish, Arabic, Bulgarian, Romanian, French, Polish, Ukrainian and lesser-known tongues—but the Ulpanim were established to teach the newcomers.

The difficulties of establishing Hebrew as a daily means of social intercourse were innumerable. A major difficulty was the absence of an adequate vocabulary.

The Old Testament, it has been declared, contains only eight thousand Hebrew words. The absurdity of trying to confine oneself to such a vocabulary in the modern world became evident in the mid-nineteenth century during the Haskalah or the Jewish Enlightenment. The industrial revolution contributed to the rise of the middle class and to a general alteration of social relations with stimulating notions that promoted new political, moral, economic and social aspirations. Jews everywhere looked for equality with Christians, for an end to ostracism and for the elevation of the impoverished mass of Jews in Eastern Europe. A new interest in Hebrew led to a surge of writing: novels, poetry, textbooks, translations of classics, and political and scientific material. These were marked by artificial usages. Because the poetry clung to Biblical language it was awkward. In 1868 a novel appeared under the pen name Mendele Mocher Seforim. He was Solomon Abramovitsch, who wrote also in Yiddish, and his novel in Hebrew helped win him the title "The Father of Modern Hebrew Prose."

At the end of the nineteenth century he was in Odessa, and because of the presence of several men like him, that city became the heart of the Hebrew renaissance, for there too were Chaim Nahman Bialik and Saul Tschernikhovsky, the two leading names in modern Hebrew poetry, as well as Asher Ginzberg, a distinguished essayist who wrote under the pen name Ahad Ha'am. These men ground the ancient language in the mortar of creativity so that a new awareness ran through the Jews. Today Bialik is hailed as Israel's national poet.

Another irony bearing on the revival of Hebrew arises here. Bialik and Tschernikhovsky, regarded as preeminent in the classical period of modern Hebrew, wrote with an Askenazi accent to their lines, while today a modified Sephardic pronunciation is spoken in Israel. Since the latter places most of the accents on the last syllable of each word where the Askenazi did not, the two greatest poets cannot be read easily by the average Israeli. Despite this, the speech in Israel today is closer to the ancient Hebrew of Genesis than American speech is to Chaucer. But the pronunciation of modern Hebrew in its revival became a problem. Several different pronunciations and several dialects were developed in the Diaspora, and the new state had to opt for one.

Pronunciation remains a difficulty to this day as the scholars struggle to standardize spelling, grammar, syntax and vocabulary. A living language is a wild horse. The Hebrew writers of the modern renaissance first moved from Biblical Hebrew to incorporate that of the Mishnah, a codification of Jewish law involving considerable commentary and hence many words that do not appear in the Pentateuch. Writing Hebrew was one thing; talking Hebrew all day long was another. Ben-Yehuda and his colleagues, to catch the reality of daily life, had to invent words. One of the first words Ben-Yehuda invented

was *millon,* which remains today as the Hebrew word for "dictionary." He also took any number of awkward antique expressions and created new words for them. Of the monumental dictionary that he planned, the *Thesaurus Totius Hebraitatis,* only five of the seventeen volumes were published in his lifetime. The final volume did not come until 1959.

The matter of introducing new words into Hebrew is now the prerogative of the Academy of the Hebrew Language, which grew out of the Hebrew Language Committee Ben-Yehuda and other scholars had formed. The academy was established by law in 1953 "to guide the development of the Hebrew language on the basis of research into its different periods and branches." Of its members (twenty-three is the maximum) most are scholars, but poets and other writers are included. While the academy rules, minor committees do the work, and what is approved by the academy goes into the lexicons and the textbooks of Israel. This does not involve merely the definition of words or the invention of new words, but grammatical and syntactical questions, to say nothing of spelling, punctuation and pronunciation.

One of the problems facing Hebrew today is the transliteration of Hebrew names into foreign languages, English, for instance. Lacking an established rule, proper names of persons and towns are often spelt several different ways in English to the confusion of readers, travelers and mapmakers. Chaim, Haiim, Haim and Hayyim are, for example, all the same name, and so are Shaul and Saul. On one occasion an Israeli newspaper took the public works department to task for giving an English spelling of Nazareth no English-speaking tourist would ever recognize.

Once any language becomes the language of the home and the street, slang is certain to develop. So it has been with Hebrew. When Hebrew was proposed as a mundane language the strongest opposition came from the Orthodox Jews, who regarded the language as sacred and not to be debased by the vulgarities and obscenities of the commercial world or the household. For all its bluntness the language of the Old Testament is puritanical, a language of high delicacy. To have it proposed for the use of the gaming table, the brothel and the ballfield, to say nothing of the vituperative debates of the Knesset and political rallies, and the modern indecencies of advertising, shivered the hearts of the rabbis. They did not prevail: nationalism was too strong.

Now the scholars are the ones who are seeking to control slang and keep it from debasing the language. Since they have the Academy, which can control the content of the dictionary and the textbook, they can keep more of a checkrein on the words and idioms than English or American lexicographers who, because of commercial competition in which rival dictionaries can give status to casual street talk, find their dictionaries bursting at the seams with an explosion of verbiage. Hebrew slang there is, however, and American English has made its contribution to it, as have Arabic and some European

75

languages. The Hebrew word, *pantscher*, a current slang word for any kind of unhappy mishap, is merely a variant of the English word *puncture*, used in the sense of a flat tire. Some experts believe, however, that as Hebrew becomes overwhelmingly the language of the people of Israel, the slang will take its rise chiefly from Hebrew itself, although the French experience with Franglais doesn't encourage that view. What the presence of slang always indicates — and nowhere more than in Israel — is the vitality of the language. That Hebrew has.

One demonstration of the depth of the roots that Hebrew has sunk in the society is the present-day attitude in Israel toward Yiddish. When Hebrew was first advanced as the speech of the Yishuv and then promoted as the official speech of the Jewish state-to-come, Yiddish, in opposition, made a strong bid. After all, it was a Jewish language in that it was unique to them despite its Germanic origin. Secondly, it has a lively modern literature of its own and is a flexible, vibrant tongue, suitable for the scholar or the clown. The Yiddish theater was famous around the world, and a Yiddish audience could be found on all the major continents. Millions of Jews spoke Yiddish; it would not have to be taught. Those who spoke it abroad would have ready communication with a Yiddish-speaking people of Israel. Among the arguments against its adoption was its foreign origin, which made some regard it as a badge of shame, the language of the ghetto, a language forced on Jews in exile, a reminder of the isolation where it developed. After the Holocaust, its German origin doomed it. When Israel was established the place of Hebrew was not all that secure, so the speaking of Yiddish was discouraged. Children were taught that it was wrong to speak it, or indeed to speak any language in the home or elsewhere except Hebrew. Today Hebrew is of the essence of being an Israeli, germane to the Jewish state, magnificently appropriate to the Jewish people, and so secure in its preeminence that Yiddish is being encouraged. The Yiddish theater again enlivens the stage in Israel, and Yiddish poets write and read in public. Whatever its origins, whatever unhappy memories may cling to it, Yiddish is, nevertheless, a Jewish creation and a Jewish language, with a proud history and an imposing literary heritage.

Someone tells the story of seeing the great Bialik, the foremost Hebrew poet, entering a store to buy a package of cigarettes and asking for them in Yiddish. Someone asked him what he, the great master of Hebrew, was doing speaking Yiddish. "Yiddish is faster," he said, leaving the store in a hurry. While Yiddish becomes again welcome in Israel (as a foreign language), its circle of speakers outside Israel shrinks apace. The number of Yiddish publications in the United States, for example, has diminished, and the circulation of those that remain has dropped. The great body of Yiddish-speakers who dominated the Lower East Side in New York, about whom Irving Howe, Milton

Hindus and others have written so movingly, has all but disappeared as families move to uptown New York City, the suburbs, Long Island and Connecticut.

Outside Israel, the circle of Hebrew-speaking, Hebrew-reading Jews widens. The World Zionist Organization as well as the State of Israel has promoted the study of the language throughout the world. Although it needs teachers of Hebrew badly at home, Israel has sent hundreds of teachers to dozens of countries to teach the language of Israel. Thousands of young people from abroad have gone to Israel to study the language, many of them with the intention of teaching Hebrew in their homelands. To facilitate this program the World Zionist Organization supports two teacher-training colleges in Jerusalem.

Throughout the United States the teaching of Hebrew—at least the rudiments—has been stepped up at synagogues and temples. Adult education classes are common. In hundreds of seminaries and colleges through the Western world Hebrew is still taught as a classical language, enough to familiarize Christian ministers and priests with the Scriptures or at least with the words and phrases on which controversy turns or which offer particular insight into the Biblical text. More than two hundred colleges or universities offer courses in modern Hebrew literature, although not all demand a reading knowledge of the language. Without doubt, the scholarly interest in Israeli Hebrew will increase as the body of literature in that language grows and grows.

What cannot be estimated now is the effect that the revitalization of Hebrew will have not merely in the production of literary works, but in the growth and development of the Jewish psyche in Israel and elsewhere. To give so brilliant a people, with that great floor of history beneath them, a new language, with the inevitable evolution of expanding concepts, could expand the compass of human knowledge.

Psychologists recognize that the human personality, to its depths, differs in persons from one culture as opposed to another. It is not simply that they take a different view of things. They are different in their interior structures. Given three, four or five generations of Israelis not merely managing in or mastering Hebrew, but thinking in Hebrew, a Hebrew brought into the twentieth and twenty-first centuries with a new flexibility and a vocabulary that encompasses all the concepts that the knowledge explosion has put into the world—given such generations of scholars, what may we not look for? It is no exaggeration to say that it is an experience in which the whole world has a share, an experiment, which, the world being older, cannot again match the mystery, magic and majesty of the Bible but could nevertheless assemble a body of thought that might enable a violent-prone society of nations to reform itself into a City of Man with some of the serenity of the City of God. What

must also be seized is this: Israel is an outpost of Western civilization in the Orient. The Hebrew language gave more than much to the Western world. Now the Western world is giving back to the Hebrew language. Although Hebrew is a Semitic language and remains so in its structure, it is Westernizing, so to speak, as it alters, as all languages must in the speaking, and this among other things links the people of Israel close to the West almost as much as the establishment of a Western-style democracy has done.

One must not dismiss the notion that one reason the presence of Israel is detested by the Arabs and the Moslem nations is not merely the political wrangle over borders or Palestinian claims, but rather that any Western civilization set in the midst of those nations becomes a rebuke to them and a threat to the feudal state of mind that still persists in them, the loss of which would shake their very foundations and destroy their aristocratic dictatorial establishments. To hear Hebrew coming over the air waves in the Middle East is to hear the voice of revolution. In brief, the Moslem nations cannot stand the competition, and that helps drive them to an aggression that is merely a manifestation of their xenophobia.

LETTERING

The revival of Hebrew as the everyday speech of Israel and its secular use in handwriting, documents, posters and all the proclamations of advertising, has stimulated an explosion of calligraphy and typography in the infant state. As in the other arts in Israel, the renaissance was underway before the state was founded. Like the development of Hebrew itself as the common idiom of the streets of Tel Aviv and elsewhere, the development of lettering, calligraphy and type design continues at breakneck speed. A Jewish scholar told me he cannot read some of the new scripts, and some of the sabras find some calligraphy incomprehensible. Such mild demurrers to one side, the fact is that here again we have an efflorescence, the delineation of a new and dynamic spirit expressing itself in the magical symmetry of letters.

The Levant is the home of the alphabet, and the ancient Hebrew letters are among the oldest in the world. Although they altered gradually over the centuries, their sacredness inhibited scribes from tinkering with them, and while the scripts of ancient scribes or *sofrim* each had its holographic idiosyncrasy, nevertheless no serious attempt was made to alter them into a new design. The first alphabet, the Phoenician, had twenty-two letters, all consonants and no vowels, and so it was with the Hebrew alphabet, which in its present form arose in the Persian empire. The Zohar, the chief work of the Cabbalah, the Jewish mystical system of secret knowledge, recounts that the twenty-two letters of the Hebrew alphabet stood in the crown of God in His Heaven before the creation of the world. Sacred indeed, and not to be tampered with.

The oldest specimen of Hebrew writing on earth consists of letters drawn

79

three thousand years ago with a reed on a clay tablet, now hardened into immortality. Such early lettering differs greatly from the square black letters so immediately recognized today as Hebrew by any literate person. Those letters seemed to settle themselves about the fifth century B.C.E. and for two thousand years remained roughly the same, undergoing a second sort of calcification with the discovery of, first, block printing and, then, movable type.

In his charming little booklet, *The Art of Hebrew Lettering*, the late L. F. Toby of Tel Aviv wrote:

> Modern Hebrew writers at the end of the last century encountered, broadly speaking, the same Hebrew letters as by then had been in existence for two thousand years, except for the products of a handful of hasty reformers and their stylistic misinterpretations. The Roman alphabet, which shares the same North Semitic sources, had reached its final classical form about the end of the first century A.D. and thereafter continually changed its style in common with the pictorial arts, thus increasing in variety. Hebrew characters on the other hand, until very recently, were unaffected by such changes. In searching for the reasons one finds the same causes which prevented the creation of any important specifically "Jewish" art during the time of the Diaspora: the essence of Jewish spirit was directed toward ethical behavior rather than the creation of forms.
>
> This "anti-hellenic" attitude was necessary to enforce strict obedience to the Second Commandment and its wider implication of prohibition, the making of images. Furthermore, the vagrant homelessness of the Jews could never give them the sense of feeling settled and secure, so essential to a steady growth of art.

The letters of the Hebrew alphabet are unique, different from all other alphabets in the world in three respects: their square shape, their discreteness (that is, their separation from the letters beside them; the complete absence of ligatures) and the absence of capital letters. Before the invention of printing, the instruments that a scribe might use, a reed pen or a goose quill, would give a certain touch to the letters, and the material on which the writing was done would also have its influence.

To be sure, since Yiddish is written in Hebrew characters, Yiddish newspapers throughout the world have constructed typefaces suitable for journalism. But one has only to scrutinize back copies of the *Jewish Daily Forward*, published in New York City, to see the paucity of typefaces in the spread of pages. Not more than half a dozen are discernible, and that includes condensed and expanded versions of the same type family. The other variations merely reduce the serifs on the traditional block letters. One result is a monotony that newspapers with roman letters avoid by the use of a variety of typefaces, including italic versions by contrasts between headlines and body type, and between headlines by the use of capital letters. Advertisements become a playground of type, in striking contrast to the sameness that runs through the advertisements in Yiddish newspapers. Then too, roman lettering

gains variety and contrast by the juxtaposition of capital and lower case letters, and the use of capital letters and small capitals, lightface and boldface. It is of major importance that, subtly, readers' eyes demand typography that shares the essence of the flavor of the age.

The history of Hebrew writing can be divided into four periods: the Biblical, the Mishnaic, the Medieval and the Modern. Throughout them all, calligraphy was a sacred thing. In the beginning, Hebrew was not called Hebrew. At the beginning, it was called *lashon ha-kodesh*, the sacred tongue. Throughout its Jewish history, calligraphy was not merely honored but deemed a sacred procedure. For use in religious service, where it is central, the Torah must always be written by hand. When the ancient scribe sat down with reeds, brushes, quills or pens to inscribe the Torah on a scroll, he was obliged to wear his *tallit*, the religious shawl, and his *tefillin* or phylacteries, small black leather boxes, one bound to the left upper arm and the other to the forehead during prayer. They themselves contain sections of the Torah written on parchment by a scribe. Having thus vested himself, the scribe then began a most strictly regulated operation. He was allowed to alter nothing; bound to follow the most detailed instructions, most of which forbade change, setting even the space between letters. The scrupulosity with which this was done over the centuries was demonstrated vividly by the discovery of the Book of Isaiah with the Dead Sea Scrolls. In two thousand years the text had not been altered except in trivialities. To this day Torahs in synagogues or temples must be lettered by hand. The calligrapher still holds an honored place. For study, of course, Torahs can be printed like any other book.

The Mishnah, which with the Gemarrah constitutes the Talmud, was, until the invention of type, written by scribes on parchment or the skin of clean animals, although here the same sacerdotal attitude was not taken by the scribes. These set forth the law, interpretations of which were constantly modulated or expanded or extrapolated to meet the changing circumstances of the centuries. Always, however, the scribe was an artist, concerned with the beauty not merely of the letter he was drawing but of the word, the line, the paragraph and the page. Aesthetic heights were attained, as might be expected, in transcribing the Talmud, where the scribes sought to make their work worthy of the sanctity of the text.

Throughout the centuries of the Diaspora, Hebrew calligraphy was affected by the calligraphic styles of the countries where Hebrew scribes worked. With the invention of printing, the first Hebrew typefaces came out in Spain, and the first Hebrew books printed came out of Italy in 1475. The center of Hebrew printing shifted elsewhere, to Warsaw, to Prague, to Venice, where a Christian printer, the Dutchman Daniel Bomberg, took the lead in Hebrew printing and set the style. As the times changed, however, the Hebrew typefaces grew

clumsy and antiquated — until the twentieth century. In England William Morris, and later Edward Johnston, had revivified interest in lettering, typography, calligraphy and bookbuilding, and the movement spread to the continent, where the first modern Hebrew faces were designed.

Of course, the center has now shifted to Israel, and it is there that the best work has been done and is being done. Sans-serif types were created for display and advertisements, and other typefaces for general text. Not all the typefaces designed were successful. Legibility is the first requisite in type, with beauty required — but not permitted to distract. Persons whose interest lies in type designing or the making of books have found the ferment in Israel engrossing, another mark of the creative vitality of the state and the aesthetic determinations of its people.

The Book and Printing Center of the Israel Export Institute of Tel Aviv issues, for the benefit of prospective customers who wish to have printing done in Israel, an *Israel Presses Typeface Directory*, which lists numerous samples of Hebrew faces, as well as several Arabic, one Persian and numerous English language faces. Not all the new designing of Hebrew letters has been done by Israelis. With the establishment of the State of Israel, some of the great type foundries of the Western world have had Hebrew faces cut, some as successfully as those done in earlier centuries in Spain, Italy, France and Holland. For me, one of the most interesting of modern Hebrew typefaces was cut by Eric Gill, the English sculptor, craftsman and one of the great stonecutters and letterers of modern times. Gill designed a Hebrew alphabet and cut it in stone, giving it a unique style. While the Roman and Greek alphabets were given their classic design by stonecutters, Hebrew was given its classic design by scribes working with reeds or perhaps a stylus cutting into soft clay that was subsequently baked or allowed to harden in the sun. Gill's method affects the ultimate design of letters, giving them a line that the eye is not used to. Consequently Gill's alphabet, while not popularly used in Israel, is one of the many fonts the Israeli publishers offer and may well have a future.

In many ways, the story of the love of lettering and calligraphy inherent in the Jewish tradition from Biblical days centers on the Haggadah, the compilation of prayers, songs, narratives, sermons and commentary read at the Feast of Pesach, or Passover, to celebrate liberation from exile and slavery in Egypt. Excepting the Torah, no Jewish book has been printed as often in as many lands and over as many centuries as the Haggadah.

The book includes the ritual for the celebration of the Seder feast, the traditional central act of the celebration of Passover, which in turn is the greatest Jewish liturgical ceremony reserved for the home rather than the temple. Besides the instructions as to how the dinner should be served, there is a dialogue set forth for the father of the family and his sons, and there are also

hymns, prayers, sermons, history and commentary varying from age to age, sometimes touching on current events. Yet the basic text has remained unchanged over the centuries, and a Jew from New York City transported through time to a Seder dinner in Jerusalem in the ninth century C.E. would be at home with the ritual.

This Haggadah is a book of exuberance, and consequently nowhere else in Jewish artistic life was the Second Commandment so ignored. Haggadot were decorated by scribes with drawings of historical events in the life of the Jewish people, and in the lettering and calligraphy artistic leeway was welcome, and an ecstasy of design and pictorial art entered in.

During the Middle Ages, when the illuminated manuscript came into its own, miniaturists decorated copies of the Haggadah for the well-to-do Jewish families, and the poor decorated their own. Among the most famous is the Darmstadt Haggadah of the fifteenth century, lettered in what was known as Gothic style by Israel ben Meir, a celebrated scribe. The illustrations are beautiful and perhaps not done at the same time as the text. With the arrival of printing and movable type, more illustrations flourished, and the great collections of Haggadot at Harvard University, and the Jewish Seminary in New York City, are examples of exquisite bookbuilding, illustration, typography and calligraphy.

The dearness of the Haggadah to the Jewish family can be seen in those Haggadot that have been preserved from the dread concentration camps of Europe, where they were drawn on scrap paper and somehow mimeographed to pass around to the imprisoned. How meaningful to them the cries of anguish of the slaves in Egypt and the eternal hope for salvation and redemption and freedom that well up in the pages of the Haggadah!

The modern Haggadot produced in Israel shine with the modern techniques of printing and art, the exuberance everywhere emphasized in the illustrations. The story of the Exodus is central, and although much of the material is pedagogic, often the text is hand-drawn and each page a beautiful creation in itself. The Muslims have long referred to the Jews as the people of the Book, and the Book is, of course, the Bible. But they might well be called the people of the book and have the reference turn on the Haggadah, for there is no other people in the world to whom a beautiful book is central to an annual domestic liturgical event.

The coming of Hebrew into the marketplace gave the artist new interest in Hebrew writing. Lacking ligatures, Hebrew calligraphers have never reached the aesthetic heights attained by their Arabic counterparts. Indeed, Arab calligraphy, it may be fairly said, provides the highest artistry ever attained by the Islamic world, surpassing even its architecture, which can be exceedingly beautiful. The ligatures between the letters enable the calligrapher working

in Arabic to achieve a magnificence of design. Any attempt at that in Hebrew would necessarily destroy the quintessential nature of the script. More rigorous than the Jews in eschewing figurative art, the Muslim artist turned all his genius into design, giving the world the *arabesque*. The extravagance of the art of calligraphy in the Islamic world often left the artist to incorporate meaningless letters and phrases for the sake of the design. The rejection of representation still persists in the Islamic world and will probably continue to do so since Islam, unlike Judaism, tends to reject the natural order and insist on a dematerialization of the world.

The discreteness of the Hebrew letters is no disadvantage where typography is concerned, though it can be considered a disadvantage in calligraphy. But it has not deterred Israeli artists from creating page after page of calligraphic beauty, each having an iconographic charm and thrust to it, or designing letters and incorporating them into their paintings.

While we have said that any literate person is familiar with the nature of the black square Hebrew letters that are commonly seen one place or another, few are familiar with the cursive script used traditionally in writing letters and other private correspondence. These letters have been brought into public use in Israel in advertisements, signs, decorations, paintings and the like to give a startling variety not seen elsewhere. They have often been given artistic and sometimes fantastic shapes to catch and hold the eye. But they are subject to two disabilities. They are without ligatures, although some are used sparingly when the lines are compatible. This script also is without capital letters.

A native-born painter who is also a master in calligraphy is David Sharir, born in Israel in 1938 and educated in Tel Aviv, Florence (Accademia di Belle Arte) and Rome. He had his first one-man show in Tel Aviv in 1959, and in the United States at the Pucker Safrai Gallery in Boston, whose proprietor, Bernard Pucker, has no peer in bringing Israeli artists to the attention of the American public. Sharir's fairyland paintings, with their doll-like figures, lapidarian draughtsmanship and gemlike colors, are in museums all over the world. Sharir has used exquisite lettering in many of his paintings, but he is not the only artist to do so.

In inscribing one of his own poems, Sharir has used the Hebrew cursive script and given it a lyrical charm that soothes and delights even the eye that cannot read it. Most non-Jews, I believe, are not aware that Hebrew has this cursive script, and its presence in paintings can impart a touch of mystery. With this script the artists of Israel, particularly the graphic artists, have found a new playground to which over the centuries little attention has been paid. Jews have always been concerned with legibility, being, as they are, perhaps the most literate people in the world. What has guided them throughout

84

the ages in this regard is an admonition from the Book of Habakkuk, "Write the vision, make it plain upon tablets, so he may run who reads it." Or as a modern translation reads, "... to be easily read," although that may not have been quite what the prophet intended.

Another Israeli artist who has mixed calligraphy with figurative drawing and painting is Polish native Malla Carl, born Malla Carl-Blumenkranz, who trained in Switzerland and the United States before settling permanently in Israel. Her work as a graphic artist led her to find a combinative place for calligraphy and painting in her work, which while intensely modern stands in the great tradition of the Middle Ages. Much of her work is done in English as well as Hebrew. She has worked in a mode we have not mentioned: the *ketubah*, or marriage contract. For centuries, such a marriage contract was given to the bride, duly witnessed to protect her interests in the event of a divorce. As time went on they became handsomely illuminated documents, and they are still retained by the Orthodox and in modified form by Jews of the Conservative branch. Even if regarded by the secular Jews as an amusing talisman, they make a handsome decoration on any wall, and Malla Carl has lettered some beautiful ones. Of course, she is not alone in such work.

One branch of calligraphy among the Jews is unique, at least in its persistence and practice: micrography, the art of weaving minuscule and even microscopic script into designs in ketubot and other documents or into end pages or what are called carpet pages of books. As an art it reached its apogee in the fifteenth century, when human and animal figures as well as designs were drawn with lines that were tiny Hebrew letters.

No one knows when drawing such tiny letters began, but Jewish scribes must have been at it very early putting commentary into the side of Biblical or Talmudic texts. Then too the scribes were called upon to prepare texts for enclosure in philacteries or mezuzot. Some scribes also used micrography to elaborate their own colophon in sacred books they had done. The work continues today in Israel among some calligraphers who may draw a portrait of David Ben-Gurion or some other statesman using quotations from them to make the lines. It is most likely to be seen in the United States in some ketubah on a household wall.

One might add that it is no surprise that people of the book, as Jews have been called, are also people of the written word, and that calligraphy will continue to engross any number of Israeli artists.

85

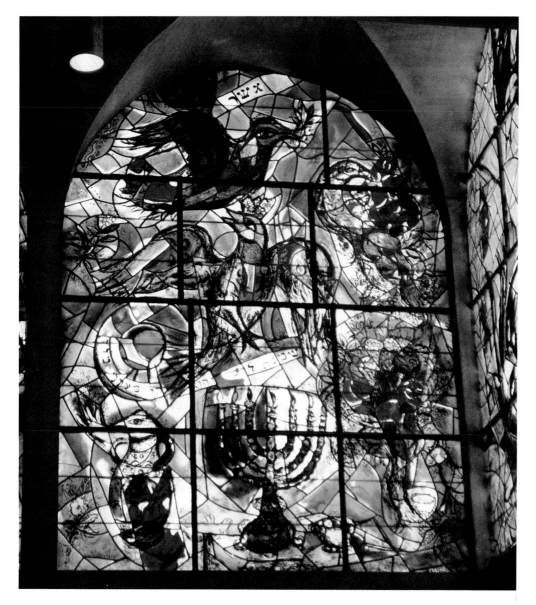

The Tribe of Asher, *by Marc
Chagall, one of his celebrated
stained glass windows in the
synagogue at the Hadassah Hos-
pital outside Jerusalem, which
represent the twelve tribes of
Israel. They are one of the favor-
ite shrines for tourists of all
faiths in Israel.*

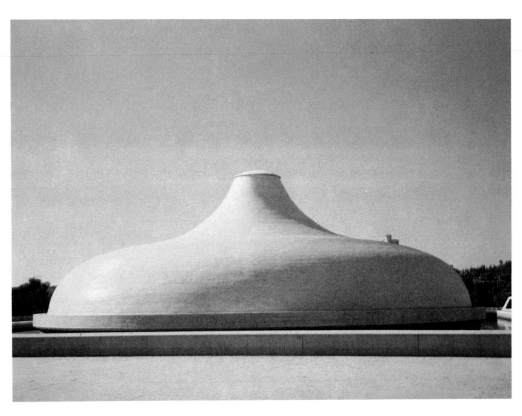

The famous Shrine of the Book, where the most sacred of the Dead Sea Scrolls are beautifully presented for the visiting public. The white dome is designed after the style of the great urns in which many of the ancient scrolls were found in an isolated cave on a mountainside near the Dead Sea.

One of the most famous sculptures in all Israel, this stone lion carved by Aharon Malkinov, dedicated to the defenders of Tel-Hai, stands at the Kibbutz Kfar Geladi and shouts defiance to the sky.

No American president was
more popular in Israel than John
F. Kennedy. This monument, a
memorial to him, was erected
shortly after his assassination.
The decor honors the fifty Amer-
ican states. The building itself
is designed as a tree, symbol of
a life truncated by death.

Candles play a vital role in Jewish ceremony, both in the synagogue and in the home. This Dutch shabbos candle-holder dates from the eighteenth century.

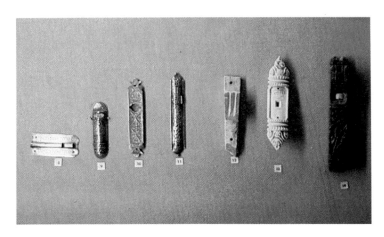

*The door of every Jewish
home should have a mezuzah, a
small, oblong case holding a
parchment scroll with a sacred
text. Their range in style and
craftsmanship is illustrated by
the above collection.*

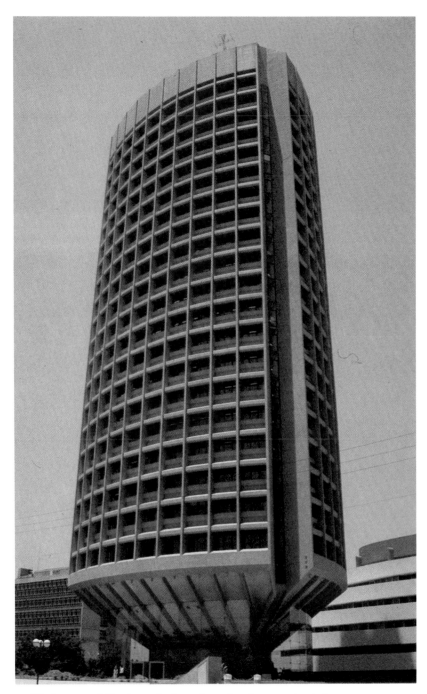

Modern architecture in Israel varies from oriental domes and arches to modern skyscrapers. The IBM building in Tel Aviv, rising like a crushed cylinder, dominates part of the city's skyline.

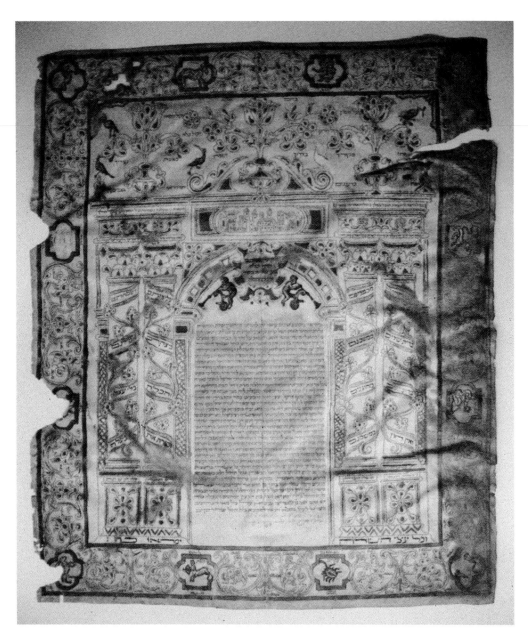

The ketubah, *or ancient mar-
riage contract, designed to pro-
tect the rights of a bride, still
obtains among the orthodox and
is often a masterpiece of calli-
graphic work. This* ketubah, *on
vellum, dates from 1774.*

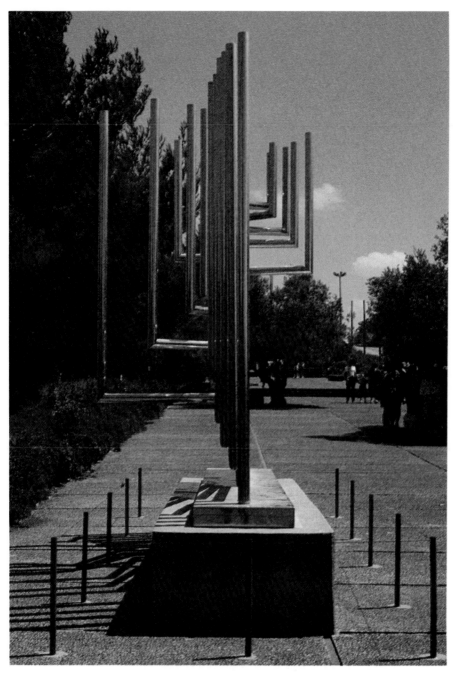

*Modern art techniques have given new forms to ancient arti-
facts of Judaism. Yaacov Agam designed this menorah using
stainless steel, one of his favorite media.*

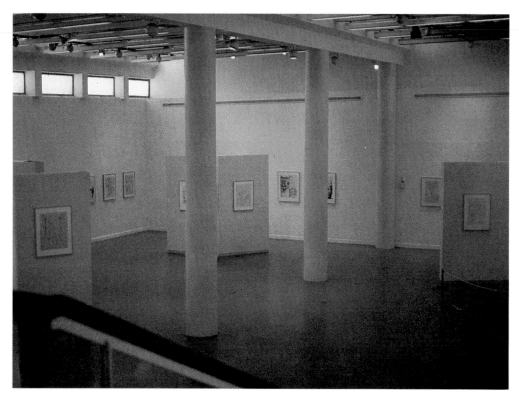

The Helena Rubenstein Pavil-
ion, now part of the Tel Aviv
Museum, has brought modern
art to Israeli art lovers for
decades, the name memorializ-
ing the American benefactor.

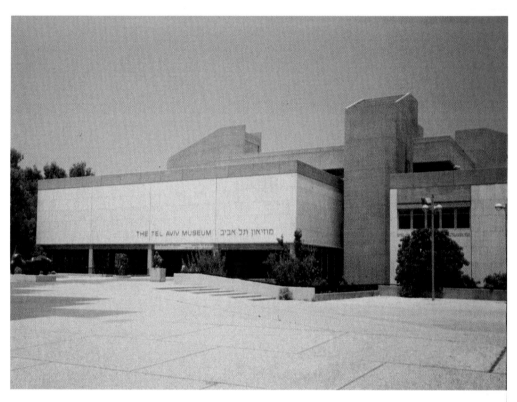

THE TEL AVIV MUSEUM | מוזיאון תל אביב

*The Tel Aviv Museum is one
of the most impressive buildings
in that bustling city and is
located only a short distance
from the Mann Auditorium to
set the central cultural cluster
of the city.*

Sculpture played its part in Israel before the state was founded, and the Billy Rose Sculpture Garden is today one of the outstanding features of the Israel Museum. This red tube by Michael Gross is a good example of his work.

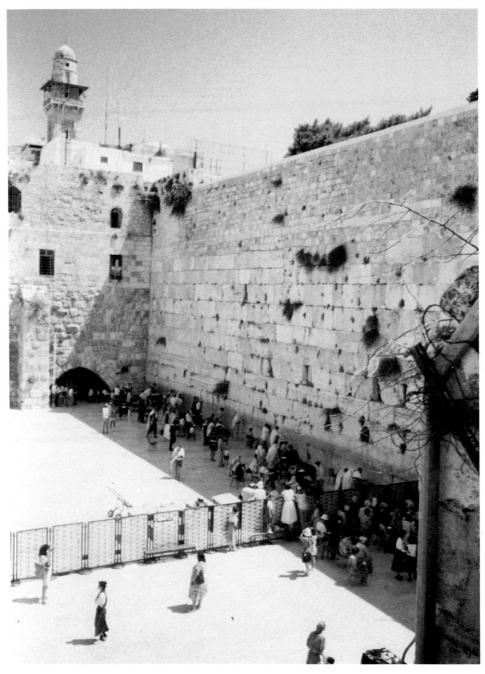

Israel's most sacred shrine is the Western Wall, the lone
remnant of the last great Temple. Here men and women gather
to pray, often placing their supplications on slips of paper,
which are stuck between the stones. The fence at right angles
to the wall separates the men's side from the women's.

*The golden dome of the Bahai Shrine stands over
the city of Haifa, one of its architectural attractions,
along with its multiplicity of museums.*

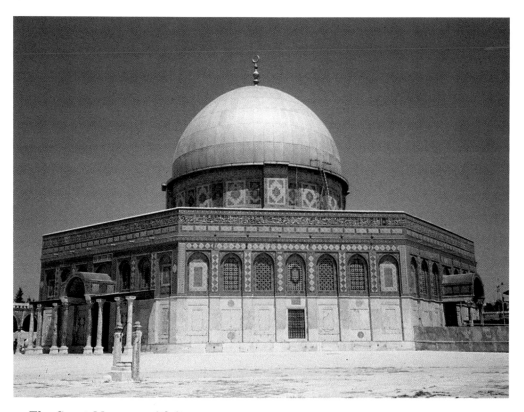

The Great Mosque, with its golden dome, dominates the Holy Mount in Jerusalem, and is deemed to be one of the most splendid specimens of Muslim architecture in the world.

Jerusalem, one of the world's most beautiful cities, sacred to three great religions and torn by political dispute, nevertheless faces the future with hope and confidence. Tourist growth is inevitable; city planning essential.

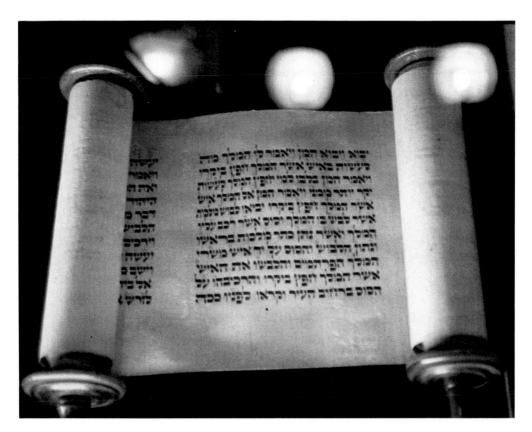

*The people of the Book are
also the people of the written
word. Scrolls remain sacred to
Judaism, and the scribe has an
almost sacerdotal role, creating
with all possible beauty such
scrolls as the above, a Torah
from Morocco.*

Purim is a Jewish feast that remains a fun day for the young when they are entitled to make all the noise they can to drown out the name of the villainous Haman. Often the ratchet noisemakers are made with illustrative imagination. This intricate noisemaker in the form of a gallows was crafted in Poland in the nineteenth century.

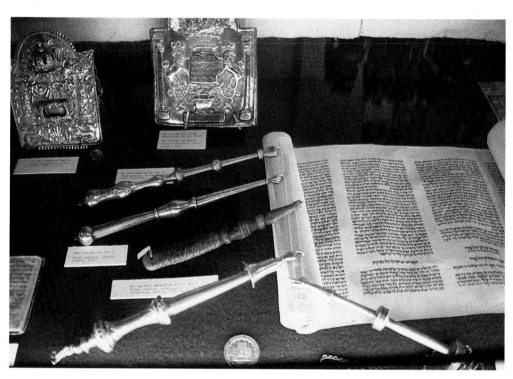

The parchment of the sacred Torah should not be touched with the hands lest it be soiled. Here are several specimens of the Yad l'Torah, Torah hands, used as pointers to keep one's place in the sacred text. Some are intricately and imaginatively made of precious metals or ivory.

*This contented pipe-smoker is a charming example
of the confident artistry of Israeli sculptors, who have
not neglected traditional forms despite their pursuit of
modern innovations.*

The Mann Auditorium in Tel Aviv, designed by Dov Carmi and Zeev Rechter, is one of the finest concert halls in the world today and the home of the Israeli Philharmonic Orchestra, which itself has an international reputation.

Pillar of Heroism, *by Buky Schwartz, rises into the Judean skies outside the Yad Vashem memorial, another tribute to the heroism of European Jews during World War II.*

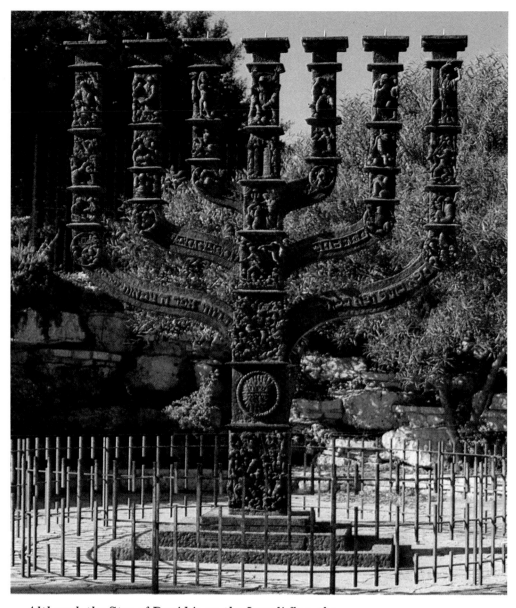

Although the Star of David is on the Israeli flag, the menorah is the official symbol of Israel. This great menorah, elaborately decorated, stands outside the Knesset. The various panels illustrate Jewish history.

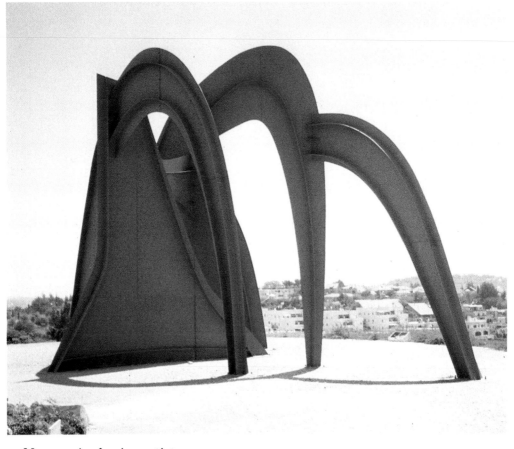

Many major foreign artists
are represented in Israel, not
only in the museums but also
in public places. This imposing
stabile is by the late Alexander
Calder.

Israel has produced many great painters, but to most Israelis the first name to come to mind is that of Reuven Rubin, an immigrant who became ambassador to Romania. He took his inspiration and his colors from the countryside. This work is entitled Flowers on My Window.

There is no more solemn shrine in Israel than Yad Vashem, the memorial to the victims of the Holocaust. It is managed by the Martyrs and Heroes Remembrance Authority, established by the Knesset in 1953 to investigate, collect, study and record the martyrdom and heroism of European Jewry. The striking entrance is the work of artist David Palombo.

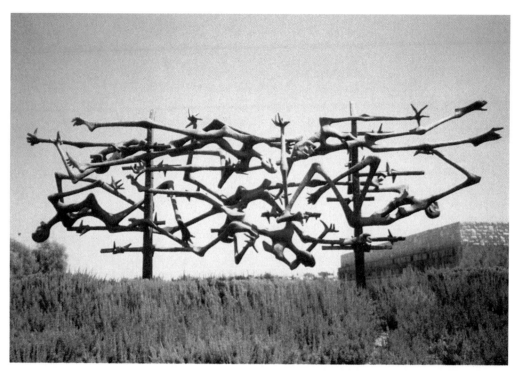

This haunting memorial to the victims of the Holocaust is part of Yad Vashem. A similar sculpture is at Dachau.

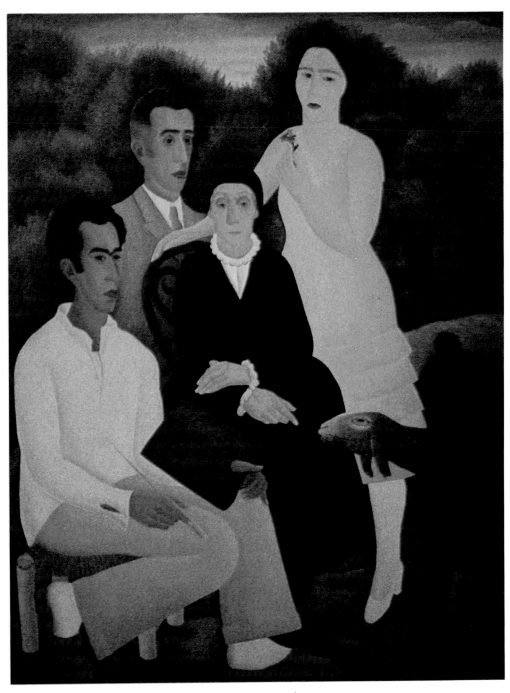

An early oil canvas by Reuven Rubin called The
Family.

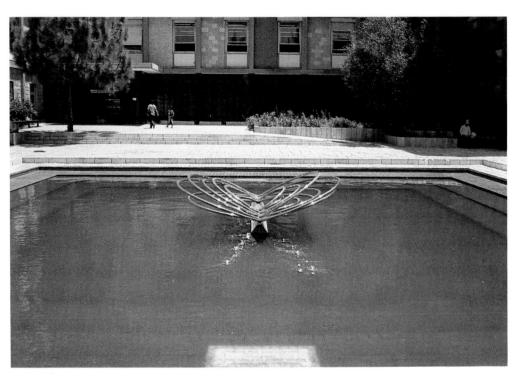

This work in stainless steel, entitled Beating Heart, *is another example of Yaacov Agam's imaginative approach to sculpture.*

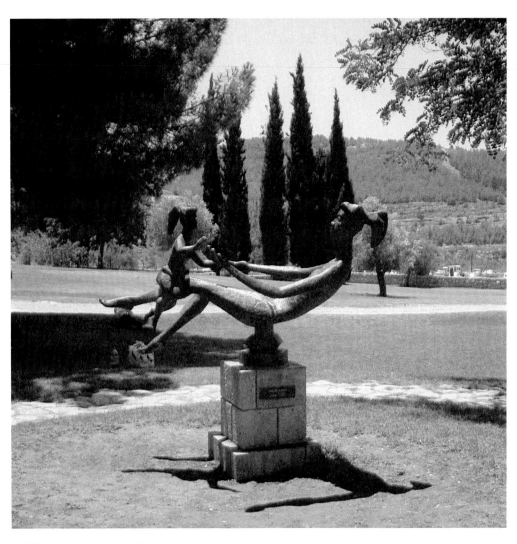

This sculpture on the attractive grounds of the Hadassah Hospital is called Mother Playing, *by Haim Gross.*

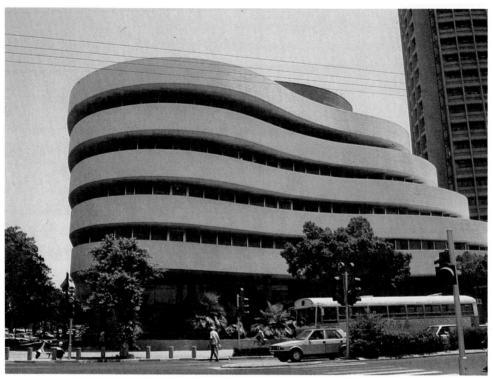

One of the most striking of
Tel Aviv's newest constructions
is Asia House, with its folds of
concrete moving upward in a
slow spiral. The lobby is a mag-
nificent achievement in decora-
tive art.

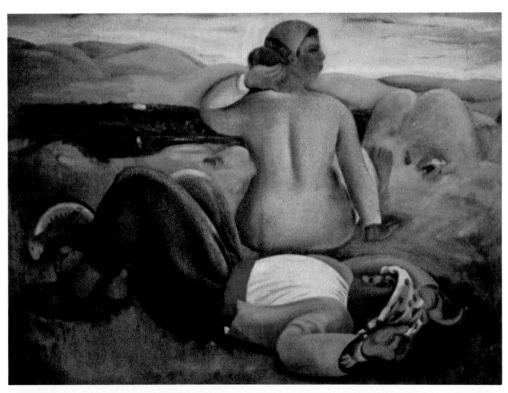

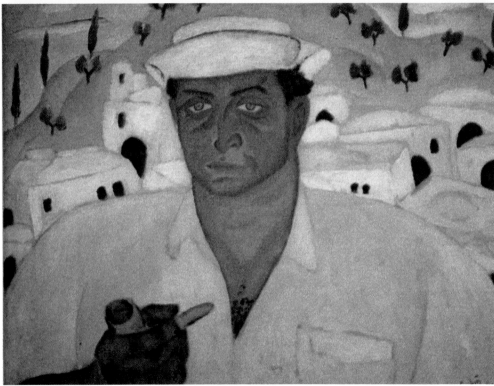

Striking works by two of Israel's earliest major painters, Resting at Noon, *by Nahum Gutman, and Reuven Rubin's* Melinkoff.

HEBREW PROSE

The amount of writing in Hebrew in Israel today—fiction, literature, jour-nalism, polemic, politics, drama, history, biography, poetry—is so vast as to be incomprehensible, in the sense of unencompassable. For convenience, we will divide it into creative prose and poetry.

The history of Hebrew prose begins, of course, with the Torah, the first five books of the Bible compiled over centuries. From the Torah to the nine-teenth century there was no true tradition of Hebrew prose in the popular sense. There was continuous scholarly work, Talmud and Midrash, and philosophical works such as the writings of Maimonides, who also wrote in Arabic. The sacred tongue was reserved for religious ceremony and religious commentary. Some poetry was written, but fiction was not thought of.

In discussing modern Hebrew prose, we look back to the period in Europe following the French Enlightenment, and coming down to the presentation of the Nobel prize for literature to the Israeli novelist Shmuel Yosef Agnon, and to his predecessors and successors. When the French gave citizenship to the Jews after the Revolution, prompting the Jewish Enlightenment called the Haskalah, the movement stimulated a good deal of writing in Hebrew. But, too romantic, too secular and too assimilationist for the majority, the writing provoked a reaction. Out of the conflict came something of a com-promise. The moment had arrived when Jews began to write secular literature in Hebrew. In 1853 Abraham Mapu published his novel *Ahavat Ziyyon* in Vilna, long a center of Jewish intellectuality and cultural life. It was the first novel ever in Hebrew. Before it were only essays and poems. It was an immediate success.

If nothing else, dialectic comes naturally to Jews. No sooner had such secular literature appeared in Hebrew than critics arose to condemn the use of Hebrew for fiction and other secular subjects as sacrilegious or "impractical." But the spirit of nationalism was abroad and intensifying. In Odessa, a Jewish intellectual center, Dr. Leo Pinsker formed a committee promoting agricultural colonies in Palestine, and zealots were insisting that Hebrew should be the language in them. In Odessa at the time were several masters of Hebrew. Among them was Asher Ginzberg, who began to publish essays in Hebrew under the pen name Ahad Ha'am ("one of the people"). His essays apotheosized the idea of Jewish nationhood and all but personalized it, giving it a will and destiny of its own that were not to be questioned. Those essays were seminal, directive and forcefully written. He remains for many the father of modern Hebrew prose. Of course, he was a Zionist, and while he did not look for a massive in-gathering, he looked for a Jewish state that would be a spiritual center for all Jews and would stimulate a national culture. His conviction was that a spiritual and cultural revival had to precede the formation of a state.

His predecessor, Sholem Jacob Abramovich, who wrote under the pen name Mendele Mocher Sephorim in both Hebrew and Yiddish, is deemed by many the first Yiddish writer of importance, the Jewish Cervantes and the grandfather of Hebrew prose. Abramovich, however, ridiculed Zionism as Jewish dreaming.

In the early part of the century, the number of persons writing in Hebrew was growing. Some were in that first aliyah moving to Eretz Israel, enthusiasts who turned their backs on the Haskalah and went to join the Yishuvim. After the early pogroms and later the destructive turbulence in Russia following World War I, the number of Jews moving to Eretz Israel increased, both political Zionists hoping for statehood and cultural Zionists seeking a spiritual awakening. The bulk of them were ideologues bent on working the land and establishing socialist settlements. The writers among them saw Israel as the center of burgeoning Hebrew literature and Hebrew publishing, which indeed it soon became. Among these was Chaim Bialik, the preeminent Hebrew poet whose body of work is deemed the acme of European Hebrew. Though influenced by Ahad Ha'am, they had their differences. *The Jewish Encyclopedia* says of him that in his genius "a delicate balance is attained between the old traditionalistic culture nurtured on the sacred books and on a medieval religiosity and the new European culture to which the products of the old culture now turned." Such a balance was sought by scores of Hebrew writers.

There was an awakening that challenged the strictures of the past. A number of writers settled near Jaffa and would be part of that company that went out from there to found Tel Aviv. The early Hebrew fiction writers in Israel looked in the main to Jewish subjects: the Diaspora they had left behind,

88

the agony of exile, the beauty and dignity of labor on the sacred soil of Eretz Israel, the hope for egalitarianism in the kibbutzim, the socialist dream, and *chalutziut,* which is pioneering idealism. Almost all were touched by the tension between the old religious life and the strengthening secular culture. The majority of the early settlers were seeking a secular Zionist culture. That Jewish life in the Diaspora was futile, if not sinful, was a common conviction.

Many of the writers struggled to reconcile modernity to the traditional religion. Others were bent on leaving the God of Israel behind. The majority of the writers in the first aliyahs were more or less exalted by arriving in the Holy Land, full of *chalutziut* and the vision of life on The Land. Many among them, committed to the socialism of the kibbutzim, wrote socialist-realist fiction that so often is terribly unreal, seeking more to exhort than to entertain and enlarge. For Ahad Ha'am and another idealist, A. D. Gordon, physical labor was essential to the redemption of Israel; to deserve the land the Jews must work the land. Such thinking helped produce the most dynamic and powerful writer of the Second Aliyah period (just before World War I), Russian emigre Yosef Chaim Brenner. Brenner produced a body of work — critical essays, short stories and novels — marked by pessimism and the shadow of despair. In his idealism he showed only contempt for the Jews who remained in the Diaspora and drew caustic and cruel pictures of those with whom he had worked in the London ghetto after leaving his native Russia. He went on to draw brutally frank, pejorative portraits of the Jews in the Holy Land. Strength, as he saw it, came only out of despair.

That it took half a century before his fiction was translated into English highlights the tragic gap between the literature of Israel and the literate Western world. Brenner worked as a laborer and lectured to laborers even as he wrote, convinced of the necessity of physical labor. His last book, and one of his best, was significantly entitled *Bereavement and Failure.* Cornell University Press published it in this country in 1971, fifty years after his death. An essay of his written in 1910 that sought to separate the Jewish religion from Jewish life, a plea in brief for a secular Jewishness, provoked an international storm that modulated into a battle over free speech.

Like many an early immigrant to Israel, his life reads like a romance. Born to a pious, poor family, Brenner lost his faith in Judaism, joined a revolutionary party, edited an underground Yiddish paper, but became as disillusioned with Marxism as he had with Judaism. He was drafted into the Russian army, deserted, was arrested, imprisoned and then delivered by some old revolutionaries who enabled him to escape to Germany and then to London, where he arrived in 1904. He went to Israel in the Second Aliyah, already a distinguished literary figure. He was killed by a terrorist during the Arab riots of 1921.

One of the writers Brenner befriended in Israel was S. Y. Agnon, the first Israeli to win the Nobel prize for literature. He was born in Buczacz, Galicia, like Brenner into a pious Jewish family. Unlike Brenner, he remained a man of faith, and his novels deal for the most part with persons who are. In an age when zealots were deprecating the Diaspora and pitying those who remained there, Agnon portrayed them with affection and profound insight, but always with a detached irony. His best-known novel, *The Bridal Canopy*, written in 1931, portrays the wandering of a Hassidic rebbe in Galicia seeking husbands for his impoverished daughters. The age portrayed is an age that is gone and that no sabra wants back. The novel many consider his masterpiece is *T'mol Shilshom*, which deals with the conflict between secular Zionism and the old religious life.

A contemporary of Agnon, considered his peer by many critics and his superior by some, was Chaim Hazzaz, a native of the Ukraine who fled to Constantinople and Paris and arrived in Israel in 1932 with something of a reputation as a writer because of his short stories, which had appeared in Hebrew periodicals, and a novel published in 1930. He was concerned with the disintegration of Jewish society under the impact of modernity. For his subject he chose Yemenite families in transition. His works became very popular in Israel, but both he and Agnon suffered from lack of attention because of the difficulties that lie in translating Hebrew into other languages. Winning the Nobel prize helped bring much of Agnon into English and aroused interest in some others. Both Agnon and Hazzaz eschewed the derogatory depictions of Brenner.

Just as Israeli politics is marked by tension — between the secular Jew and the believing Jew, between the believing Jew and the intensely believing Orthodox Jew, between the Askenazi and the Sephardi, and between Israelis and the Jews in the Diaspora — so is the fiction marked by such tensions, confrontations and contradictions. As might be expected, a number of novels have dealt with the theme of Jewish boy and Arab girl, love affairs ending in tragedy, but much remains to be done by Hebrew writers exploring the Arab world, although many have written about mistreatment of the Arabs. Arab literature written in Israel is just finding itself as more and more Arabs graduate from the universities, some of them writing in Hebrew as well as Arabic.

The Holocaust became the subject of various novels, short stories and poems by wartime refugees, among them Aharon Appelfeld, who in 1983 was awarded the Israel Prize for his work. "In his special tackling of the portrait of the Jew after the Holocaust and before it," his citation read, "Appelfeld has succeeded in defining man's condition in a restrained, subtle and stylized fashion. He had plumbed the depths of the existential condition of the man haunted

by his memories and attempting to adjust to a new life." His novel *The Immortal Bartfuss*, translated by Jeffrey M. Green, was published in the United States in 1988. Critic Robert Taylor in the *Boston Globe* said of him, "He is a maestro of ambiguity and omission. His spare style always implies more than is stated, so the reader must collaborate to a marked degree." He is one of many grappling with the angel of meaning that must lie behind the Holocaust, a meaning that only the future will reveal. Until such time, novelists will continue to deal with various aspects of that horror, compelled by the Jewish commandment "Remember."

The War of Independence in 1948 brought a wave of war novels, some exalting heroism but more deploring war. The Six Day War and that of 1973 brought novels not merely denouncing war and all its random cruelty, disaster and death, but puzzling over the political approach to Israel's problems. The early war writers, known as the Palmach generation after the fighting units of the Haganah, were sabras, Israelis born and bred, reared speaking Hebrew with no interest in the Diaspora but only in economic survival in a pinched age. They were stung by the contrast between Zionist ideals and the day-to-day compromises survival demanded. In the bulky novel *Y'mei Ziklag* (Days of Ziklag), Yizhar Smilansky describes a Palmach unit stuck in the Negev in the War of Independence, the soldiers sick of it all like soldiers in battle anywhere, doing their duty, shirking at times, longing for furlough and tired of the rhetoric. Through the stream-of-consciousness Smilansky vividly contrasts the dreams and the realities.

There is a digression here that is deserved. In 1952, 1958 and 1961, the Ministry of Defense of the government of Israel published three volumes of writings by men and women who had died in defense of their country. The work was entitled, *G'vile Esh* (Parchments of Fire). No more moving literature has come out of Israel. The truncated contents span all emotions and all affections: hatred of war, the glory of heroism, the tenderest expressions of love, meditations on Gandhi, lyric poetry, love of the very soil of Israel. How many of these were Agnons or Bialiks? The toll of war seems to have been as severe among the talented as World War I.

The young men who were dying had no memory of the horror of the Holocaust, and no doubt the disaffection among the young at the privations and military demands in Israel was alarming. At one time, emigration from Israel was larger then immigration to Israel. The Eichmann trial, which rehearsed the Holocaust, helped to reeducate the young. The Six Day War and the reunification of Jerusalem brought a surge of patriotism. Through all this, literature in Israel was moving from idealism to individualism. Israel was growing and its literature maturing. Also, the audience was increasing as the population went over three million.

The tragic events in Lebanon, where the Israeli army endeavored to eliminate the continued terrorist attacks of the Palestine Liberation Organization, brought a new wave of disillusion among the intellectuals, and not them alone. Returning soldiers wrote bitterly about their experiences. The massacre of Palestinians in Lebanon by other Arab militants bit hard the Jewish conscience. To a greater degree the harsh measures needed to stem the 1988 riots in the West Bank and the Gaza Strip have gnawed at the consciences of many writers. Many Israelis were unhappy about the manner in which religious settlers were moving into the West Bank to the distress of the Arabs, a movement that seemed to be pushing peace further away. The literature of self-doubt returned in force. Where novelists had written in grief about the decline of the early Zionist ideals, they now mourned what they saw as a diminution of the great claim Israel had on the world: its claim to be a moral force.

The secular fear of the intensity of the religious determinations in the country, which seem allied to the militarist minds, brought a cry of anguish from Amos Oz, one of the nation's leading contemporary novelists and certainly the one best known in the West: "Concede heavenly Jerusalem for the sake of the Jerusalem of the slums," the Jewish Telegraphic Agency quoted him as saying, "waive messianic salvation for the sake of small, gradual reforms, forgo messianic fervor for the sake of prosaic sobriety." He asked, "Perhaps the entirety of our story is not a story of blood and fire or of salvation but, rather, a story of halting attempts to recover from a severe illness." His is but one voice of the many protesting. If dialectic comes natural to the Jew so does moral fervor, whatever the cause.

To an extent, all writers want to address the world. Because of the Biblical tradition, the Israeli author is stirred to be a prophet, but he finds himself in a bind. The prophet in the Jewish mystique has a major role. Jeremiah and Isaiah denounced the sins of the people, and many a Jewish novelist thinks of himself in such a role, sometimes overtly. The bind is a double bind. The audience in Israel is small, and although Israelis buy books and presumably read books in greater percentage than any other people, they do not constitute a large enough market for many writers to hope to live by the pen. Inasmuch as a significant percentage of the population is still mastering Hebrew, which was the first language for, let us say, only half the population, attempts at what might be called the loftier flights of literature seem quixotic. Agnon with his symbolism, Arabisms and tight texture is tough reading. The audience outside Israel sufficiently schooled in Hebrew to appreciate Hebrew style is small indeed. The Israeli author will reach a major audience only through translation, and modern Hebrew does not translate that easily. Some authors have thought of writing in English, which is spoken widely by polyglot Israelis. Only a handful of Israel's novelists find ready translation outside their country:

Agnon, Oz, A. B. Yehoshua and Moshe Shamir among them. Professor Robert Alter of the University of California, the foremost critic of Hebrew literature in this country, who has himself done some translations, believes that the best of Israeli fiction lies in the many novellas that have been published, particularly where they deal with moral dilemmas and personal psychological problems.

The contrast with Ireland is interesting. Ireland attempted to revive the Irish language, but the effort foundered for economic reasons. The majority of the Irish spoke English, and the majority of its literateurs wrote and write in English and so have access to the worldwide English-speaking markets. Sometimes the themes are too Irish, too parochial for that large market, but those Irishmen who have won the Nobel prize for literature are read around the world, as are many of their less-favored colleagues. Israel's laureate is too little read, and the majority of Israel's writers, who deserve a universal audience, are not read at all. Generations will be needed—and an audience of persons in the United States literate in Hebrew—before they get their due. If Edmund Wilson learned Russian to enjoy the Russian classics and comment on them, some American critics of tomorrow may bring a proper evaluation to the literature of Israel. Fortunately more and more of Israeli literature is being translated into English. But there is an old Italian saying, the translator is a traitor.

Israeli authors writing in Yiddish find their market outside Israel shrinking. At one time there were a dozen and more theaters in the Lower East Side of New York City with Yiddish-speaking companies and half a dozen Yiddish newspapers. Today there is one of each. Israel has become the great Yiddish center in the world, but the Yiddish writers complain that they are faced with a paucity of translators. They have the feeling they are writing for each other. Tragically, the great Yiddish centers in Europe were destroyed by the Nazi government, and the Yiddish speakers in the United States and elsewhere are diminishing in number. There is a great literature in Yiddish from Abramovich in Russia to I. B. Singer in New York, and it is doubtful if it will ever die. Yet, it does not have a state of its own like Hebrew.

While there have been Israeli musicians, Israeli architects and others who have left Israel to make their careers elsewhere, no major writer has left the country to find his audience. They may denounce their compatriots as Jeremiah the prophet denounced them, and they may rail at them as Brenner railed, presenting them in a sorry light, but they stay to grapple with the nation's problems. No novelist has been more in the tradition of Brenner than A. B. Yehoshua, one of the few who finds English translation. In his latest novel, *Molcho*, published in 1987, there is a change from the high critical tone:

> When I saw the depths of crazy self-hatred to which some of my leftist
> friends had sunk, I started thinking. I decided that I would judge Israelis
> by the same standards as I judge the rest of the world, not by absolute

standards, but the same as those by which I measure the English or French or Americans. Now it's clear that I'm not as good as the Norwegians but I'm better than other peoples in a thousand ways...When Englishmen or Frenchmen hate themselves — and some do — it doesn't put their country at risk.

The war of 1967 shocked him and the invasion of Lebanon sickened him, he said:

> Thanks to the defeat we took there, we learned some sense...I think that this country did learn a lesson from Lebanon, just as America learned a lesson from Vietnam. We learned it faster...I then decided to put aside ideology and to support the national unity government. I became more optimistic.

Others who share his optimism found their own shaken by the stern response to the 1988 riots. The problems of Hebrew literature in Israel relate closely to the contrasts of the sacred and the secular that arise in the use of the Hebrew language. Another difficulty arises in this: outside the state there is no body of critics sufficiently literate in the Hebrew language to evaluate the flood of writing in Hebrew coming out of Israel. A century is going to pass before there is. Meanwhile critics in the English-speaking world will have to deal with that literature in translation. For a survey of the arts as this, it is enough to know that that Israel is in ferment with writing. Prose and poetry and drama flow from the pens and typewriters and now word processors of Israeli writers.

Arab writing in Israel is coming into its own, as the number of Arab university graduates come of age. A recent estimate put the number of Arab writers at three hundred, about half the membership of the Hebrew Writers Union, which stands close to six hundred. For many years poetry in Arabic made the bulk of writing in Arabic, but nonfiction and fiction are mounting.

The best way for outsiders to keep abreast of the writing being done in Israel is the use of the publications of the Institute for the Translation of Hebrew Literature at 66 Shlomo Hemelech Street, Tel Aviv. The future in the United States must look to more and more courses in Hebrew.

POETRY

Poetry is as old as man, and nowhere older than in the Hebrew Psalms, still the most widely read poems in the world. Not only are they read by Jews everywhere, but they are chanted in Christian churches regularly, and every Catholic priest is bound to read them daily. David was one of the few kings in history who was also a poet, and Israel has been one of the few countries in the world with a president who was also a poet. He was Zalman Shazar, the state's third president, who served ten years in that office. Shazar, who spoke both Russian and Hebrew, wrote his poetry in Yiddish. It was translated into English for publication in the United States, and he knew enough English to check and approve the translation.

Robert Frost said that poetry is what is lost in translation, and Chaim Bialik said that reading poetry in translation is like kissing the bride through her veil. On the other hand the great Jewish philosopher Maimonides said that translation is in itself creative. Israel abounds in poets, but the English-speaking world lacks sufficient translators, enough outlets for their work or enough encouragement. As in the case of Hebrew prose, the Western world is the loser.

In less than half a century, since Bialik left Odessa to live in Israel, a massive body of work in Hebrew has been produced. He stands with Saul Tschernikhovsky at the beginning of modern Hebrew poetry. Tschernikhovsky, a native of the Crimea, is preferred by many to Bialik because of his love poems.

Despite their Askenazi accent, no longer used by Israelis, both are recognized as Olympians at the very threshold of modern Hebrew poetry. As with many more of the poets writing in Hebrew in Israel, Hebrew was not their first

language. Both were reared in Russia and spoke both Yiddish an Russian. Other early Israeli poets suffered the same disability, if it can be called that, of not having Hebrew as a first language, but it is doubtful if any critic studying the works of Israeli poets could distinguish between those who grew up Hebrew-speaking and those who acquired it. Sabras, reared in Hebrew, use a modern idiom, slang and words that did not exist when Bialik and Tschernikhovsky were writing. Such an idiom, of course, is also available to recent immigrants to Israel, as well as those reared speaking Hebrew. Hebrew, from day to day, is a rapidly developing language.

Born in the Ukraine, Bialik was reared by a stern grandfather after the death of his own father. The grandfather saw to it that Chaim received a good education in Jewish principles and practice. For his formal education he went to a famous Talmudic school in Lithuania, and from there he went to Odessa, already a center of Hebrew writing. The essayist and critic Ahad Ha'am recognized his talent and saw to the periodical publication of his poetry. He returned to the Ukraine and married the daughter of a wealthy merchant but returned to Odessa to teach in the Hebrew school there.

He went into the publishing business and spent three years at it in Berlin, but then moved in 1924 to Tel Aviv, where he became a famous and lionized figure. Before his death he was recognized as the national poet, became chairman of the Hebrew Language Council and translated Shakespeare and other classics into Hebrew. The life of the Jewish nation was generally his theme, and he sang of its joys and sorrows, its triumphs and disasters, and its endurance, its memory, its very being.

Tschernikhovsky, born two years after Bialik, outlived him by nine years. Their physical appearance was a contrast—Bialik cleanshaven, Tschernikhovsky mustachioed; Bialiak bald, the other with a crop of curls. Their upbringings also contrasted—Bialik's early life was hard; Tschernikhovsky's pleasant; Bialik's education was traditional Hebraic; Tschernikhovsky went off to Germany to study medicine and returned to serve as a medical officer in the Russian army. He would go on to practice medicine in Israel at a time when doctors were badly needed. Bialik preceded him to Israel. There, however, both were celebrated, although the Orthodox did not like the proclaimed Hellenism and hedonism of Tschernikhovsky or Bialik's secular cast. Whatever the Orthodox might say against Tschernikhovsky, the young people took his love lyrics into their hearts.

His army service gave him a military bent, and he deprecated the lack of militancy shown by the Jewish people in the face of persecution. In a long poem on medieval persecutions he sounded a call for "revenge." He would have approved Israeli retaliation against the terrorists who strike at the country.

Although Bialik, like Tschernikhovsky, anguished over the persecution the Jews have suffered throughout the centuries, he did not urge revenge. He did call upon all Jews to resist attacks, reject passive martyrdom and not accept it as an expiation of sin. In brief, both of them spoke for and to the Jewish nation, the heretical Tschernikhovsky, the more traditional Bialik. Both played salient roles, not merely in the advancement of Hebrew poetry, into which Tschernikhovsky in particular introduced new metrics and new forms, but in winning adherents to the Zionist pioneering adventure in Israel.

The name Rachel is dear to all Jews. The beautiful daughter of Laban, beloved of Jacob, she became the mother of Joseph and his brethren, to stand as one of the major figures in the Torah. To tens of thousands of Israelis, the name Rachel is twice dear because of the poetry of Rachel Blaustein, the poetic link between the giants Bialik and Tschernikhovsky and the present poetic world in Israel. She was the first major figure to write in the Sephardic accent, the popular speech of Israel, and she sang of the simplicities, the heroisms, the sufferings, the dreariness and the glories of the early settlers, the kibbutzniks whose dream was to till the soil and build a peaceful Zionist state.

To anyone who has a vivid memory of David Ben-Gurion with his open shirt and a pitchfork in his hands, the poetry of Rachel strikes a chord. Although her poetry is deemed by sophisticated critics to lie somewhere between Edgar Guest and Robert Frost, she is much nearer the grandeur of Frost than the banalities of Guest. She too was a product of Russia, and Hebrew was not her first language. Because of its simplicity, her poetry is caught much better in translation than that of Tschernikhovsky.

One of the major poets to follow her but take his philosophy from Tschernikhovsky was Uri Zvi Greenberg, whose work denounces his people for their passivity and complacency, asks for revenge and retaliation for persecution, holds to messianism and cries, "Amen, I sing the day / on which the miraculous line of the race which Titus rent in two / will be joined." Greenberg has few disciples, but he has contributed some of the most powerful poetry to come out of Israel. He saw the 1967 reunification of Jerusalem as a happy symbol of the joining he sang in the poem. In Poland in the 1930s he begged his compatriots there to emigrate to Israel. If they had, he said later, those that did would have escaped the Holocaust. While his bellicosity won him few zealous followers, Israeli poetry remains in great part very national in its concerns. Just as in archaeology, where the Israelis dig to find themselves, so in poetry the poets struggle with the problem of the fullness of being an Israeli; of being in a small, isolated country, linguistically as politically, walled in by enemies; of being heirs to a prodigious literary tradition that has sanctified too many words, that has built into the language too many phrases with resonances and connotations arising out of the Torah, the Prophets or the Writings. Some manipulate the language to avoid as many of the old words as possible; to escape those sacral overtones.

When poets wrote in the early generations there were politically and emotionally no uncertainties. The Zionist dream held them all, and Rachel could sing with the unconcern of a nightingale. Today, the kibbutznik finds himself too often estranged from the soil, involved in industry, subject to military draft, lost to the idyllic aspirations of the early farmers. Concerned about his nation, he finds it marked by consumerism and standing as one of the major military powers locked in unremitting international tensions. One critic has called the tension the Israeli poets suffer the tension between home and horizon, their effort to reach the world frustrated by the barriers of language in a country that exhausts itself staying alive, denied the legitimacy promised by the United Nations.

After 1948 poets of that Palmach generation wrote with confidence. The victory brought with it a sense of euphoria that could indulge in antiwar effusions. After the war of 1967, the famous Six Day War, the euphoria that had been waning returned with the reunification of Jerusalem though doubts were setting in. In 1978 the battlefield costs were patently so high it hurt, and then the invasion of Lebanon and the massacre of Palestinians by other Arabs shocked the intellectual community. The poets turned to an examination of conscience, to a reassessment of Israel's place and purpose, or alternatively they drifted into the individualism that has created so much hermetic poetry in the West. Some went, in brief, into their very private worlds.

Before the 1988 riots in the West Bank and the Gaza Strip, which were echoed even in Jerusalem, Israeli poets protested in anguish against the militarism thrust upon the country by the struggle for survival. The force necessary to control the riots in the occupied territories disturbed many. Poets cried out for the sufferings of the Arabs. After Lebanon, Efraim Sidon wrote in tragic irony, "I accuse the children of Sidon and Tyre/whose numbers are still uncounted/ three year olds, seven year olds and others of all ages,/ of the crime of residing in the vicinity of terrorists/. . .Now you will be punished." His voice was not alone; others are speaking out.

All today are troubled by the problem of words, words, words. The adoption and imposition of Hebrew as one of the official languages of Israel made Jewish writers intensely conscious of language and the word. The Hebrew language is struggling with the sacral overtones arising out of the scriptures bumping into the developing language on the streets of Tel Aviv, with the resonances given old phrases by modern irreverence, with the slang that comes and goes, and with the problems supervening on the Academy in determining the official recognition of new words. The importation and adaptation of words from other languages, the clash with Yiddish and Ladino, the hundreds of accents as immigrants learn the sacred tongue—in brief, the unique circumstances of Hebrew's "revival" and subsequent development give the poet difficulties as

well as opportunities. Whereas before the State of Israel was founded students in Haifa demonstrated to have all their studies in Hebrew, today some scientists are asking that their subjects be put into English because of the rapidity with which new words come into science and have to be recreated for Hebrew.

As in discussing Hebrew prose in too brief space, to mention one name in poetry is to neglect a hundred. In a recent article in the *Massachusetts Review*, Ruth Whitman, herself a distinguished American poet who has translated from Yiddish and Hebrew, chose nine Israeli poets for her essay. The nine were Yehuda Amichai, perhaps the most popular Israeli poet in Israel and the United States; T. Carmi, an immigrant to Israel from the Bronx and an ornament to Israeli literary life; Dan Pagis, late professor of Medieval Hebrew literature at Hebrew University; Abba Kovner, a hero of Lithuanian guerrilla resistance to the Nazi Wehrmacht; Amir Gilboa, who lost his family in the Holocaust; Dalia Ravikovitch, a sabra and kibbutznik; Leah Goldberg, an immigrant and major literary figure in Israel who died in 1971; and two Israelis who write their poetry in English, Robert Friend and Dennis Silk. They are not the only poets writing in English in Israel. Since English is a second language for many Israelis, poets writing in English in Israel can find an audience, attentive if small. Most of these poets writing in Hebrew mentioned above are available in English. Silk, and Friend have done translations of their fellow Israelis. Translators and critics of translations agree on the difficulties involved in bringing Hebrew over into English, trying to catch the rhythms, the rhymes, the assonances, the nuances, the resonances. Miss Whitman won acclaim here and in Israel with her translations of Tel Aviv poet and critic Miriam Oren and numerous other poets. It is a labor of love. Compounding the difficulty of getting Israel's poets into English and published in the United States is the ongoing reluctance of major American publishers to bother with any poetry on the grounds that it doesn't sell.

One of the best approaches to bringing Hebrew poetry to the American public was made by the Israeli poet T. Carmi in collaboration with New York's Stanley Burnshaw, poet, critic and translator, and Ezra Spicehandler, then professor of Hebrew literature at Hebrew College in Cincinnati, in a book called *The Modern Hebrew Poem Itself*, published by Holt, Rinehart and Winston. It is the sort of thing that publishers should do often to bring the poetry in foreign languages to the monolingual American people.

The editors took selections from two dozen Hebrew poets and printed the Hebrew alongside a phonetic rendition of the lines. An absolutely literal translation of the poem is then given, followed by an explication of the nuances of tone and overtones of words, and other fine points of the rhyme schemes and various vocal subtleties. With diligence a reader can come closer to seizing the beauty of each poem than through any approach I can think of short of

a university course in Hebrew. Unfortunately, such a presentation is expensive for a publisher; sales were not that great, and the project was ahead of its time. The latest Hebrew poetry deserves such treatment and a new updated edition of the work.

For the reader with no Hebrew other translations of Israeli poets are given in *Ariel*, the handsome quarterly published in Israel and one of the liveliest magazines concerned with the arts that one could ask, and in a quarterly called *Modern Hebrew Literature* published by the Institute for the Translation of Hebrew Literature at 66 Shlomo Hamelech Street, Tel Aviv. An English publishing effort called *Modern Poetry in Translation* devoted one issue to Hebrew poets and more recently the magazine *Poet Lore* devoted an entire issue to translations of more than a score of Israeli poets. Perhaps the growing number of persons studying Hebrew outside Israel will give them the audience they deserve. A poet deserves to be read in the language in which he writes.

THEATER

When Elliot Norton, long America's dean of drama critics, visited Israel some years back to survey the theaters there, Emil Feuerstein, his counterpart in Israel, told him, almost with a note of alarm in his voice, "We are a theater-mad people." Yischayu Weinberg, then director-general of the Cameri Theater in Tel Aviv, put it less emotionally: "We have in Israel the largest popular audience in the world. They are simply there!" He was speaking not in numbers, but percentages. In size Israel might be compared to Massachusetts, something over 4,500,000 people. In their enthusiasm for the theater, the Israelis, so far as percentages go, do better than the citizens of either Boston or New York. The two men were speaking of Hebrew theater, by far the largest theater in Israel, although some plays are performed in Yiddish and some in English.

The history of the Jewish theater is longstanding, but like Hebrew prose it is not an unbroken tradition. The first Hebrew play of record was produced in the sixteenth century at Mantua in Italy. It was the work of a Jewish poet, Yehuda de Somo, who wrote a book on theatrical techniques. In the seventeenth century, Antonio Enrico de Gamus won the sobriquet "the Jewish Calderon." Many plays were presented around Purim, a holy day that is also a holiday, Jewish carnival time, and plays, sketches and farces became common. In the late nineteenth century came the Yiddish theater, which was founded in Russia within the Pale by Avraham Goldfadden and prospered until he had to flee to America because the Tsarist government forbade writing in Yiddish.

In Eretz Israel, the very first play produced in Hebrew was performed in Jerusalem by the students of the Laemel Trade School. The year was 1890

and the play was *Return to Zion*, by Moshe Lillienblum. Goldfadden's plays were attempted in Jaffa, in Yiddish at first, and then in Hebrew by pioneers who saw the stage as a method of furthering the knowledge of the Hebrew. Then in 1921, David Davidov founded the Teatron Ivri (Hebrew Theater), a professional theater operating in Tel Aviv, which struggled against lack of talent, lack of finance, lack of everything theatrical until it went out of business, was revived, and lasted until 1927 when it went out of business for good. It had been enthusiastically received, but economic and political conditions at the time were not favorable.

In Moscow, meanwhile, the true bole of the Hebrew theater had grown in a backstreet of the turbulent capital,where the Habimah Theater was founded. In Hebrew, the word means "the stage." A group of zealous young Jews who dreamed of the day when they would have a Hebrew theater in their own state in Eretz Israel resolved to have one in Russia. The enthusiasm of the group caught the attention of Constantin Stanislavsky, the famous actor, director and inventor of "method acting," who was seized by the idea of helping with a play whose language he did not understand. He assigned one of his disciples, Evgeny Vaktangov, who likewise knew no Hebrew, to help. Help he did. On October 8, 1918, the Habimah Theater gave its first performance at a moment when the entire cast was half-starved. Russia was torn by revolution, and food and fuel were scarce. That premiere was entitled "An Evening of Beginnings," and four one-act plays were presented. Although the audience, for the most part, was confined to an intellectual elite not all of whom perhaps could grasp the Hebrew, the success of the company seemed assured. The troupers then began working on *The Dybbuk*, which was to give them an international reputation and bring to the fore the woman who would become the first lady of the Hebrew theater, Hanna Rovina, then in her twenties.

The driving personality behind the Habimah was Nahum Zemach, an indomitable dreamer who envisioned the day when the Habimah would have a home in Eretz Israel. The Russian revolution ended with the Bolsheviks seizing power. Russian xenophobia set in worse than under the czar. Hebrew was deemed a counterrevolutionary language, particularly by Jewish Communists, who branded the use of the language as "nationalistic" and "bourgeois." Zemach was able to turn back their attack at first, but they won out, and in 1926 the Habimah left Russia in a body, never to return. The company decided on a world tour. Between 1926 and 1931, it visited the Baltic states, Poland, France, Austria, Germany and the United States. Tours have continued to this day. As recently as 1987 the company was invited to perform in Hungary.

In 1928 the Habimah landed in Palestine for the first time, and four years later, after a second world tour, settled there for good. Some of the company

had stayed behind in New York City, including Zemach, who had originally been so intense on building a Hebrew theater in Eretz Israel. Hanna Rovina and Zvi Friedland, the director, led the majority of the troupe back to Israel. Today the Habimah theater in Tel Aviv is a landmark, one of the architectural splendors of Tel Aviv. First built in 1945, the building was twice altered to reach its present status. In 1957 the Habimah was proclaimed the National Theater.

Three years before the Habimah first went to Eretz Israel, the Ohel, or the Workers' Theater, was founded with the backing of the Histadrut, the major labor organization, which had been established only five years before. The aim was to bring proletarian and socialist plays to the people. The moving force here was Moshe Halevi, who had been with the Habimah in Russia and believed in "proletarian culture." It was he who approached the Histadrut and it was he who gave the theater its name, Ohel, the tent, which appealed to many of the workers who were indeed living in tents. He spurned professional actors and chose his troupe from among the workers.

Workers' plays were not easily come by, and Halevi hit on the stories of J. L. Peretz, adapted as plays, which were touched with Hasidic mysticism but had sufficient social content. The members of the troupe built their own theater on the sands of the beach at Tel Aviv and went to work. The formal structure of the company was that of a kibbutz, although it was meant to be peripatetic, performing all around the country. Their first performance was a critical and popular success and did tour the country. Ohel's second production dealt with the crew of a fishing boat who were let drown so the capitalist boat-owner could collect the insurance. After that it was hard to find proletarian plays, and Ohel settled into being a repertory company of the usual kind. The company had great success when it went on tour. Halevi wanted a workers' theater but forgot that actors are workers. At first he tried to have them working the soil by day and rehearsing by night, but that had to change.

The tone of the theater was nationalistic and socialistic, with its nationalism rooted in the Bible. The company found that the public soon tired of the proletarian, and Bible plays were as hard to come by as proletarian plays. In time the Ohel tired of Halevi. With the influx of immigrants from Germany, the social content of the productions was reduced, and in 1958 the Histadrut withdrew its sponsorship. Ten years later Ohel was in effect dead.

The Habimah also went through a crisis that nearly destroyed it. During the war of 1948, while other troupes were either fighting or entertaining the troops in the field, the Habimah went touring the United States. The tour was not successful, and its absence was criticized. The new government stepped in and helped, and the Habimah, rejuvenated, went on to permanence. On its fortieth anniversary it won the position of National Theater—actually

a mixed blessing since it served in part to calcify its operations and stimulate the popularity of the Cameri and half a dozen other theatrical movements.

The Cameri was founded in 1944. Its support came from the sabras who found the Hebrew of the Habimah not only stilted but tinged with a Russian accent. The man who founded the Cameri and made it great was Yosef Millo, who gathered some rebels from the Habimah and began to bring to the stage such comedies as *The Man Who Came to Dinner*, translated into the vibrant Hebrew of the streets of Tel Aviv. The overblown acting style of the Habimah was replaced in the Cameri with a simpler realistic style. His actors, in effect, "Israelized" the theater.

Millo had come out of a small theater group in Tel Aviv called Matate, which had no hall of its own and whose indulgence in satire became too sharp. But it was one of many small companies that sprouted and withered in Tel Aviv in small halls and basements and even private homes. Some of the more notable of these were the Zavit, the Green Onion, the Zira, the Zuta and El Hamman. In time, Millo's Cameri became Tel Aviv's municipal theater, with support from the city treasury, and to the minds of many the best play group in Israel.

In 1961 the Haifa Municipal Theater was established, the first theater outside Tel Aviv and the first publicly established theater in Israel. Its first production was *The Taming of the Shrew*. It was in this year, also, that the Habimah Theater produced the first major play by an Israeli author, Nissam Aloni. The play was *The Emperor's Clothes*, one of six plays done that year. The enthusiasm of its supporters has made the Haifa theater financially viable.

Commercial theater came to Israel in the 1950s through the genius of Giora Godik, an amazing entrepreneur and theater manager, whose career ran from triumph to tragedy. He first came to notice bringing foreign stars into Israel to perform, and then by bringing in the entire New York production of *West Side Story*, the first musical Israel had seen. Godik then proposed to produce *My Fair Lady* in Hebrew, not by bringing in a foreign company but by producing it with Israeli actors and Israeli technicians. At first he was the only one who thought it could be done.

The premiere was given February 6, 1964, and the curtain came down on an audience that was almost hysterical in its delight. An old movie house in Jaffa was taken over by Godik and made resplendent. Money or the lack of it could never deter his ambition or his determination to have the best and to make all professional. After *My Fair Lady* his company did *How to Succeed in Business without Really Trying*, which didn't do too well, and then *Fiddler on the Roof*, which did better. All sorts of criticism arose to mark these successes. The public may have been charmed, but the critics had demurrers. They were afraid that the cheapness of Broadway would tarnish the Israeli stage; they feared Americanization; they thought that *Fiddler on the Roof*

104

debased the story of their beloved Sholom Aleicham. Bomba J. Tzur, a veteran actor who had been a hit as the father of Eliza Doolittle in *My Fair Lady*, ceded the role of Tevye in *Fiddler on the Roof* to Shmuel Rodensky, whose Russian accent was made for the part. With the public it was a great success, despite the critics' cavils. Godik answered the protests about Americanization by staging *Casablan*, an Israeli musical from top to bottom by an Israeli author, with Israeli music, an Israeli choreographer and Israeli performers. The critics were still not happy. For them *Casablan* was an Israeli musical all right, but done to a Broadway formula. The public loved it. But Godik was in trouble; he had overspent himself in his striving for perfection, and had to fly the country before his creditors caught up with him. On hearing of the death of Godik at fifty-nine in Germany, just as he was reestablishing his financial position in order to return to Israel, Mendel Kohansky, one of Israeli's leading drama critics, wrote in mourning, "Never before — and, alas, never since — had Israeli audiences seen shows produced to such perfection."

Israeli actors for years had to learn their craft in the acting companies themselves. Effort to start schools to train actors would founder for want of financing. For a few years the theaters recruited from the ranks of the army, from among those soldiers who undertook to amuse their fellows with small productions. In time of war the acting companies themselves went to the front to entertain the troops. Like all able-bodied men and women in Israel up into their fifties, actors are subject to annual military duty. The stage has given its share in the defense of the country. Hanna Meron, one of the stars of the Cameri theater, lost a foot when an Arab terrorist bomb was hurled at the bus in which she was riding in Germany. It did not diminish her enthusiasm for the stage. She had been serving in the army when she met her first husband, and on their discharge they joined the Cameri. The kibbutzim were another source of actors for the professional theater, young men and women who performed for the entertainment of their fellow kibbutzniks.

In a theater with only forty years of indigenous history, it is unlikely that the quality of acting in Israel will match that found in England, France or the United States. Some foreign directors visiting Israel commented on the fact, but the establishment of acting schools and university classes is challenging that weakness.

Some of the best acting came in the 1960s, when the Yiddish theater had a rejuvenation in Israel even as it died out in the United States, where it had once been so successful. The influx of Yiddish-speaking refugees after World War II created a demand for Yiddish performances. Once Hebrew was firmly established as the official language, and once authorities felt it was securely in place, the Yiddish theater blossomed. Old time favorites were revived, and many well-known Yiddish actors all but forgotten came back into public view.

Ida Kaminska, one of the great names in the Yiddish theater, produced the character *Mirele Efros*, a perennial favorite touched with schmaltz, remembered by thousands as a tearjerker. As many as five Yiddish troupes were performing at one time. The audiences were mostly Middle Europeans, middle-aged or older, many of whom did not have enough Hebrew to follow the Hebrew shows. The Yiddish shows, however, with their melodrama and the sentimental warmth that suffuses them, with their wonderful repertoire of music and popular songs, won the hearts of many of the sabras. The upshot of it all is that the Yiddish theater is alive and well in Israel and likely to remain so, if it remains anywhere.

While Tel Aviv has long been the center of Hebrew theater, Jerusalem now has its own massive, modern Jerusalem Theater, which opened in 1975. The home of the Jerusalem Symphony Orchestra and the Israel Chamber Ensemble, it also has a hall for visiting theatrical companies. Jerusalem also has the Khan, where shows are staged in structural quarters contrasting the ancient with the modern. The building was an ammunition storage place for the British, but began as a Turkish caravanserai. In 1938 it was remodeled and opened as a theater, restaurant and nightclub. Its repertory company is noted as "adventurous." It is the only professional repertory group in Jerusalem, and while it has an astonishing subscription list, it needs, as all theaters do, a subsidy. Plays in English are performed on occasion in the Khan but quite regularly in some of the hotels. There is also the Tzavta company, which began in Tel Aviv and maintains a branch there. The Tzavta provides a variety of entertainment, including improvisational theater. The religious orientation of Jerusalem and the large Oriental population made starting a repertory company a chancy thing, but the young people of Jerusalem have been most enthusiastic.

The theater, always referred to in the United States as "the fabulous invalid," is healthy indeed in Israel.

DANCE

Above all other art forms, dance is the most gratuitous and evanescent. Literature may stimulate national pride; it is written and it lasts; it remains on the shelves of the libraries and is accessible to millions. Painting can inspire national pride in almost as many, for on the walls of museums and homes it is readily accessible and remains for critical evaluation. The same with architecture and statuary. Coins stay in circulation, stamps can be collected and arranged in albums to be studied. Plays can be filmed without too much loss, and their texts can be read with profit. Music can be played again and again; symphonies can be recorded; other compositions scored for amateur groups or for solo performers. All day long the radio can discourse. Dance, however, serves, besides the performers, only those persons who make up the audience. Nor does dance do as well on television or in films to convey its true measure as music does through recordings. For the best appreciation of dance one needs the electric human presence. Consequently, it can be said, dance in its purest form, not in the ballroom or the streets, or when it is subservient to musical comedy, can be taken as a touchstone of true dedication to the arts.

That is why dance masters in the United States and Europe have been delighted with Israel's devotion to dance and have given unstintingly of their own time and effort to help Israeli groups reach the high degree of attainment that they have. They have recognized that such devotion to this most basic and ancient of art forms, where above all others the performer becomes the instrument, is a true measure of an appreciation of the importance of the arts to the very soul of a nation. Dancing in its purest form — not social dancing, not liturgical forms, not theatrical distortions of dance, fun and demanding

as they may be—is an art form least appreciated in the United States. American observers perhaps least appreciate Israel's interest in dance, and yet Israel's dance is rooted in the Western tradition. If we can say as an over-simplification that Far Eastern dance depends mostly on the arms and fingers, and Western on the feet and legs, one can see quite readily that here as elsewhere Israel is an enclave of Western civilization. Israeli dance is primarily Western. The Orient has made less impression on its dance than it has on its early music. In brief, Israel's dedication to dance and its achievement on the boards deserves the admiration of the world.

Of all nations, all tribes, all peoples, American people, I believe, dance the least. The Israelis are almost as passionate for dance as they are for music. Israel is perhaps the only country that has struck a coin with dance as the theme. On the eleventh anniversary of the founding of the State of Israel, a five-pound coin was struck with a reverse that showed eleven persons dancing the Hora, each in his native costume. One arc of the circle of dancers was left unjoined, and the dancers at the ends have their hands extended to welcome additional immigrants. The title of the design was "The Ingathering of the Exiles." The Hora is, of course, a dance of joy, and although it has its roots in Romania, it has become the best known of all Israeli folk dances, at least outside the country, and a symbol of the vigorous cultural life of the nation.

Dancing is as old as the nation. The Bible has eleven words for dancing or describing dance, and has innumerable references to dancing, an indication of how deeply dancing is rooted in Jewish culture. The prophetess Miriam led the Israelites in singing and dancing after the crossing of the Red Sea. King David sang and danced for King Saul, then danced before the Lord, and there the Bible uses five different words to tell how he danced. All the Hebrew festivals feature dancing. What is evident throughout the Biblical references is that the Levitical rationality of the Jews tempered the dancing so that it was marked by a classical restraint and did not lend itself to the Dionysiac excitement of the Greeks, the sexuality of the pagan dances of the East or the fertility dances of their neighbors. The same restraint marks Israeli dancing today.

Through the centuries of exile, the Jews danced at various festivals, at mar-riages, at circumcisions and bar mitsvot. They danced for their holidays of gladness and they danced the dances of the nations where they lived in exile. The concern with dancing, the recognition of its naturalness to the well-being of man, is evident in the New Testament. Jesus refers to children dancing and to the dancing of the guests and the family in their rejoicing at the return of the Prodigal Son. Salome danced for Herod, it will be remembered, and it is assumed that it was more Greek than Jewish, sensual rather than

sacramental, as that Hellenizing ruler would have surely preferred. For Hasidic Jews, dancing is sacramental, an all but sacred thing, a way of worshipping God. Hasidism was a Jewish revivalist movement founded in the eighteenth century by Israel Baal Shem or Israel Baal Shem-Tov, meaning Israel, Master of the Good Name, who was born Israel ben Eliezer, where the Ukraine and Galicia meet. Of the most humble origins, lacking rabbinical status, he became a mystical, wandering preacher, preaching, however, to a most depressed, despondent people a religion of joy: God was everywhere, everything was blessed by Him, and the world was filled with the beautiful and the good and with melody. He defied and denounced the Talmudists, and they in turn denounced him, burned Hasidic writings and excommunicated him. In vain. Hasidism swept up half of Jewry in its enthusiasm. The Hasidim placed emphasis on mysticism and magic, and read from the Cabbalah, a textbook on Jewish mysticism. The word itself means "traditional lore," something not contained in the Torah. And they sang. Song was as good as formal prayer. And they danced. The psalmist had said one's very bones should honor the Lord! So they danced in the mystic circle, and they danced for joy. They still dance in Jerusalem with an abandon that makes the Hora look like a calcified minuet. If for non-Hasidic Jews, now the majority, dancing is not a prayer, it is a significant part of life in Israel, a means of communication between God and man, or certainly between man and woman.

The Jews who went to Israel to swell the Yishuv brought with them the folk dances of half a hundred countries, many of them with an ancient vigor that may well have run back to the days of the Second Temple. These came from the Oriental Jewish enclaves, from Yemen, Bukhara, Morocco, Persia and other parts of Africa and the Arab world. Joined with these were all the folk dances of Central and Eastern Europe, among them the familiar Romanian Hora. Of all the immigrant groups, the two with indigenous dances were the Hasidim and the Yemenites, the first an international grouping linked by religious tenets, the other an aboriginal group whose culture had been refined by centuries of semi-isolation in a backward country.

The Yemenite tradition, with its folk songs and melodies that all but defied notation and its unique dances, became one of the earliest major influences in Israel. The Yemenites were unique in many ways. In their centuries of isolation from the rest of the Jewish people they had developed a rich tradition of music, dance and decorative arts. They had no theater; life was their theater. In time the entire community of Yemenite Jews was brought into Israel, a happy cultural infusion for Israel, but, in the eyes of many, unfortunate in that assimilation by Israeli society will have dissipated all the autochthonous magic bred over centuries into that unique people.

Because of the cultural integrity and power of the Yemenite customs and the genius of a Yemenite orphan who had been brought up in Western style

in a kibbutz, Israel got its first modern dance group, the Inbal Dance Theater. The genius was Sarah Levi-Tannai, whose ambition to be an actress was frustrated in part by the Slavic orientation of theater in Israel at the time. She devoted her talent to staging pageants in her kibbutz and studying the culture of her Yemenite people. By the time she formed her Inbal Dance Theater, in the year 1949, the people of Israel were somewhat familiar with the unique quality of the Yemenites. Nomadic artisans had brought Yemenite jewelry with its marvelous filigree work into the markets of Israel. The famous Yemenite folk singer Bracha Zefira had introduced Yemenite music. They had not seen Yemenite dances. Like the dances of the Hasidim the Yemenite dances were rooted in their religious practice. The men danced separately in the synagogue; the women danced separately at marriages and other festive occasions. Not only were their movements and their music sui generis, their costumes were spectacular in cut and color.

Levi-Tannai brought together a group of Yemenite boys and girls, organized and instructed them, and struggled against her own deficiencies as an autodidact. She developed two types of Yemenite dancing: one represented the ritualistic movements of the dance in the tiny synagogue; the other was served by the wide-open spaces of the desert, for dancing is always movement in space. Both styles were marked by a gentility and a gentleness characteristic of the Yemenite. From the domestic functions of the Yemenite woman as well as from her role in the marriage ceremony, Levi-Tanni developed other dances, making use even of the very Oriental subjection of the woman to the man. Artistically, success crowned its beginnings.

Had it not been for the distinguished American choreographer Jerome Robbins, the beauty of the Inbal Dance Theater might never have won the wide audience it did. Robbins went to Israel as a guest of the America-Israel Cultural Foundation in 1952 and persuaded the foundation to give the company financial aid and professional instruction. Anna Sokolov, an American, was sent over as instructor, and Ovadia Tuvia, a Yemenite composer, became the musical director. When the group gave its first major public peformance in Tel Aviv, its success was immediate and overwhelming. The piece de resistance of the program was *A Yemenite Wedding*, in which the seven attending days of ceremony were encapsulated into five scenes.

In 1956 the Inbal Dance Theater made a foreign tour of seven months duration to enthusiastic audiences in Europe and America. Other European tours followed, and then a second visit to the United States, during which the company took part in the filming of a motion picture, *The Greatest Story Ever Told*, a life of Jesus based on a book by the late Fulton Oursler. A furor followed, with Orthodox Jews chilled by the company's participation in such a Christian

110

affair. Not because of this, but subsequently, the company lost favor; the newness had worn off, stars left the company to form their own groups, and the roots of the Yemenite culture had been torn up. No source of renewal was left; critics found the performances lacked their early vivacity.

Before the luster had worn off the Inbal Dance Theater following its years of greatness, two other modern companies formed. Early on, proponents of dance recognized the need for a school of dancing in Israel if the folk dances were to be preserved, encouraged and refined, and some approach made to a native Israeli dance. In 1960 Chasyah Levy-Aronsky (Hassia Levy Agron) went to the Rubin Academy of Music in Jerusalem to associate her efforts with the academy. The purpose was to train dance teachers and choreographers as well as for dancers to establish schools in rural settlements and instruct existing folk-dance groups. Today, the academy has taken a preeminent position among the dancing schools of Israel.

As a young, aspiring dancer in Israel, Hassia Levy Agron had found no school there to turn to. She came to the United States, where, like so many others, she studied with Martha Graham. When she returned to Israel in 1951 she was bent on starting a school to train teachers of dance. Like so many Israeli ventures the dance department started with practically no budget, but with zealousness. Such has been the success of her program that the school began to turn pupils away. From the first, distinguished dancers, teachers and choreographers were persuaded to lecture, demonstrate and perform, among them Martha Graham, Merce Cunningham, Anna Sokolov, Jane Douglas and numerous others from the United States and Europe. Such visitors diminished for the students the sense of isolation one can suffer in a country as small as Israel.

In 1964 Baroness Bethsabee de Rothschild, a refugee from Hitlerian madness who had gone to study with Martha Graham in New York City, founded the Batsheva Dance Company in Tel Aviv. There was more than a resemblance between the Batsheva and the Martha Graham company in New York; there was a relationship. Miss Graham gave permission to the company to use some of her repertoire, received Batsheva students in New York and sent dancers to Israel. From the beginning the Batsheva presented determinedly "modern" dance. As early as 1920 a classical ballet company had formed to complement the opera company directed by Mordechai Golinkin, with Rina Nikova as the leading figure. The company withered, only to be revived by Edis de Phillippe for her opera company. The ballet company outlived them both.

What the baroness missed was a sufficient tradition at the time to maintain a ballet company and mount the stage settings necessary for the classical productions, but she also recognized the necessity of rigorous training, the need, in brief, for a school. She found the person she wanted in Jeanette Ordman,

a ballerina who had come to Israel to perform but opened a studio instead. She had been born in South Africa and, at the age of ten, received her dancing teacher's diploma from the Royal Academy of Dancing in London. After additional study in Europe, she joined the Johannesburg Festival Ballet at the age of fourteen. After dancing leads and solo roles in Johannesburg, London and the European continent, she turned to Israel, immigrating in 1964.

To the Baroness de Rothschild and the ballerina Jeanette Ordman, Israel owes its second modern dance company, the Batdor, which also incorporates a school. The ferment in dancing and in these two troupes runs high. They were not five years old when they spawned a third troupe, the Jazz-Plus. This group, which dances in a lighter vein marked by American influences and leaning on pop, jazz and rock, was founded by Shimon Braun, who had been a member of the Batsheva company. The interaction of these various groups can be measured in a way in the career of Moshe Efrati, a Batsheva dancer and choreographer. Efrati began his dancing career in the Department of the Dance under the tutelage of Levy-Agron at the Rubin Academy in Jerusalem. At the instigation of the Baroness de Rothschild, he became a choreographer. Among his first productions were *Sin Lieth at the Door* and *Ein Dor*, both based on Biblical themes and received in Europe with as much enthusiasm as in Tel Aviv. Efrati left the Batsheva company and formed his own company but suddenly found himself a world pioneer.

He was approached by Avraham Reich, director-general of the Association of the Deaf in Israel, who was interested in broadening the artistic interests of the deaf. He wanted something more for them in the way of dancing than the Hora. Efrati took up the challenge and then moved from instructing deaf dancers to forming the Kol Demama Company in which deaf dancers and those with hearing perform together. The company has been a distinct success on the basis of its artistry and has performed to acclaim in several European countries.

The Batdor has become Israel's leading dance company, marking its twentieth anniversary in 1988. Miss Ordman's insistence on classical techniques, blending them with the modern, has enabled the company to develop a varied repertory of the utmost flexibility. The name itself means "contemporary," a "now" group. Since 1970 the company like the Batsheva has toured extensively in Europe, South America and the Far East. Critical reception has been excellent, and the school prospers.

From the beginning Miss Ordman found herself performing usually at the request of foreign choreographers and directors who came to Israel at the invitation of the company to broaden their vision. Many Americans have visited, but Israeli companies have been insistent on native choreographers.

If dance in Israel has lagged behind the rapid development of the theater,

the reason is not far to seek. Any great dance troupe requires a tradition not in years but in decades. The celebrated Royal Ballet Company in Denmark is two hundred years old. In Russia the tradition is equally venerable. In Israel the desire and demand for a ballet company was recognized before the existence of the state. The National Ballet Company was formed in 1920. Nevertheless, such dancing as Israel has sent outside its borders has been recognized as first-rate. The choreographic work done in Israel is being received with enthusiasm in various countries, and dance companies outside Israel are commissioning work by Israeli choreographers. Works by Efrati have been performed by the Ballet Contemporain of France, the Ballet Von Flanders of Belgium and the Stuttgart Ballet and the Deutsche Opera in Germany.

All these companies would acknowledge a debt to one of the most distinguished women of Israel in the arts, Gertrud Kraus, a Viennese ballerina who emigrated to Israel in the 1930s. She had visited Palestine to perform solo dances, for which she had won a superlative reputation in Europe, fell in love with the country and yearned to go back there. In Austria she had had her own dance company and turned Jewish themes to works of terpsichorean art. In one of them the scene was the Western Wall, so one can realize that the lure of the Holy Land was strong before she went there. Although she returned to Vienna after the tour, her mind was made up. This was almost a decade before the establishment of the State of Israel, and the path of the artist was doubly hard. She accepted that, set up shop in Jerusalem, but performed in Haifa and Tel Aviv as well. She taught and she danced and she created dances. The Palestine Folk Opera was struggling to bring the giants of Western civilization to the stage, the Philharmonic Orchestra was seeking permanence and the Hebrew theater was taking shape. She worked with all three. In her sixty-eighth year, Miss Kraus was awarded the the Israel Prize, given for years of service to the cultural life of Israel. It was in 1935 when she settled in Tel Aviv, having left behind an eminent career on the European stage, acclaimed for her expressionist performances in *The Town Is Waiting*, her own creation, and *Dream of a Musician.*

She lived and taught and performed all during the bloody years of World War II and then the War of Independence when, traveling to dance for the troops, she was often in danger of her life. In an interview with Judith Brin Ongebar, an American dancer who taught and performed in Tel Aviv, Miss Kraus told a most dramatic story of the difficulties under which she worked.

> Often I would perform for the army, considering it my duty. Once in particular I remember going past Zichron Ya'akov on the way north. We had to hide in the bottom of the army car, and tommy guns stuck out the window holes. I sat in my seat swaying back and forth. One of the soldiers asked me what I was doing, and I said that maybe a bullet would come from

and suddenly there was a shot and the soldier next to me fell into my lap bleeding all over from his head. I took one of my costumes and wrapped his wound. Eventually, we got out to the place where we were to dance, took the soldier to a hospital and I went to perform, the fear having filled my whole being.

No story could better exemplify the difficulties under which any number of early artists worked in Israel.

One mark of the advance of dance in Israel despite the difficulties, some old, some new, is the formation of a dance library in Tel Aviv. The conception was that of Anne Wilson, well-known American dancer and choreographer who had visited Israel many times, danced, taught and lectured. On her return from a 1971 visit she formed a committee with the assistance of the America-Israel Cultural Foundation. For many years a group known as Americans for Music Libraries in Israel had been headed by Max Targ, a longtime patron of music and ongoing benefactor. They, with others, had stocked quarters in the Mann Auditorium in Tel Aviv to overflowing, all under the curatorship of Zvi Avni, a musicologist and composer.

Because of the growth of the music library, new quarters were needed and a former city hall in Tel Aviv was made available. When the music library moved into its new quarters the dance library went with it, and it has grown apace since with numerous gifts from dancers in the United States and elsewhere. Miss Wilson still remains the spirit in this country and is the constant recipient of scores, programs, correspondence and the personal collections and manuscripts of many performers. The Committee for a Dance Library in Israel has won itself a permanent role in the development of dance in Israel. One of the first purchases the library made was the World Dance Catalogue of ten volumes from the dance collection of Lincoln Center.

The National Ballet Company, formed as early as 1920, lost its way, reorganized and finally in 1947 became the happy complement to the Israel National Opera, with Fima Tschertkow as its chief choreographer. The year was 1947 and the thirtieth anniversary found it with a repertoire of more than half a hundred ballets, including compositions by such musicians as Tchaikovsky, Stravinsky, Satie, Lizst, Chopin, Offenbach, Saint-Saens, Johann Strauss, Prokofiev, Ravel, Verdi, Delibes, Debussy, Massenet, Rimsky-Korsakoff, Grieg, Bizet and Bach as well as George Gershwin.

Besides the professional companies, the students at the Hebrew University have their dance company, and it is a strange kibbutz or mosha that doesn't feature dancing fairly regularly, the workers themselves as the performers. Dozens of dance teachers have gone forth from the various schools to the kibbutzim and the moshavim and the small rural areas to add dance to the cultural ferment that stirs the country.

Israel has also sent on trips to the United States the Hasidic Festival Troupe of young men and women whose two-hour performance takes its songs from the Bible, its costumes from the Hasidic tradition and its dances from the rousing Hasidic religious celebrations. The performance exudes the joy of Hasidism and has all the vigor that marks the sabra.

Each year the Israel Folk Dance festival brings three thousand dancers from a dozen and more countries to participate in a week-long celebration. But such dancing can be seen at almost any celebration in kibbutz or moshav, in every village and town. When the United Nations voted to establish the State of Israel, Jews danced in the streets of New York; when the charter of the State of Israel was signed in Tel Aviv the Israelis danced. It has become a definite national characteristic. No wonder that Harvard University's President Derek Bok on visiting the country remarked on its intensity.

USIC

From the earliest moments of their history, the Jews have dwelt in music. Through all their years of exile they brought music with them like a tegument, or to change the metaphor, a tonic for the spirit to keep hopes and dreams alive. To this day, the Song of the Sea, which dates from the tenth century B.C.E. and celebrates the Exodus, holds a salient place in the sacred ritual. The song recounts the crossing of the Red Sea, the parting of the waters, the inundation of the pursuing Egyptians and the miraculous departure from Egypt after the years of bondage there. Miriam, the sister of Moses, led the singing and the dance of triumph and thanksgiving. It is no surprise that music rose from the soil of Eretz Israel—and still rises—in a paean of triumph, in strains of melancholy, in great variety and with unrelenting enthusiasm.

The Old Testament throbs with music, apart from the music of its language. As with the ancient Greeks, the Hebrew prophets of old used music to heighten their mystical insights. Unique with the Hebrews, however, was scriptural cantillation, which required that the Torah be read in public with musical intonation. The style became traditional and reserved to the scriptures, and whoever sang them "in the manner of a secular song" abused the text. Instrumental music supporting intensely trained choirs of Levites resounded in the ancient Temple. Trumpets, such as those that brought down the walls of Jericho, were used in sacred liturgy. Authorities list more than thirty musical instruments in the Old Testament, but only the *shofar*, the ram's horn, is deemed uniquely Jewish. It is used to this day by them and them alone and then to announce the New Year. The sounding of the shofar is said to be an art in itself, but its use is primarily cultic.

The use of a ram's horn (straightened somewhat by heating) relates back to Abraham substituting a ram when the Lord spared Isaac to end forever human sacrifice. No doubt the shepherd's reed was the first musical instrument among the Hebrews, as among many peoples. In Genesis 4:21 we are told that Jubal was "the ancestor of all who play the lyre and the flute." His stepbrother was Tubal Cain, the "ancestor of all metalworkers."

In a museum in Philadelphia is one of the oldest known musical instruments from the Holy Land, a lyre from an archaeological dig in Ur, the native city of Father Abraham. Formally, the tradition of Hebrew music dates from King David, who played on such a lyre when he sang for King Saul and when he sang and danced before the Temple. Between Jubal and David, a musical tradition was developing which today has tremendous force in the world. Some authorities say that Jewish vocal music can be traced back three thousand years in such isolated Jewish communities as those that existed in Yemen, Iraq and other Arab countries. Not until after the Babylonian captivity did the Jews develop a full musical liturgy, for it was during those centuries that they discovered and annealed their unique identity. Choruses and choirs came into being with antiphonal singing, accompanied by instruments. Such music continued in the liturgy until the destruction of the Second Temple in 67 C.E. With that all changed. The Jewish priests ordered the faithful as a sign of mourning to abandon singing and instrumental music, as centuries before in Babylon they had hung their harps on trees rather than sing for their captors. In the Diaspora, the maintenance of elaborate choirs and musical programs became impractical.

To the extent that music went out of the synagogue, it gathered force in the Jewish home. Once again, as in Babylon, the table replaced the temple as the center of ceremony. The Hebrew music tradition that began with King David and the Psalms associated with his name has become one of the great musical heritages of civilized man. The Psalms have been chanted or read in Christian churches throughout the world since their earliest foundation. They are chanted still today. No Christian church in the world is without its Alleluia or its Amen. Thus, although the traditional music disappeared from the temple it went into the churches, and later the church would repay the Jewish benefaction.

With the Renaissance, Jewish musicians became inspired by Western polyphonic music. The first preeminent modern Jewish musician was Salomone Rossi, a composer and friend of Claudio Monteverdi, and it was he who brought harmony into the synagogue. From then on a succession of Jewish musicians and composers would find their place in Western music, all of them taking the coloration of the societies in which they lived and worked.

In the synagogue itself when the choirs disappeared, the *hazzan*, or cantor,

came forward, and he maintains his sacerdotal role to this day. The local coloration that Jewish musicians took on was all part of their assimilation into European life, and that very assimilation later brought on a reaction within the Jewish people. As their Europeanization grew the fear of losing their identity drove many Jews to Eretz Israel in the nineteenth century. It is in Israel that Jewish music has prospered as never before.

Many persons in Israel and outside its borders would agree that the prime cultural achievement of Israel so far as the arts are concerned is the Israel Philharmonic Orchestra. Despite the size of the country, the 105-member orchestra is among the best symphony orchestras in the world. It is the fruition of the dream of one of the leading violinists of this century, Bronislaw Huberman, a native of Czestochowa, Poland, who became a child prodigy in Warsaw. At the age of ten, the wunderkind performed for Emperor Franz Joseph, and at fourteen he played the Brahms Violin Concerto in the presence of Brahms himself. In the 1930s, however, he felt himself an exile from the Europe he loved and refused a request to perform with a German symphony orchestra because of Hitler's developing anti-Semitism. By then Jewish musicians were fleeing from Germany, and Huberman conceived the plan for a Jewish orchestra in Palestine.

As a world-renowned violinist he commanded the respect of all musicians and, as a man, had among his acquaintances and friends some of the most distinguished musicians of the day, among them, happily, Arturo Toscanini. He set about gathering musicians and money to bring his orchestra into being. He was determined that only the best musicians would play in it, and he traveled incessantly through free Europe auditioning players and at the same time raising funds. The governor of Palestine under the British mandate was well disposed toward the venture, so there was no difficulty there. When the orchestra was assembled, however, there was the problem of where it was to perform. A large cinema hall with some makeshift acoustical boarding mounted behind the players served at first and not too well. Huberman was painfully aware of the need for a first-class concert hall. Not until 1957, ten years after his death in Switzerland, would Tel Aviv's magnificent Frederic R. Mann Auditorium be built.

Huberman's moment of triumph came December 26, 1936, in a large hall in the Levant Fairgrounds when the orchestra had its debut with Toscanini conducting. Thousands remember him and Huberman embracing at the first general rehearsal, a euphoric moment for the Jewish Huberman and the Catholic Toscanini as well. The orchestra was first called the Palestine Orchestra, then the Palestine Philharmonic Orchestra, and, in 1948, the Israel Philharmonic Orchestra. Long before that date, however, its reputation was international. Today it has the largest group of subscribers of any symphony orchestra in the world, an incredible tribute to the devotion of the people of Israel to music.

119

Acoustical difficulties were not the only early problem. The polyglot composition of the orchestra was another. The conductor was likely to find himself trying to give instructions in half a dozen languages. The sophisticated nature of the audience was a challenge and an advantage. Many of the pioneers had been schooled in music in Europe and Russia and were accustomed to hearing some of the finest orchestras the continent had to offer. They were extraordinarily knowledgeable. The story is told of the late Serge Koussevitzky, the morning after a concert, being stopped on the street by a laborer who thanked him for the performance. The laborer then engaged Koussevitzky in a joint discussion of his interpretation of a Tchaikovsky symphony. The first audiences in Israel came from all ranks in society, and those today do also.

The IPO, once composed solely of immigrant musicians, is now more than 70 percent Israeli-born, and even more of the musicians are Israeli-trained. The orchestra is a cooperative with the players adjusting their own recompense. Although it receives some government assistance and more from the America-Israel Cultural Foundation in the United States, it has retained its independent status, and owns 50 percent of the Mann Auditorium, sharing the ownership with the city of Tel Aviv. Despite its cooperative status it does not suffer from what might be called a civil-service syndrome or tenure-itis; early in 1987 a dismissed violinist was suing its directors. Seniority governs nothing; each vacancy is filled by competitive auditioning. More than thirty-three thousand persons subscribe to the concert series, and to meet this demand fourteen different concert series are scheduled: in Tel Aviv, the home of the orchestra, eight series of twelve concerts each; in Haifa, three series of ten concerts each; and in Beersheba, four concerts.

Tours have taken the orchestra to Europe, the United States, the Far East and Latin America. It is interesting that the first tour the orchestra ever made was to Egypt — only two weeks after its debut. Touring also had been a dream of Huberman's — that the Israel Philharmonic Orchestra would carry the culture of Israel around the world.

Two years after the Mann Auditorium was built in Tel Aviv, Zubin Mehta, a Parsee from Bombay and now conductor of the New York Philharmonic Orchestra, became music advisor for the IPO, spending two months a year in Israel with it. He conducted on tour in Australia, New Zealand, Hong Kong, Austria, Italy, England, Scotland and at major European music festivals in Salzburg, Edinburgh, Venice and London. His connection did not cease when he replaced Leonard Bernstein in New York. Bernstein himself has conducted the IPO many times and never on a happier occasion than the concert in Carnegie Hall in New York City, October 18, 1972, in celebration of Israel's twenty-fifth birthday. The concert was sponsored by the America-Israel Cultural Foundation, and Isaac Stern, violinist, chairman of the board of the

AICF, was the guest soloist. The AICF took the occasion to present its King Solomon Award to Bernstein for his years of service to the cause of Israeli music.

Besides the IPO, Haifa and Jerusalem have their orchestras, and Ramat Gan boasts the Israel Chamber Orchestra. Jerusalem also has its Brass Ensemble. On more than one occasion the Israel National Youth Orchestra has taken first prize in international competitions. There are major academies of music in Tel Aviv, Haifa and Jerusalem. Recording studios and music publishers flourish, and, of course, the American public is well aware of Israeli virtuosos who have become internationally known artists. Among them are Itzhak Perlman, whose platform geniality charms television audiences, Pinchas Zukerman, Shlomo Mintz and Miriam Fried. Young, aspiring artists in great number have been helped financially by the AICF. About a thousand young persons each year get such assistance.

In all the glamor of this, however, it must be remembered that the musicians, like all artists and performers in Israel, are subject to military service and have to take their regular turns on the barricades, serving in one or another of the branches of the armed forces or playing for the troops. The outstanding flautist Yadin Tenenbaum was killed in the front lines in the Yom Kippur war. The success of the musical life of the country has been achieved and continues in force while the nation itself, surrounded by enemies, threatened with total destruction by the Arab nations and tormented by terrorists, struggles to survive and maintain an economy constantly strained by the necessity of enormous defense expenditures. If art comes from suffering, Israel is an example of that truth.

The year 1936 is the point of origin for the modern musical tradition in Israel, not only because of the birth of the IPO but also because of the establishment of the radio broadcasting station in the Holy Land. The station gave a great impetus to native music, and Jewish composers received better treatment from the station than from the IPO. In time the radio station became the official station for the State of Israel, and Kol Israel (Voice of Israel) broadcasts go out to the world in Hebrew, Arabic and English. The trilingual programming has done much for cultural and mutual understanding, but many consider the station's greatest accomplishment is what it has done for music.

Although the radio station under the British mandate broadcast only on one band and for only five hours each day, one of its first actions was the formation of an orchestra. This became in time the symphony orchestra of the Israel Broadcasting Authority, and from the first it was applauded for performing the works of local composers. Indeed, in 1947, one year before the birth of the state, the station had a celebrated "month of Jewish music."

Today the orchestra is known as the Jerusalem Orchestra and has benefited

in recent years from an influx of excellent Russian refugee musicians to add to the kaleidoscopic ethnic nature of the membership. Once again, conductors are confronted with giving instructions in several languages since almost all refugees have very little Hebrew when they arrive. Israeli music continues to be its speciality, and annually it commissions compositions that are presented in proud premieres in the season's programs.

Each year it offers three series of ten public concerts. The American composer Lukas Foss has been its conductor for several years. Foss divides his time between the Brooklyn Philharmonic Orchestra in New York and the orchestra in Jerusalem. The associate director with Foss is Yuri Aharonovitch, former conductor of the Moscow Radio Orchestra, who went to Israel in 1972. One of their joint endeavors has been a musical marathon in which the orchestra broadcasts for five hours steadily the works of one composer. Audiences pack the Jerusalem Theater for each performance, the whole marked by an informality that somehow brings music closer to the listener.

Two decades before the opening of this century, Jewish pioneers were farming in Palestine. Perhaps the first concert there was one held in the school opened by Boris Schatz in Jerusalem. In 1909 Tel Aviv was founded, and before the streets were paved a school of music was opened. It was named the Shulamith School after Mrs. Shulamith Ruppin, a founder and patron. A second was opened within five years and still another in Jerusalem. During World War I, the musical scene had so advanced that a student orchestra entertained the British troops.

Under the British mandate, the Turkish strictures gone, Jewish music flourished. A music institute was founded in Jerusalem in 1918. In 1923 Mordechai Golinkin assembled the Palestine Opera, and in the summer of that year in Tel Aviv he presented Verdi's *La Traviata*, which was translated into Hebrew for the occasion. Four years later the company failed for lack of money, but another opera company would come. Golinkin managed intermittent performances until 1947. Several small orchestras were formed during these years as well as the IPO.

All this was accomplished at great personal sacrifice on the part of the individuals, most of whom were earning their living by the sweat of their brows in stony, arid fields of the the Holy Land. Even today a small percentage of the musicians of Israel earn their entire living from their music.

Although the first opera company lasted only five years, the Israel National Opera celebrated its twenty-fifth anniversary in 1972, a remarkable achievement. Like many an institution it is the shadow of one powerful personality. In this case it was the American-born soprano, Edis de Phillipe, internationally famous opera star. When living in Paris she began to meet refugee performers fleeing the Hitlerian terror. She resolved to create an opera company in Israel

to rival those in the West, but the outbreak of World War II ruptured her plans. She, like other American citizens, was shipped back to the United States, there to await an end to hostilities. After the war, she was soon back in Europe working to establish her opera company. Conferences with Israeli leaders and with leading Zionists, meeting in Basel, gave her encouragement and support. Innumerable difficulties confronted her in organizing singers, an orchestra and a ballet company. She overcame them all. The premiere production, *Thais* by Massenet, was a success, for her a triumph. For the first decade of the company's existence she sang in the productions. In 1956 she gave up singing and devoted all her energies to directing and managing. Half a hundred operas and operettas are now in the repertoire of the company, and millions of Israelis and visitors have attended. Half a dozen conductors have worked with the company, including Arieh Levanon, himself a composer of choral works and instrumental pieces, and Golinkin. Included in the repertoire of the company is the Israeli opera *Alexandra*, by Menahem Avidon, who went to Israel from Europe in 1939 and has become one of the foremost composers in the country.

Another distinguished if younger musical group in the country is the Israel Chamber Orchestra, directed by its founder, Gary Bertini. The ensemble, created in 1965 (the year the Israel Museum opened), consists of thirty instrumentalists and vocalists. Bertini sensed the need for such an ensemble in Israel, sensed the potential that lay among the young musicians in the country and the possibility of bringing them together. Aid came from the AICF and the Ministry of Education in Israel. The latter was most interested because Bertini intended to do what he has come to do, bring his musical group to the small Israeli communities where the larger orchestras could not be accommodated.

Within five years of its formation the Israel Chamber Orchestra made a triumphant tour of Europe and the United States. Twice a year it performs abroad. Like the IPO when it was first formed, the Israel Chamber Orchestra needs a hall of its own designed specifically for the performance of chamber music. Like other musical groups, the members are subject to military service. In the case of the ICO this particular obligation was brought home with special impact. The orchestra had scarcely been formed when it found itself called upon to perform not for isolated farming communities but for the troops in the front line of the Six Day War.

Bertini's reputation has grown largely during the years, and in 1976 his engagements overseas took up seven to eight months, with appearances in the United States, Scotland, Germany, England and Switzerland. At the Munich Festival he conducted the world premiere of the opera *The Experiment*, by the Israeli composer Josef Tal.

123

Minor musical groups in Israel come and go, catching the popular fancy for a while but succumbing to the financial difficulties that are common. One group that has made its way nicely is the Baroque Players, which started as a group of recorder players but has been joined by oboe, clarinet, violin, harpsichord and vocalists, to win international applause. In the past two decades, the Kibbutz Chamber Orchestra has also won itself a front-rank place.

In 1941 the Palestine Folk Opera was founded, and it produced the first opera drawing its inspiration from Palestinian folk life. The opera was *Dan the Guard*, composed by well-known conductor of operettas Marc Lavry. The libretto was by Sholomo Schalon and Max Brod. The opera had its premiere in 1945, the same year the city of Tel Aviv instituted the Yoel Engel prize.

Besides orchestras, innumerable choral groups formed throughout the country, and these more than anything else have given the new Israeli folk songs a character all their own. In 1944 twenty-four choral groups mounted a chorus of a thousand voices at the Ein Harod Choir Festival in the Jezreel Valley. In 1985 Rinat, the National Choir of Israel, one of the musical ornaments of the state and a winner of an International Choir Competition, celebrated its thirtieth birthday. Cameran Singers, the Chamber Choir of the Rubin Academy of Jerusalem and the Jerusalem Opera Society are outstanding vocal groups. The annual World Hasidic Festival is one of the most exuberant song fests of the year. Jazz is making a big comeback. An annual dance festival brings together five thousand dancers from all over the world performing popular choreographic creations. Any number of smaller festivals were held throughout the country, all this before independence. Since 1948, the intensity of music performance has heightened in Israel. One unfortunate result has been an emigration of musicians from Israel, many of them seeking more remunerative requests for their talents in countries where the musical competition is somewhat less intense and the pay is more.

Yohanan Boehm, a distinguished Israeli music critic, remarked on this in one of his articles:

> But even a number of "satisfied" musicians, with well-paying jobs and comfortable flats, have left it all for "greener" pastures. It seems the Wandering Jew complex—plus the gypsy inherent in perhaps every artist—are the cause of this migratory trend: the same bug has bitten a lot of Israeli musicians and one should not single out the Russian immigrants. Language problems, different habits, the limitations in performing in Israel—have contributed to the emigration.

He had been commenting on the departure of some musicians who had come to Israel from Russia and were dissatisfied with what they found. Another reason may lie in this: in Russia some musicians are well taken care of if they obey the rules; in Israel, creature comforts may not be so readily available

for professional musicians, and intellectual freedom may fail to satisfy someone who is content to play whatever is put before him wherever he is told to go.

One of the brightest and most exciting events on the Israeli musical calendar is the Artur Rubinstein Piano Masters Competition, named for the late master who lived long enough to be honored by the event and to present the awards. Held every three years, the competition brings about forty young pianists from almost as many countries chosen from three times as many aspirants. The competitors approach a three-stage challenge. The number is reduced twice, arriving at three to six finalists who play required pieces with the Jerusalem Orchestra under conductor Mendi Rodan. The competition owes its inception to Joseph Bistritzky and its continuation, more than likely, to the extreme enthusiasm of the public. All performances have been standing room only.

Music festivals are a major aspect of the musical scene in Israel. Two of the major ones are the Israel Festival of Music and Drama, held annually in the late summer, and the Ein Gev Music Festival, held annualiy during Pesach (Passover) on the shores of Lake Kinnereth (Galilee). The first music festival was held in September 1961 in the open-air amphitheater that had been constructed by King Herod in 12 B.C.E. The theater's availability was a result of the Israeli passion for archaeology, since it was dug out of the sands in 1959 after being unused for centuries. The highlight of the festival, aside from the performance of native groups, was the presence and performance of the late Pablo Casals, who played a Bach sonata for viola da gamba. The next year the festival was held in Jerusalem.

The Israel Festival annually brings a variety of musical groups and performers from a score of countries, providing concerts, operas, ballets, drama and other events. The festival has involved on occasion more than nine hundred performing artists. One must not think that all Israeli music is given over to classical works or in presentation and extension of the folk airs from Jewish settlements of half a hundred countries. There are the modern groups: rock groups, country singers, ensembles drawing their inspiration and their idiosyncrasies from the United States of America. Nowhere in the Middle East is such an accolade paid to the native music of the United States, although some European countries have shown a like passion.

The Golden City String Band (one wants to write the Golden Gate String Band, but Jerusalem, of course, is the Golden City) plays American country music, western music and whatever. The costumes are right out of Texas. Guitar and double bass are made to harmonize with the only autochthonous American instrument, the banjo. What instrument could be more foreign to the Holy Land? The vocalist with the group, Sandra Johnson, teaches singing at Tel Aviv University. They give you Hebrew with a Kentucky hillbilly accent.

Then there is the Safam—an Israeli rock group—and the Poogy, which has been described as Israel's reply to the Beatles. The seven members of the group combine many antics, not unlike those that marked the Monkees in the United States, with some first-rate music. In their trips abroad they sang first in Hebrew but found it a bit of a handicap, particularly in competitions, and now use English when the occasion seems to call for it. These are not all, of course; there are others. Music is the air they breathe in Israel.

COMPOSERS

The burgeoning musical life of the State of Israel, brief as it is, has given an encouragement to Jewish composers they never enjoyed before. From the fifteenth century on, there have been Jewish composers in Europe, but generally speaking their music was indistinguishable from the styles of the nations in which they worked. There was liturgical song but no uniquely Jewish music in the classical sense. With the readaptation of Hebrew following the Haskalah, a surge of interest occurred in the composition of music that would be identifiably Jewish. At first, it was concerned with the melodies of folklore; much was done in that regard and is still being done. But for a more profound beginning of "Jewish" music, one turns to the United States and Ernest Bloch.

Bloch was born in Switzerland in 1880 and in his thirtieth year had his opera *Macbeth* performed at the Opera Comique in Paris. He came to the United States and made his career here, ending it as professor of music at the University of California. But while he was director of the Cleveland Institute of Music he set out to create a distinctively Jewish music. This resulted in *Trois Poemes Juifs*, the symphony *Israel*, the rhapsody *Schelomo*, and Jewish Sacred Service. What it pointed to was a synthesis of the music of the East and West. It launched a movement that has grown and for which Israel became fertile ground. Musicologists in Israel recognized that those composers on the soil of Israel had a special destiny in this regard. In 1950 the ministry of Education in the infant democracy established the Ethnological Institute for Jewish Music.

Of course, Jewish musicians and composers had been in Eretz Israel for some time. It was the odd kibbutz that did not have its choir and musical

performing group. Composers came in from Eastern Europe, where the same stirrings that had launched modern Hebrew literature were arousing musicians to dreams of a distinctive Jewish music composed in a thoroughly Hebraic ambiance. The first musicians who came in the late nineteenth century could not shake off their previous acculturization, could not acclimatize themselves to the new-old country. But the younger men were finding a way, and the number of composers working in Israel even before Israel became a state is astounding.

As early as 1936, a society of composers, authors and music publishers was founded in Tel Aviv. Called ACUM, its aims were to safeguard the interests of its members as well as members of all affiliated organizations in the matter of public performance and reprint rights; to fight infringement of copyrights and to collect royalties. When the State of Israel was founded, the society had more than three hundred members. Nothing, it seems to a casual observer, indicates more the depth of music in the Jewish soul than the necessity of forming such an organization so early in the game.

As we mentioned before, the opening by the British of a radio station in Palestine had a significant impact on music in Israel. Musical groups were forming all over the country. The composer Mordechai Sanburg, remembered for his oratorio, *Ruth*, formed an Institute for New Music. In 1939 came another milestone: the immigrant composer Paul Frankenburger, who would change his name to Paul Ben-Haim, composed the first Israeli symphony. Ben-Haim was not the only one who had been encouraged by the accelerating events. Before emigration to Israel, Alexander Uria Boscovitch, who would become one of Israel's leading composers, wrote a suite for orchestra entitled *Chansons Populaire Juives*, using Eastern European Jewish melodies and rhythms. The drive for a Jewish music, later an Israeli music, led him and other composers to turn to Oriental themes, and they drew upon the Yemenite culture, music from the Jewish communities in the other Arab countries and the Persian heritage. A Middle East-Mediterranean style emerged that marks the works of many of the early composers, including Paul Ben-Haim and Yosef Tal, two of the major figures. There were many others, and there was renewed attention to the work of the pioneer musicologists and composers.

To mention one name or another is to neglect scores. Ben-Haim and Tal are standouts from the prestate days. Ben-Haim was born in Germany in 1897 and trained at the Munich Academy, emigrating to Israel in 1933. He had already established himself in Germany as an excellent musician and rising composer. Like other immigrant composers, Ben-Haim's work at first took on the coloration of his background. In 1940 a sharp break came in his compositions, and he began to bring to bear modern techniques on Oriental rhythms, melodic tropes and instrumental coloration. The late Serge

Koussevitzky, celebrated conductor of the Boston Symphony Orchestra, considered Ben-Haim the greatest composer in Israel and conducted several of his compositions. Many regard his First Symphony, also the first ever composed in Israel, as his finest work. His Sonata in G for unaccompanied violin ranks high in contemporary music. A listing of his works covers pages.

The name of Yosef Tal, a refugee from Nazi Germany, is well known in Israel and Europe. His work marks him as one of the most distinguished composers to work in Israel. He was born Joseph Gruenthal near Poznan, Poland, studied music at the Berlin Academy and toured Europe giving piano concerts. In 1934 he was in Israel living in a kibbutz and toiling as a farmer for a year. In 1937 he joined the faculty of the Academy of Music in Jerusalem, and in 1950 he was named lecturer in music at the Hebrew University. It was there he set up the Israel Center for Electronic Music, a pioneer and salient influence in the country. In 1971 he was honored by the Berlin Academy of the Arts in the city where he had once worked for a radio station before having to flee persecution. His musical compositions span a wide spectrum: opera, symphonies, chamber music, piano and ballet music, concerti and oratorios. *The Experiment*, the opera given its world premiere in Berlin, was produced later in New York City, a historical first in the history of Israeli music.

Two early composers were Yoel Engel and Abraham Zvi Idelsohn, the first born in Russia in 1868, the second in Latvia in 1882. Both had reputations before they came to Israel. Engel had provided the stimulus for the formation of the Society of Jewish Folk Music. He had delivered a popular lecture on Jewish folk music which greatly extended interest, and the music itself was to inspire his own compositions. He was to win the title of the Father of Jewish Music from some and the Father of Israeli Music from others.

When he was a boy, Tchaikovsky urged him to attend the Imperial Conservatory of Music in Moscow. On his graduation from there, he taught school and wrote musical criticism before delivering his epoch-making lecture on Jewish folk music. After two years in Berlin he went to Palestine to teach at the Shulamith School in Tel Aviv, and there he began his collections of folk melodies and compositions based on them. He soon became one of the heroes of Jewish culture in the Holy Land. Rehov Engel in Tel Aviv honors his name. His nursery songs, soon sung by every schoolchild in Palestine, are still sung today. He composed the music for the play *The Dybbuk*, with which Habimah would make its reputation, but his piano pieces are perhaps his most celebrated works. After his death, the Yoel Engel prize was established to honor his memory.

If Engel was composer first and scholar second, with Idelsohn it was the reverse, though his interests lay in the same directions. He composed an opera, some liturgical pieces and, like Engel, songs for children. His outstanding work

of musicology is his *Thesaurus of Hebrew-Oriental Melodie*, a ten volume anthology of sacred and secular music which, between 1914 and 1933, was published in Hebrew, English and German, although in books of varying lengths. Idelsohn had gone to Palestine in 1906, the same year as Boris Schatz, and was the first to draw on the widespread popularity of folk songs that were a diapason running through the growing Jewish communities in the Holy Land, songs brought by the immigrants from countries all over the world. The songs were as popular in the kibbutzim as they were in the cities, in the schools as well as in the homes, in the fields as well as in the concert halls. All bore the marks of the countries of their origins despite their Jewish character, and the first songs composed in the kibbutzim or elsewhere imitated them.

The composers were interested most in the songs from the Oriental countries because of their greater age and the purity of line they had maintained over the centuries. It was to the Jews of Yemen, Morocco and other Arab countries and to those of the Persian tradition that the composers and musicologists listened, mostly in order to seek a distinctive Israeli style. The work of Engel and Idelsohn continues today under the aegis of such scholars as Robert Lachmann and E. Gerson-Kiwi. That mingling of East and West gave a peculiar and unique character to the early compositions. Ben-Haim's First Symphony took one movement from the melodies of Jews from Persia.

Although music in Israel today, like its painting, is taking on an international character, the Oriental influence in it is still there, although some younger composers dismiss the Oriental strains as "snake-charmer" music. Some musicians fear that an Israeli style is not developing in Israel, but others point out that too much must not be expected from a nation that is less than fifty years old and has not been given a week's respite from terrorism and excessive taxation in that time. Other composers fear that too identifiable a style might exclude them from performance abroad. There is just about every point of view expressed in musical circles, indicating the vitality of the milieu.

The miracle of Israeli musical composition is patent; no country of comparable size can match it. Since the Society of Israeli Composers has more than seven hundred members, any attempt to give even a listing of the members would be oppressive. There are the composers who came to Israel from Eastern Europe, the composers who came to Israel from Western Europe, and the composers who were born in Israel. Major among the first class is the name of Solomon Rosowsky whose father, Baruch Leib Rosowsky, was a celebrated cantor-composer at the Great Synagoue in Latvia for half a century. The son studied music in Russia and had Rimsky-Korsakov among his teachers. He was one of the organizers of the Society of Jewish Folk Music. After a career in Russia and Latvia, during which he wrote, lectured, taught and composed, he went to Palestine, where he remained for a good many years

until he finally settled in New York. He had been musical director for the Jewish Art Theater in Russia and composed for the theater in Palestine. With Gabriel Grad and Moshe Rapaport, he remains a precursor in Israeli Music.

A more significant contemporary is Yitzhak Edel, a native of Poland, who, after a successful career in Eastern Europe, went to Israel in 1929 and took a position as teacher at the Levinsky Women Teachers Seminary in Tel Aviv, remaining there until his retirement in 1965. He made important contributions to Israeli musicology and composed chamber and choral music, piano solos and a suite in memory of the Polish victims of the Holocaust.

Another early major figure was that of Erich Walter Sternberg, born in Berlin in 1891, whose devotion to Jewish music was intense long before he arrived in Tel Aviv in 1932. He won the Engel prize in 1940 and 1946 and was honored memorably by the city of Tel Aviv on his eightieth birthday. Among his many orchestral and choral compositions two of the most celebrated are *Twelve Tribes of Israel for Orchestra* (a theme for each tribe) and *Yishtabach* (Song of praise) for chorus, baritone solo and speaker, and an opera for children based on Hugh Lofting's *Dr. Doolittle.*

Another of the early composers to work in the Jewish-Oriental style was Oedeon Partos, a Hungarian who became the principal violinist in the Palestine Philharmonic Orchestra in 1938 and later leader of the viola section. In 1951 he became director of the Israel Academy of Music in Tel Aviv and ten years later associate professor at Tel Aviv University. His viola concerto, *Yizkor*, written to honor the memory of the victims of the Holocaust, won the 1948 Engel Prize. Among his other works are Five Israeli Songs, Metamorphoses for Piano, and Three Fantasies for Two Violins in the thirty-one-tone system.

A key figure in the development of Ben Haim's music and Partos's songs was Bracha Zefira, an early Israeli folk singer. Zefira, an alto, born in Jerusalem of Yemenite parents, was familiar with Oriental music traditions, both Jewish and Arabic. She studied in Europe where she met and married the composer Nahum Nardi, who became her accompanist. She influenced Nardi's compositions, but not only his. She commissioned Partos to provide an instrumental background for songs she sang a capella to him. She also influenced Ben-Haim, and she introduced the Oriental style to Boscovitch, Marc Lavry and Menahem Avidom. All used her melodies or composed for her. She was one of the first national figures in Israel's musical scene and the first famous folk singer among the people of the Yishuv. It was to the Jews of Yemen, Morocco and other Arab countries and from Persia that the composers and musicologists listened mostly in order to seek a distinctive Israeli style.

In 1945 the city of Tel Aviv instituted the Yoel Engel prize, which Sternberg won twice. Other prize-winners have been Ben-Haim, Lavry, Mordechai Starominsky, Alexander Uriah Boscovitch, Menaham Mahler-Kalkstein and

Oedeon Partos. Not too long ago the League of Composers declared the Israelis not sufficiently interested in their own composers, with the result that conductors do not present enough native music, contending that it hurts box office. The protestation is the same heard from the Boston Symphony Orchestra and its neglect of New England composers. What composers miss in Israel is the opportunity to hear the symphony orchestras and other large musical groups from foreign countries which, for economic reasons, rarely perform in Israel. Israeli conductors, among them Israeli's only woman conductor, Dalia Atlas, hear foreign orchestras when they go abroad, but unless the composers manage to travel they do not. Guest conductors from some of the world's great orchestras make fairly frequent appearances in Israel, but the orchestras themselves do not.

Composers of popular songs are more numerous per capita in Israel than in the United States. It has its own Tin Pan Alley, and like those of American composers many of the songs are drifting into the classification of folk songs; some have become indistinguishable from the ancient folk songs of a hundred countries that have been re-adapted for Israel. Most however are in the "popular" song mode. Time and again Israeli songwriters have won the Eurovision Song contest or generally distinguished themselves, either with a prize-winning song or by the performance of a musical group. One Israeli song, "Tzena Tzena Tzena" by Issachar Miron, swept the world. Here Is Israel, a prize-winning group, toured the world to unrelenting plaudits. Moshe Wilensky, another Israeli composer, has been called the King of Songwriters.

All this is moving toward a distinctive Israeli music, bucking, at the same time, the urge toward internationalism. At the moment the music of Israel is a rich tapestry woven in designs that speak of Israel, but the threads can still be identified from their sources. This is true of the national anthem, "Hatikvah," which like the national anthem of the United States is not quite satisfactory. The original melody is not Jewish at all, but comes out of Bedrich Smetana's *Moldau.* He had it from a Czech folksong. Then, too, the Hatikvah speaks of Zionist hopes rather than Israeli accomplishments, and, by the Jewishness of its theme, would seem to exclude Christian and Muslim Israelis. This is a more serious defect than its Czech origin, for, of course, the "Star-Spangled Banner" is of German origin. In any event, the Knesset has never given Hatikvah the official accolade it has given the Israeli flag or the state seal, but, despite all that, it remains indestructibly popular and impervious to the demurrers of a minority.

THE PHOTOGRAPHIC ARTS
AND RADIO

The people of Israel are cinema-mad. As a matter of fact they have great enthusiasm for the theater in general. The average Israeli adult attends the films about ten to twelve times a year, an incomparably high incidence. In the past year, however, the motion picture houses are suffering from the competition of home-shown films on the household's VCR.

Generally speaking Israelis seem to prefer films made abroad to those made in Israel itself. The reason for this is in great part the international popularity of American films, and films from those nations in Europe that have a long history of filmmaking, such as France and Italy. The reason is not the lack of quality in Israeli-made films. The filmmakers there very early passed from the apprentice stage to that of expert. They lack, of course, the multimillion-dollar budgets that make foreign films so attractive.

The films made in Israel divide into two sections: those made by Israelis and those made by foreign producers on Israeli soil. One must realize, however, the latter are produced with important help from the Israeli government, which as early as 1954 established an Encouragement of Filmmaking in Israel law which has been a boon to native and foreign filmmakers working in Israel. The government recognizes the film industry as a channel of propaganda, but beyond that there is evidence of the persistent Israeli interest in all forms of artistic endeavor.

The first film ever made in the Holy Land on a Jewish subject was an Edison-produced motion picture entitled *A Dance in Jerusalem*, filmed there in 1902.

Little more is on record until Sidney Olcott filmed *From the Manger to the Cross*. After World War I, newsreels and some Zionist propaganda films were made there, but it was not until the late 1920s that a formal film company was founded. The company, Moledet, was founded by Russian immigrant Natan Axelrod. The company concentrated on newsreels but made at least one successful feature film in Hebrew, *Oded ha-Noded*. Axelrod soon had a newsreel competitor, Baruch Agadati, who had been trained as an artist. Foreign companies were coming in to make films, and in 1933 Alexander Ford, the Polish film producer, brought in a Polish crew to make *Sabra*, a documentary film. Ford, incidentally, would leave Poland in 1970 because of censorship and emigrate to Israel. After World War II, the American director Herbert Klein made films of two scripts by the late Meyer Levin, *My Father's House* and *The Illegals*.

After the War of Independence, the Israeli government commissioned documentary films at two Israeli studios, the Herzliyyah and the Geva. Then came the Encouragement of Israel Films legislation. Some time later the Israel Film Center was set up in the Ministry of Commerce and Industry in Jerusalem. One of its foremost concerns is to assist foreign investors and film-makers to take advantage of Israeli film potentialities. Israel offers unique advantages. First of all year-round sunshine ensures uninterrupted production schedules. Any director who has sat around the Dingle peninsula in Ireland waiting for a return of the weather conditions under which he photographed earlier sequences yearns for steady sunshine such as one gets in Israel. Then too there is varied location. The contrasting topography of Israel has special value for moviemaking because the varied locations offer innumerable opportunities for filming. Thirdly, professional talent among actors, extras and technicians abounds. The Israeli industry suffered for want of talented scriptwriters, but they have come along fast.

On the technical side, Israel is strong. Complete production facilities with the most modern equipment are available: studios, laboratories, service companies and, above all, government financial assistance are major inducements. The financial assistance offered is a complicated matter involving bank loans, tax refunds, rebates on tickets at Israeli showings, reduction in taxes and special tax arrangements with nine other countries. The result of such government enthusiasm and support has had results. Taking 1968 as the turning point, filming in Israel has become a boom business.

The primary financial incentive to foreign investment in film production is the Refund of Indirect Taxes, which reduces considerably production costs. The refund is granted on any foreign currency converted into Israeli currency and spent in Israel on production of any category of film, excluding newsreels, provided that the total cost of "cinematographic services" rendered by Israeli

residents amounts to no less than 25 percent of the total expenditure in Israel on a given production. It is one of the tragedies of Israeli life that the government feels obliged to offer any foreign producer War Risk Insurance against any loss caused by an act of war or terrorism. But it is there. Motion picture producers are allowed to wander freely around the country and to choose their locations. Permits, naturally, are required for airport and military sites, and for some wildlife preserves and archaeological digs. Import duties are remitted on materials brought in for filming, and special workmen's compensation can be procured to cover accidents.

Two large laboratories handle the processing of color films, both located near Tel Aviv, while a third in Jerusalem handles black and white. The Israel Motion Picture Studio has a large soundproof filming studio with all modern stage features; catwalks, rails, automatic controls, air conditioning and more. Several studios are equipped for expert recording. Video equipment is on hand; technical personnel available in depth.

Because Israel is a small country of great contrasts, much is available with little travel. Mountains and plains, waterfalls and desert dunes are only minutes apart. The sea or woodlands, craggy desert scenery or green hills or a mountain peak, raging river-runs or the natural horror of the Dead Sea are close together. The wildlife preserves, with their ambiance of serenity, in which regard Israel has shown a sense of international responsibility, are shoulder to shoulder with the grim iron of Israel's defenses against enemy attack. One can dehydrate in the desert or plunge beneath the waters of the Mediterranean to observe the colorful submarine life.

Each town or city has its unique features to offer the filmmaker, and within the country also is the same contrast in time as there is in topography, from the oldest streets in Jerusalem to the most modern in Tel Aviv, from the Crusaders' walls at Acre to the latest longshoremen's equipment at Haifa. From the modernity of the Habimah Theater in Tel Aviv to the Roman antiquities of Caesarea, Israel is a nation of time warps. This shows in the films made there. They have an authenticity that cannot be matched by the faked facades of Hollywood or London; they are real.

When it comes to Biblical films, it is ridiculous to think of them being filmed anywhere else. Mildred Freed Alberg, a non-Israeli who has produced three films in Israel, said bluntly in an interview that Biblical films "must be done in Israel...it is the only natural place to do them." The best known of the films she has done there is *David and Saul*, shown nationally on American television.

Television came to Israel in 1968, giving great stimulus to filmmaking. An immediate expansion of facilities took place, personnel multiplied, and every studio found itself with more work than it could handle. By that time, Israel

135

had well established itself as a country to be reckoned with as a producer of films. Menahem Golan has produced at least nine films in Israel, including *Tevye and His Seven Daughters*, which translated to the stage in the United States as *Fiddler on the Roof* and ran for years on Broadway and in all major cities. The same film made Chaim Topol, one of Israel's leading actors, internationally famous when he took the show to London for the stage. In 1967, the year before the television boom, Oded Kotler, another Israeli star, was given the best actor's prize at the Cannes Film Festival for his performance in *Sheloshah Yamim ve-Yeled* (Three days and a child). In 1969 the government formed the Israel Film Center. For the most part Israeli films are in the Hebrew language, aimed at that small but enthusiastic audience. What has been seen in the United States is only a small fraction of the whole.

What is certain is that the Israeli filmmaking business — both independent and foreign — is growing and will in time take its place among the leading producers. The same Jewish genius that contributed so much to filmmaking in the United States and elsewhere is at work in Israel, and significant results can confidently be expected. The enthusiasm runs high. Jerusalem has just inaugurated its own version of the Oscar and Emmy awards, complete with ritualistic presentations and gold, silver and bronze trophies. The first Jerusalem Film Festival was held in October 1976 with government assistance and some foreign capital. A special emphasis was put on films about Jews made by non-Jews. Jewish stars of television and motion pictures from all over the world were on hand. The festival has become a regular event of cultural life in Jersualem.

Films remain the most popular art form in Israel, and while it was thought that the introduction of televison would reduce drastically attendance at the cinemas, this has proved not to be so. The cinema audience, in Israel as elsewhere, is a youthful audience. Television, once introduced, expanded very rapidly. The government estimates that half the population watches television daily, but as in the United States, the medium is a disappointment. The programs with the best ratings are, unfortunately, those which rate highly in the United States, such things as *Kojak* and reruns of other American crime shows. Television, however, plays an important part in the education of the peoples of Israel.

Despite the introduction of television and the impact it necessarily has on rival media, cinema attendance in Israel continues per capita the highest in the world. Though there are no figures on the number of VCRs in Israeli households, it is obviously growing. Radio broadcasting suffered more than the cinema in households that have television. The benefits of television to the film industry have already been cited.

Television has become a source of great concern for the government because

the effect of its incalculable impact on the populace worries political scientists, particularly those Zionists who hope for the creation of a distinctive culture and fear an extension of creeping Americanization or Europeanization. Whether it will impede or contaminate the effort to create a distinctly Hebraic culture is an open question.

The issue of whether or not the country should have television at all was debated for ten years. Advocates insisted it would stimulate Hebraic culture, educate the immigrants, aid the mastery of Hebrew and inculcate Israeli patriotism. Others saw it as the best way to reach the Arabs, not merely in Israel but outside its borders. In 1960 probably less than 2 percent of the population had television sets in their homes to pick up what programs they could from outside Israel. When Israeli telecasting began in 1969, more than 30 percent of the population had sets, and by 1975 the incidence was over 60 percent, and about 80 percent of those set-owners regarded themselves as regular viewers. Sets are expensive, and one must pay for a license to own one. The government station broadcasts only a limited number of hours.

About 50 percent of the programs are imported, and a good proportion of the teletime is given over to programs for the Arabs, which doesn't please those Jews who cannot get enough of American programs. Many of them complain about the quality of all television, a state of mind not uncommon elsewhere.

Two Israeli scholars, at the instigation of the late Zalman Aranne, Minister of Education and Culture, made a concentrated study of Israeli cultural responses in all areas—from football to television to reading books and newspapers. They are Elihu Katz and Michael Gurevitch, founders of the Communications Institute of the Hebrew University in Jerusalem. The study was published under the title, *The Secularization of Leisure: Culture and Communication in Israel.*

The study is chock full of statistical information as to who in the population does what, prefers what, needs what, and disdains what, and what all that forebodes for Israel. Each chapter in the book could be extended to a book in itself, or indeed many volumes. What is most interesting is that the study itself is a pioneering work for which we have nothing analogous in the United States, and perhaps could not achieve in so large and diverse a country.

The Katz-Gurevitch study presents a whole galaxy of cultural aphorisms and suggestions, and poses any number of very knotty questions regarding the support of cultural activities in a democratic society. Among them is the question of whether or not, seeing the amount of leisure time given by the population to television, whether or not the government expenditure on improving its quality should not be greatly increased, a most sensible question which is not even being asked in the United States. In Israel, of course, television carries no advertising.

137

The authors also make two final points. First in their own words:

> The investment in culture, however, cannot succeed ultimately without giving careful attention to the education of the consumer of culture. Knowing how to view a film or television program is as important, these days, as knowing how to read a book or a newspaper — not that many people approach those arts as critically as they might. The education of the consumer of culture and mass communication begins at home and school of course, but like all education it is a lifelong task. It thus properly belongs in the realms of the cultural policy-maker and the adult educator.

In this regard, Israel already does quite well, but the determination to do better is the outstanding mark of all approaches to the arts in Israel. The second final point they make is that such studies as their own should be made periodically, perhaps every five years.

While television has not cut drastically into film attendance or reading habits, it has certainly reduced the number of persons who listen to the radio. Before television came they listened approximately an hour a day, according to one study. But these figures are discounted, and indeed, actually denied. It is difficult to arrive at any figure on how much time is spent listening to radio, since many people keep their radios on all day long for background music or just friendly, companionable noise. Indeed, one could say that radio-listening in Israel is ubiquitous and constant.

The reason for this is a sad one. Israelis are voracious for news because of the constant dangers that enfold the country, and they are forever on the alert for the ominous announcements that they are again being stormed, terrorized or summoned to arms. The important point to be made is that Israel's Program A, which carries classical and semi-classical music and intellectual panel discussions and lectures, gets 51 percent of the educated, mature audience, as opposed to 20 percent of the young people. So long as the Jewish passion for music persists in the Israeli of the twentieth century, the radio in Israel will have a large stable audience, let television do what it will.

The Israeli Broadcasting Authority, which has charge of television and radio, offers the country five radio programs on twenty-five wavelengths, more than half of them FM, for a total of eighty-two hours daily. News bulletins in Hebrew are given regularly, and there are daily news bulletins in half a dozen languages, including easy Hebrew for immigrants studying the official language. One network broadcasts 17.5 hours a day in Arabic, news programs, commentary and discussion, as well as Christian and Muslim religious services. English and French programs are also beamed over the same radio network. Another network sends programs on shortwave overseas to Europe and Africa in ten languages. The government also ships transcribed programs to more than seven hundred organizations all over the world.

Israel is, of course, one of the most photogenic countries in the world, and it should be no surprise that still photography should be an important art form there. In 1980 an international show entitled *Vision* went on the road. It was received with great critical acclaim in the United States where it demonstrated the versatility of photography. In their catalogue the twenty photographers represented in the show published a statement by one of their members, Eyal Onne:

> Our photographic heritage may be divided into four periods: the Ottoman period, 1839-1917; the British mandate, 1917-1948; the independent state of Israel's early days, 1948 to the early 1970s; and the current period, beginning in the 1970s. During the Ottoman period, intense photographic activity was motivated by commercial, scientific and religious incentives. It was mainly a foreign activity, practiced by visitors from the West. Later on, especially during the period of the British mandate, the shift was toward propaganda photography, practiced by new immigrants working for such institutions as the Jewish agency. Thereafter, largely during the third period, the craft of photography and its utilitarian functions developed into a professional discipline.
>
> During all this time there was no supporting framework in the form of galleries, museums, periodicals, schools or workshops to promote and nourish photography as an art form. It was only in the early 1970s that things began to change. The return of Israelis from abroad, together with the arrival of new immigrants who studied photography and practiced it as an art form, left a positive impression on the Israeli photographic scene. The First Triennale of Photography in 1973, and the second in 1976, both held at the Israel Museum, offered an opportunity for photographers from around the world. In 1974 the first display of Israeli photography was shown at the Israel Museum, an exhibition entitled *Situation* (which had been the last link of the First Triennale). Although this exhibition overly inclined toward photojournalism and a documentary approach it was undoubtedly a stepping stone. Thus it is not surprising that in this exhibition we find two photographers whose work is included in *Situation.*

By 1978 the Tel Aviv Museum had appointed an advisor for photography, and the Israel Museum had inaugurated its photograph department. In the same year, the White Gallery, the first gallery in Israel devoted exclusively to photography, was opened in Tel Aviv. In 1982 Tel Aviv witnessed the opening of the second such gallery, the Gallery of Photographic Art. It is an interesting note that of the twenty photographers who exhibited in the *Vision* show, four were born in the United States, three in Germany and one in Yugoslavia. The remaining dozen were sabras.

POSTAGE STAMPS AND COINS

Israel's concern for the artistic is nowhere more visible and yet generally unnoticed than in its postage stamps and coins. Philatelists and numismatists, of course, are very conscious of the artistic quality of Israel's stamps, even its cancellations and first-day covers, and its coins and commemorative medals. From the first issue, the stamps of Israel excited collectors not alone for their appreciative value but for the concern, thoughtfulness and ingenuity that have gone into their production. One inducement, to be sure, has been the manageable limitations of the postage stamps that were and would be issued — a collector could start at the beginning and be prepared to have a complete collection for a relatively modest expenditure. While this is true of any new country — and this century has seen a hundred — Israel more than the others has won the attention of philatelists.

Before the State of Israel was thought of, philatelists had specialized in postage stamps dealing with Jewish subjects, portraying on them distinguished Jews or subjects of Jewish significance. There was a great deal of that. Israel was again different. For the Jewish collector Israel presented a preeminent opportunity to form a collection with a very sentimental quality over and above such value as might arise from the charm or the rarity of the stamps. Certain collectors previously had specialized in stamps from the Holy Land or its environs regardless of who issued them. To such collectors, one can see, the Israel issues became another major facet of their collection, a new, exciting and engrossing area. None who started to collect Israeli stamps in the belief

that they would be produced with care, artistic competence and a conservative economic sense, has been disappointed.

Since its foundation Israel has produced more than five hundred different stamp issues all marked by attractive composition and colorful design. Among the many series that have been widely admired for artistry are those depicting ancient Jewish coins of the Holy Land, the twelve tribes of Israel, the signs of the zodiac, and the emblems of the cities and towns of Israel. The airmail issues featuring birds, landscapes and the exports of Israel are also philatelists' favorites.

The country has its Association of Israel Philatelists and any number of minor clubs throughout the country, all devoted to the collecting of stamps and the exchange of information. The high interest in philately in Israel is no doubt in great part due to the high level of artistic attainment in Israel's own stamps. Israeli collectors, as one might suppose, do not confine their collections to Israeli stamps or Middle East issues but, like collectors everywhere, have a variety of tastes. In Israel there are collectors who specialize, some of them concentrating just on the stamps of Israel. If one prefers the stamps that have been issued in Eretz Israel along with those of the State of Israel, it opens many doors.

The first post office in the Holy Land was established in 1852 by the French through arrangement with the Sublime Porte, the title given in those decades to the offices of the Turkish government. The French post office was located in Haifa. Two years later Austria opened offices in both Jaffa and Haifa and, in 1859, one in Jerusalem. Russia and Italy soon followed with offices, and those of Italy were the first to bear an overprint or surcharge reading "Gerusalemme." Such arrangements with the Sublime Porte ended when General Allenby conquered Palestine in the 1915-1917 campaign. In December 1917 the first stamp printed in the Holy Land under British auspices appeared. In 1920 the British government printed a postage stamp with Hebrew lettering, the first postage stamp in history inscribed with functional Hebrew. The lettering was the abbreviation for Eretz Israel. Not until June 20, 1948, did stamps bearing the legend ISRAEL appear, but they were not the first official stamps of the state. From the British departure from the Holy Land in April and May, 1948, until the establishment of a functioning Israeli postal system, a variety of curious stamps were printed by local bodies, all of them now in intense demand by collectors because of their rarity.

The Encyclopedia Judaica points this up:

> On the departure of the British in April-May, 1948, many of the post offices were taken over by the Minhelet he-Am and from May 25, 1948, by the government of Israel. During the War of Independence communications were extremely difficult, and from time to time the supply of postage stamps ran

out. In order to overcome the shortage and to continue a regular postal service until the Government of Israel could supply the new stamps, many issues of a local and provisional nature appeared. Noteworthy among these, and eagerly sought by philatelists, are the Jewish National Fund labels overprinted with the word Do'Ar (post) and the the local issues of Safed, Rishon le Zion and Petah Tikvah. On May 9, 1948, when Jerusalem was under siege, the first set of local Jerusalem stamps was issued. There were J.N.F. stamps showing the map of Eretz Israel and with the frontiers of the Jewish state and the "international" city of Jerusalem as proposed by the United Nations in its decision of November 27, 1947. Overprinted with "Do-Ar" and their value in mils in Hebrew lettering, the stamps were in use until June 20, 1948, when the stamps of the State of Israel became available.

These first stamps were printed with the utmost secrecy on a small letterpress, and on May 16, 1948, were issued the first official stamps of the new State of Israel. Curiously, they didn't bear the name of the new state because their production began before the name had been chosen. The stamps were marked "Do-ar Ivri" or "Hebrew Post" in Hebrew characters.

The set, issued with nine values, bore representations of ancient Jewish coins, and remains to this day the most coveted set of Israeli stamps. They were put on sale May 16, 1948, throughout Israel. Collectors and enthusiasts lined up to buy them while Arab bombs were still falling. The State of Israel had been proclaimed the day before and given its name, but the issue had been launched too soon to print the formal name. To depict the ancient Jewish coins on the set, which was designed by Otto Wallish, was a master stroke.

The flag of Israel was shown on one of the first stamps issued by the government, and in May 1949 a stamp was issued commemorating the issuance of the first stamp. Israel has been very faithful to the remembrance of anniversaries in its stamps. Theodor Herzl has been honored more than any other person by depiction on Israeli stamps, with Chaim Weizmann, the first president, a close second. A number of artists have been honored by having their paintings reproduced on stamps, among them Ardon, Ticho, Zaritsky and Moshe Kisling. President Harry S. Truman and Eleanor Roosevelt are among Americans honored. S. Y. Agnon, the Nobel laureate novelist, has had a stamp, as has had Uri Z. Greenberg, the poet. One of the most unusual depictions has been a graph of the decline of malaria in Israel with the infectious mosquito, the *anopheles maculipennis*, portrayed. The stamp was issued to honor the World Health Organization's fight against malaria.

An outstanding collection of ancient coins of Eretz Israel is located in the Bank of Israel. In the turbulence of the years preceding the War of Independence in 1948, during the war itself, and in the subsequent years of the infant republic, the Bank of Israel did not neglect the aesthetic aspects of the

143

new Israeli coinage. One of its earliest actions was to collect the ancient coins of Eretz Israel, not merely those of Jewish origin, but all coins related to the Jewish struggle to maintain Jewish independence in the Holy Land.

From the first it was decided that the new Israeli coinage would be — aesthetically — a continuation of the ancient coinage of the former Jewish states. A beginning of the collection the bank ultimately made had already been assembled in the Bezalel Museum, and two expert numismatists were on hand to advise the authorities, Mordechai Narkiss, a director of the Bezalel Museum, and Leo Kadman, president of the Israel Numismatists and founder of the numismatist museum in Tel Aviv.

While the Bank of Israel collection is of great value to historians, archaeologists and numismatists, above those interests was the psychological impact made by the depiction of those ancient coins on the stamps of the new nation. They document the Jewish claim that the term Eretz Israel is a more suitable name for the country at large than Palestine. That name came from the Philistines who long ago disappeared from history. Thus the representation of those ancient coins on the first stamps of Israel was a positive piece of propaganda, a magnificent assertion of the Jewish right to the land for which they had spilled their blood and would spill more. "The first stamps we've printed in two thousand years," one wit said with a whimsical hit at the truth, for the coins pictured on the stamps were Jewish coins minted two thousand years before.

The ancient Jewish coins in the Bank of Israel collection were those minted under the Hasmonean high priests (Jewish rulers hesitated to take the name Melek or king) and by the followers of Simon Bar Kochba during the two wars for independence that the Jews last fought in the years 133-135 C.E. In the first, the Hasmoneans, heirs to the Maccabees, were defeated by the Roman generals Vespasian and Titus, both of whom went on to be emperors, and in the second by Hadrian's general.

The extent of the Jewish resistance in the First War against the Romans, when the infamous destruction of the Second Temple took place, can be measured in part by the coinage struck by the Jews. They drove the Romans out of Caesarea and had control of most of the country. Nero sent his foremost general, Vespasian, to quell the revolt. He began slowly to subdue the Jews, was named emperor before the job was done and turned it over to his son, Titus. For the first year of that war, the Jews minted their own coinage in both bronze and silver. To cast money in silver was a stroke of psychological warfare, for it was understood in the Roman empire that only the emperor could coin silver. That action taken by the Jews was like a battle cry. In those days of limited communication, despite the fabulous Roman roads, coins were a common means of propaganda. For one thing, Roman coins let the peoples

of the empire know who was emperor and what he looked like. The Jews, or course, shunned putting the human visage on a coin, inhibited as always by the Second Commandment. Even the Herods, Hellenizing as they were, were careful not to offend in this manner, although they liked to indicate on their coins that they were friends of the ruling Caesar.

The coins issued in the First War against the Romans are, interestingly enough, marked by exquisite artistic design and execution, with a restrained beauty. They are dated Year One, Year Two and so on through Year Five, the years of the war, also the years of duration of that embryonic Jewish state. They do not bear the name of any king, prince or leader, but are issued in the name of Jerusalem the Holy and bear the legend Shekel of Israel. Their artistic motifs can be found in the decorations of ancient synagogues in Eretz Israel—floral patterns, the lulav and etrog, a chalice, an amphora, a vine branch or its leaves or tendrils, or a palm tree. One can readily see how the inscription, Jerusalem the Holy or another, equally common, Of the Redemption of Zion, appearing on postage stamps in 1948 when the infant state was fighting off the Arabs to "redeem Zion," would exalt the spirit and magnify the soul of any Jew. Here was continuity with the very beginnings of Israel, the legitimization of the claim of the Jew to the land he had tilled with his bones and moistened with blood and tears. The stamps shone.

The coins were also those of Bar Kochba who warred against the Romans fifty-two years after the Roman legions had destroyed the temple. On these coins Bar Kochba inscribed himself not as *Melek* (King) but as *Nasi* or Prince of Israel. He cast silver and bronze, reusing old Roman coins. He dated them as of the years of his revolt, but dropped Zion for Israel—The Redemption of Israel. The designs are similar to those minted during the First War against the Romans but with more variety of design. The charismatic leader's name appears on them as Shi'mon (Bar Kochba was a nickname). Besides the amphora, the lulav and etrog, the palm branches and the vines, the coins pictured musical instruments, the lyre and the trumpet, a wreath of leaves, a bunch of grapes and the face of the Temple.

In 1947 the Bank of Israel published an excellent book showing its collection and presenting extensive notes on the historical background of the various coins. What it shows is that although coinage came late to Eretz Israel, Jews minted the coins in the Holy Land before the Romans came in and as late as 135 C.E.

No issue of postage stamps in Israel could have the impact of that first set displaying those coins. With understandable pride, the government has seen to it that the design of present-day coinage in Israel takes its cue from the designs of those coins of the recrudescent Jewish states that sought to throw off the oppressor's yoke and reestablish Israel, the kingdom of Solomon and

145

David, the ancient and traditional government of the land. The result has been one of the most attractive coinages of the present century.

When the State of Israel was founded, Palestinian coinage continued in use for about a year, with Israeli coinage side by side. Demonetization of Palestinian coinage came in 1949. From 1948 until 1954 money was issued by the government. In 1954 the responsibility was transferred to the newly formed Bank of Israel. From 1954 to 1959 the bank continued to issue the same coins as were previously issued by the treasury of Israel.

In August 1948 the government minted the first Israeli coins, cast in aluminum and bearing an impression of a bunch of grapes taken from one of the Bar Kochba coins. The denomination was twenty-five mils, later replaced by the word *perutah*, which in turn gave way to *agorot* and that in turn to *shekel*, as the inevitable devaluation of the Israeli pound occurred. The most significant thing about it, apart from its primacy, was that it determined the sort of design that has persisted in all Israeli coinage. A stopgap coin, it was soon replaced by what is known as the perutah series, which prevailed from 1949 to 1960. In this series there were eight denominations: 1, 5, 10, 25, 50, 100, 250, and 500, each with its own design drawn from the flora of Israel and the workmanship of the past. With the perutah series the government took numismatists into consideration. It was recognized from the beginning that coin-collecting by enthusiasts and investors is as inevitable as rain and taxes. The perutah series underwent various changes over the years (there were in all four types of the ten-perutah coins in bronze and aluminum). That was not calculated. The 250-perutah coin was issued for use in cupro-nickel and then in silver especially for collectors.

The five hundred-perutah coin was minted in silver only and for numismatists only for it was not put into circulation. In all there were twenty-five types for the eight coins. From 1949 until 1954 these coins were minted in England, but in the last year the Israeli mint was established, although foreign mints would be used to supplement the Israeli production until 1957. Since then all trade coins have been minted in Israel.

The designs of the coins, while always subject to government approval, have been chosen by the Bank of Israel, by tender among qualified artists. The bank accepts the recommendation of an advisory committee.

In 1950 a new issue replaced the perutah coins. Until the the Israeli pound (*lirah* in Hebrew and hence using an £ after the English fashion) had been divided into a thousand perutah. In 1960 it was decided to divide it into a hundred agorot. Four denominations were introduced: the one agorah of aluminum, and the 5, 10 and 25 agorot of cupro-nickel-aluminum. Three years later the series was completed by the addition of the half-pound and one-pound coins in cupro-nickel. The two were so alike that the pound was withdrawn and redesigned.

When the design of the coins was being considered by the government, the first expert they called upon was the late Dr. Leo Kadman, the founder of the Kadman Numismatic Museum in Tel Aviv, now part of the Ha'aretz Museum there. Hanan Pavel, another expert, and the artist Otto Wallish, who designed a number of Israeli stamps, were also consulted. Dr. Kadman was a businessman who went to Eretz Israel in 1920. Through his avocation, numismatics, which really developed after his arrival in the country, he became an outstanding authority. At a meeting of the Israeli Numismatic Society he was cited as having "inaugurated the systematic study of the city-coins of ancient Palestine." The first four volumes of his *Corpus Nummoreum Palestrinensium* are reckoned "indispensable tools for any scientific study of the coins of Palestine."

Wallish was an Austrian Jew, born in 1906, the year Boris Schatz went to Jerusalem. Wallish arrived in Israel before the creation of the state; besides being in Zionist work, he was soon recognized as an accomplished artist. It was he who designed the famous "Do-Ar Ivri" set of stamps, printed before Israel got its name. He, with Kadman and Pavel, designed the first coins. He joined with Kadman in saying that there is no "greater satisfaction that can come to a numismatist or artist than to design the coins of his country."

Israel's commemorative coins have also won a high place with numismatists. The first of the commemorative coins was not minted until ten years after the founding of the State of Israel, minted to mark the anniversary. Anniversary coins have been issued annually, at first in five-pound denominations but since 1968 in ten-pound. Among some of the very special commemorative coins were those issued to mark the centenary of the birth of Theodore Herzl, the father of Zionism; a hundred-pound coin to mark the tenth anniversary of the death of Chaim Weizmann, the first president of Israel; coins to commemorate the Six Day War; and a hundred-pound coin to celebrate Israel's twentieth anniversary and the reunification of Jerusalem. Some half-shekel coins have been issued by the Bank of Israel to coincide with the feast of Purim. All these coins were issued as legal tender, although special issues called proof coins were issued at the same time as the regular coins.

Some of Israel's most outstanding artists have designed coins for the country. In many cases one artist did the obverse and another the reverse. It is one place where a collaboration obviously works well. Among the most beautiful of the commissioned coins are the designs struck for the annual celebration of the anniversary of the founding of the state.

Besides the special coinage that has been minted, the Israel Government Coins and Medals Corporation has struck scores of commemorative medals and medallions for a variety of reasons. One has honored the Tel Aviv International Trade Fair, another a Chess Olympiad held in Israel, another the launching

of Israel's rocket that made it the seventh member of the International Meteorological Club along with the United States, Russia, France, Britain, Italy and Japan, a triumphant scientific feat for so small a country. One medallion honored Senator Daniel Patrick Moynihan for his years as U.S. ambassador to the United Nations.

One of the loveliest state medals was struck in 1959 to commemorate the International Harp Competition. The harp has long had a special place in Hebrew culture since King David was himself a harpist, and a harp appeared on one of the coins cast by Bar Kochba in 135 C.E. To the Jews the harp was an instrument of gaiety, and the Bible tells how the sorrowing exiled Jews in Babylon would not play their harps for their captors but hung them on trees. The obverse of that medal depicts King David standing playing the harp, his royal crown on his head, his figure flanked by Hebrew lettering. Three thousand of these medals were struck in silver.

Packets of Israeli stamps are for sale, of course, in every philately store in America. For the amateur who is not eager to collect but interested in scrutinizing the achievement, Israel has brought out a postage-stamp catalogue issued by the Israel Ministry of Communications-Philatelic service.

In that catalogue are presented in vivid color all the various stamps issued by Israel. Detailed information is given on each stamp: the designer, the method of printing, the occasion for issue, the number printed, the motif, date of issue, the denominations and the date when sale was discontinued. All such material is of value to the collector. Examination of the stamps themselves will delight the eye of anyone with an aesthetic sense. They are simply good fun to look at and read about.

At one time, a Los Angeles philatelic club voted for the most beautiful stamp of Israel. The accolade went to a thousand-perutah stamp issued February 27, 1952, designed by Otto Wallish, called the Menorah Stamp. On a blue background, silver-gray emblems of the twelve tribes of Israel wreath around a menorah of the Second Temple in the same color. The stamp is a miniature masterpiece. The designers of Israel are the heirs to the great medieval tradition of the miniaturists, men who decorated scrolls, illuminated manuscripts and adorned the Haggadot. It is no surprise that several Israeli stamp designers have been elected by other countries, China for instance, to design stamps for them.

ECOLOGY

Nineteen times in the Bible, Israel is referred to as a land "flowing with milk and honey." In Hebrew, the word for honey is *devash*, but although everyone promptly thinks of honey from the honey bee, that is not the meaning at all. Honey from dates is the far more likely meaning, and fruit juices generally would suit. Over the centuries, the happy title of "milk and honey" vanished. With the departure of the Romans, Palestine was in time eroded by marauders and nomads with herds of sheep and black goats, and, as in much of North Africa, the loam was kicked and blown away and sand took over. For two thousand years the land was neglected, and little other than the Jordan Valley remained green. The people of Israel have begun to reverse the process. Well known are their agricultural accomplishments in the Negev where they have made the desert bloom. Less publicized is the concern of the people and the government with ecology. Their problem has a unique double prong: the condition of the country when they took over and the compromises they had to make to bring in and house a mounting population in a limited period of time.

With the people of Israel, however, there is a unique psychological dimension. No other people cherishes the past as do the Jews; no people's collective memory delves back as far, for their history runs to the days of the creation of the world. All through that history one thread is the sanctity of land; it is the reward for obeying the will of God. But above all, it is God's land; the Jews and others are sojourners. In the book of Leviticus, the Lord says, "The land also shall not be sold forever: because it is mine, and you are strangers and sojourners with me." The land is sacred and shall not be despoiled, and although some Israelis may ignore the commandments, the

149

tradition remains pervasive through the culture.

Today their ecological concern is ubiquitous, although not everywhere victorious. The smog over Haifa on occasion can match that over Los Angeles, and industry in other areas can have a blighting effect. But the battle has been joined in an attempt to make Israel beautiful as well as green. Much of Israel's topography is harsh, and every bit of soil is cherished. It should be no surprise that ecology (so allied to the arts) is a major concern for the government, the universities and private civic-minded organizations. The Society for the Protection of Nature in Israel publishes a quarterly magazine called *Land and Nature.* At the Hebrew University there is a Department of Forest Ecology; a Holy Land Conservation Fund has headquarters in New York; and ardent citizens in Israel have formed the Council for a Beautiful Israel. The government has a National Parks Authority and a Nature Reserves Authority.

So rapidly did Israel grow, so multitudinous were the immigrants in the early aliyahs, that kibbutzim, moshavim and towns sprang up overnight, with destructive effects on the countryside. Then one must not forget the ravages of war when the country was invaded. Land was despoiled, water wasted, and the flora and fauna in many areas hurt. The necessities of agricultural accomplishment, so highly praised, universally have caused damage. Pesticides used to make the Negev fertile and to fight the jackal and various rodents have had deleterious effects. For one thing, when the wild rodents of the Negev became poisoned, the lappet-faced vultures that fed on them were in turn poisoned. The griffin vulture is threatened with extinction. Efforts to breed lappet-faced vultures in captivity and restore them to the wild by zoologists at Tel Aviv University have been promising, however.

Nature reserves in the country have become tourist attractions. There are 120 in all, most of them open to the public, but some closed to enable scientists to pursue their studies. The largest is Mt. Meron, with 17,500 beautiful acres near Safed, the peak of the mountain in the reserve rising 3,690 feet. The Safari Park at Ramat Gan boasts hippopotamuses and white rhinoceroses and other exotic specimens. The presence of hippos and rhinos is not without justification. Millennia ago Israel had a climate like that of East Africa today, and the bones of hippos and rhinos have been found in excavations. It is an interesting and somewhat touching gesture to have them back.

The Safari Park is quite different from the eight thousand acres at Hai Bar, a nature reserve at Yotvata, forty miles north of the popular beach resort Eilat. The purpose of that reserve is to gather and exhibit the extremely diverse range of animals named in the Bible. While Israel's indigenous mountain goat, the ibex, is doing well around the Dead Sea, thanks in great part to Israeli conservationists, the Arabian oryx and the Saharan addax had to be imported for the Biblical collection. The Arabs refused to sell any to

Israel, so it was necessary to wait until they had been bred in captivity elsewhere.

Husbanding not merely the flowers, trees and shrubs that are mentioned in the Bible, but growing as great a range as possible of all the flowers, trees, plants and shrubs of the world is the ambition of the Jerusalem Botanical Garden. This extraordinary enterprise has aims deemed possible because of the geographical position of Israel, where tropic conditions meet those of the temperate zone. To be technical about it, in Israel four phytogeographic areas are distinguished: the Mediterranean, the Irano-Turanic, the Sahara-Sindic and enclaves of the tropical Sudanese. The result is that the sweep of flowers in Israel is one of the broadest and richest in the world. More than 2,250 plant species have been identified as growing there. In England there are 1,700, in Egypt 1,500 and in Norway 1,300. The Israelis are bringing in more. Even a giant redwood (not quite a giant yet) is growing there, along with a Canadian maple and a New England spruce, this last looking quite a tidy stranger beside the ubiquitous scraggly Jerusalem pines.

Millions upon millions of trees have been planted in the reafforestation program in which people from all over the world plant to honor the memory of the dead. Few visitors to Israel have failed to participate in the program. To honor those persons who, during the dread years of the Holocaust, stood heroically by the Jews, Israel plants trees. Forests planted from seed or sapling are named for persons of international distinction. The passion for tree planting takes peculiar twists. On the slopes of Mt. Carmel near Haifa there is an "Infertility Forest." Each tree planted there marks the birth of a baby to a woman with fertility problems successfully treated at the Kupat Holim Linn Clinic in Haifa. When women sought to press gifts on Dr. Shlomo Carmel, who heads the clinic, he asked that instead they plant a tree. The Jewish National Fund, long concerned with ecology, has taken over the project. More than eight hundred trees have been planted in the forest. Well over a million trees have been planted in the American Bicentennial Park, which has been created fifteen miles southwest of Jerusalem in an uncultivatable area.

The greatest reserve for birds in Israel is in the Hula Valley, a great basin north of the Sea of Galilee, hemmed in by hills and mountains. It measures twenty-five kilometers north to south and six to eight kilometers east to west and was until the 1950s a great swamp. The waterflow in the Hula Basin has been linked to the Jordan River in a huge water control project. The area suffered severely during the War of Independence and required a good deal of tender loving care to make it what it is today. The swamp has been replaced by fruit orchards and other crops; carp abound in ponds, and the whole region is a haven for native birds and a resting place for migratory flocks on their way to Asia and Africa.

Birds have a special significance for Israel. Ornithological imagery runs through the Bible. The Hebrews came out of Israel on the wings of the eagle. In the Book of Job, the Lord asks: "Who gave the ibis wisdom and endowed the cock with foreknowledge?" And again, "Can the wing of the ostrich be compared with the plumage of the stork or the falcon?" And again, "Does the hawk take flight on your advice when he spreads his wings to travel south?" Forty species of predatory bird were accounted in the Biblical lands. In all, ornithologists declare that there are 360 species of birds in Israel of which at least 150 nest there, 100 of them as permanent residents. As more and more of the land became occupied, the predatory birds retreated to the hills, mountains and gorges of the desert areas, while those species that follow farmland and civilization came in and multiplied. Along the Mediterranean coast there are gulls and other shore birds, but just as the coast is poor in harbors, it is poor in nesting areas.

At Tel Shikoma near Haifa is the Oceanographic Institute. Among its other concerns, it is engaged in the preservation of sea organisms threatened by pollution. The Mediterranean is a supersensitive sea since it has only one outlet, and that at Gibraltar far from Israel. Israel is part of the United Nations' "blue plan," an environmental program that examines various species of fish and molluscs for poisonous levels of trace metals. Oil washed up on the shore is quickly identified. Most of such pollution comes from Middle East oil tankers disposing bilge into the sea. If caught in the act in Israeli waters they are severely fined. At the Oceanographic Institute, scientific study of fish farming proceeds, studies that will benefit all African nations with arid coastlines and a need for food. Other experiments are finding uses for algae and horseshoe crabs brought in from the United States.

In Israel there are also seventy-six sorts of reptiles and more than four hundred types of fresh and saltwater fish. St. Peter's fish out of the Sea of Galilee is highly regarded on the table, though perhaps not by a New Englander brought up on haddock. Bream from the fish farming may be preferable to some tastes. More than three hundred species of fish have been identified off the Israeli coast. At Eilat, the beach resort to the south, ecologists are concerned about preserving the beautiful coral growths and the multicolored fish that abound in them. The government is acutely aware that both have suffered from the intrusions of man.

The National Parks Authority, established in 1963, today has charge of at least fifty sites designated national parks. There are, of course, innumerable Biblical sites in Israel along with the remains of Jewish, Roman, Byzantine, Muslim and Crusader constructions or settlements. Many of the archaeological digs in the country are the reponsibility of the National Parks Authority, from the Tomb of Zacharias in the Kidron Valley to the tomb of Maimonides in

Tiberias. The authority is also responsible for the Crusader "cities" at Caesarea and Acre; the Roman theater at Caesarea, where magnificent musical evenings have been staged; for ancient synagogues at Bet Alpha and Baram; and for the necropolis at Bet She'arim. One of its most visible projects for tourists arriving in Jerusalem is the green belt circling the walls of the Old City. Natives and tourists make millions of visits to the parks each year.

Although many a quarry has defaced the landscape, blasting at one near Beit Shemesh gave Israel an interesting natural phenomenon when a cave was uncovered never before seen by man. The Sorek stalactite cave is the central tourist attraction at Avshalom Shoham Nature Reserve, a park named for a hero of the War of Attrition who died in the Suez battle. While thousands are eager to visit the cave, only a few visitors can be accommodated at one time lest the presence of too many alter the temperature of the cave. The Minister for Agriculture has called it one of the "most precious jewels of the state."

In 1971 Yona Fischer, curator of the Israel Museum, mounted a show entitled *Concepts Plus Information*, an exhibition featuring conceptual art. The dominating work in the show was by the late Yitzhak Danziger, sculptor, and one of the major figures in Israeli art. The work was called *Seeded Canvas Growth*. A hanging, sloping canvas dominated a twenty-foot square area. The canvas was treated with an emulsion, seeded, warmed by lights and watered by museum attendants. With the passage of time, the seeds sprouted, changed color and had even head-scratching cynics coming back a second day to see what was happening. Danziger's piece was probably inspired by his being called in by Technion (Haifa's M.I.T.) to help beautify a torn landscape. Subsequently an abandoned quarry, left like a cruel scar in the landscape, was beautified by the museum, the Technion and industry in a collaboration. The quarry face was dynamited in order to get a slope of stone rubble that could be made to retain soil. Great care was given to soil, seed and design in order to turn what was an eyesore to a thing of beauty, not easy to do in a climate that has eight months of drought. The work was costly but effective.

Louis Bromfield, the American novelist and farmer, drew on ancient wisdom when he wrote, "As soils are depleted, human health, vitality and intelligence go with them." The Israelis are well aware of the consequences of soil depletion. In Jewish folklore the desert is evil, and in the hearts of Israelis there is a detestation of it, a determination to push it back. On the other hand , the beauty of the desert areas is magnificent, something that Israelis want to retain. The Israeli Defense Forces, after the return of the Sinai to Egypt, had to redeploy in the Negev with subsequent threat to its fragile ecology and the wildlife there. Dr. Amotz Zahavi, director of the Institute for Nature Conservation Research at Tel Aviv University, anticipated the threat and presented a detailed report to the Nature Reserves Authority to reach an accommodation

with the armed forces. Study after study of the Negev and desert areas aims at locating and conserving its wildlife.

Joseph Tamir, a member of the Knesset, founded the Council for a Beautiful Israel and brought together the Israel Interparty Committee for Ecology and Environment. He acknowledges that Israel, like the United States, was slow in awakening to the dangers involved in unmonitored industrial developments. The word "desertification" was created by Dr. Erik Eckholm of Worldwatch Institute, an environmental research organization based in Washington, D.C., to call attention to the destruction of arable land in the world as desert slowly takes over. Techniques developed in Israel could help check that catastrophic encroachment.

The Council for a Beautiful Israel concerns itself with major problems of ecology but also with such minor problems as street litter. It also has a design committee, a voluntary body of architects and artists who approach and advise municipalities on improving town appearances, the placement of street furniture, street signs, advertising signs, traffic markers, and the face-lifting of gasoline stations and public buildings. The council also has a largely volunteer program that goes into the schools to educate the children about the value of an aesthetically pleasing environment.

The eternal struggle between man and nature comes down to a bare-bones confrontation in the matter of hunting in Israel. As elsewhere there are sportsmen hunters, and there are some — among the Druzes and some Arabs — who hunt for survival. Hunters are subject to strict regulation in Israel. There are about 3,500 of them and the season runs from September through January. On occasion the season is extended when one species or another so multiplies that it is a threat to public health.

Many species of bird or beast are under special protection of the government and off limits for hunters. Among the species that are fair game are wild boars, porcupines, hares, quail, wild ducks, pigeons and partridge. The penalties for infraction of the rules are stiff, and hunters have to demonstrate their competence.

Despite all that has been said, the rivers of Israel are in constant need of policing. After the Yom Kippur war, the Golan Heights were deserted and the Israeli government brought in numerous settlers. The result was a strain on the water supply. It is the same old cry in Israel. The country stands on the edge of a desert, and is always threatened by a shortage of water. The Israelis are conscious of that, so it is not alone the aesthetic principle that makes them eager to protect their environment, but in the matter of ecology as in so many areas, the aesthetic principle is strong.

ARCHITECTURE

Late in his life Sir Richard Livingston, the distinguished Greek scholar and president of Corpus Christi College in Oxford University, wrote to a friend, "I am just beginning to see architecture." Tourists generally fail to "see" architecture unless it is something on the scale of Notre Dame Cathedral or the British House of Parliament. It is the art we are apt to pass by, the art we fail to appraise. In Israel, it is very well worth "seeing," and getting inside, to enjoy.

Like Israeli painting or Israeli sculpture, Israeli architecture is vibrant, exciting and developing, but has yet to achieve a style distinctive enough to be called Israeli. On the other hand, observing and enjoying the variegated architectural construction in Israel, one has to acknowledge that taken as a whole it does not remind one of that of any particular country. It is sometimes eclectic, here and there electric, often full of surprises and, to the amateur eye, on its way to becoming something very special. What it does have is a remarkable mingling of styles, Eastern and Western, and a few things exotic. At the same time one must grant that in the haste of constructing public buildings and housing for a new country in a hurry, Israel made some horrendous mistakes.

Architecture is the one art into which the observer can walk, an art a person must work in, live in and die in. It is an art in which the artist is subject to the demands of the landscape as well as to the demands of the patron. Not only the landscape, but the very air and sunshine of a given locale are determining factors, as are heat, cold and dampness. Always architecture is striving for the best control of space, space, space, given the aim of style and function. It is an art that brings other arts into subordinate display.

155

The word itself, *architect,* meant the bossman over other artisans, other technions. In the Middle Ages and the Renaissance, the architect knew the other artisans he worked with and was more than likely a master of their techniques. Today, the architect is more detached from his workmen than in earlier centuries. He deals with the contractor for whom machines have displaced the craftsman. Then, too, while the architect may deal directly with his patron, he has too often little or no contact with the people who will use the building he has designed. These problems are common to all architects today, but along with these the architect in Israel has his own peculiar problems.

While the influence and power of the patron and the contractor have increased, the role of the architect has been enhanced as well. The public is more conscious of his work than in the past. This has been true in Israel. But the first architects in Israel had a unique challenge. They knew they were creating for a new nation, even before that nation had been established. Even as Jews were in Palestine before there were Palestinians, so they were building in Eretz Israel before there was a State of Israel. Those architects who were commissioned shortly after the turn of the century were conscious that a distinctive architecture was being sought. Perhaps they tried too hard.

Art historians divide Israeli architecture into various periods. The first efforts of Jewish architects in Israel, seeking a Zionist style, leaned toward the Oriental, with the Islamic dome and the Moorish arch blended into an eclectic style that gave them some pleasant buildings, including the Haifa Technical College. Later the Oriental influences flagged, the Bauhaus influence came along and in turn gave way to that of Corbusier and the sense of Israel being a Mediterranean country more than an Asiatic one.

All such matters can be left to the aficionado. For the visitor to Israel with an eye for beauty, architectural gems can be found from one end of the country to another, flashing originality and charm. There was a period in the history of Israel, just after independence and the war of 1948, when hundreds of thousands of immigrants poured into the country, creating a demand for housing that was almost impossible to meet. What must be remembered is that 50 percent of the population of Israel arrived in a fifteen-year period. The result was a rash of multiple-dwelling, building-block apartment houses, some jerry-built ventures that had to be replaced and some pretty hideous townships that remain here and there to blight a countryside. Some apartment houses, however, were very imaginative and made for comfortable and gracious living.

Because the business of housing people had the priority, public buildings had to take second place. Architects put their talents to designing the ideal kibbutz, a very special task given the kibbutz philosophy of common ownership and a socialist ideology. So too with the moshavim, cooperative communities with common quarters. Richard Kaufmann distinguished himself with

156

these. Townships were planned on the English "garden city" layout which did much for gentle living. But they were not enough to accommodate the mass of immigrants pouring in. Space-packed multiple dwellings were needed. In Tel Aviv, Beersheba, Haifa and on the hills facing the coast, the ingenuity of the Israeli architects can be seen, striving to manage some beauty in the midst of hurry, short funds, lack of sufficient craftsmen and a new environment, baffling at times. Another disruptive factor in the development of Israeli architecture were the wars the country had to fight to stay alive.

Tel Aviv, Israel's largest city, built on a sandy waste beginning in 1909 by Jews from Jaffa, is an ugly city overall, a modern metropolis, sprawling like Los Angeles, and too busy and lively at the moment to improve its appearance. The city grew at an incredible rate. Today, with more than a million people in it and its suburbs, it has its share of slums, a waterfront like Miami Beach and a downtown core that is very attractive. Big, brash and noisy, it pulsates like New York City and like New York City is a city of extremes. Some of its early apartment houses are ugly, but the newer ones were designed with care rather than haste. The best run four stories high, each apartment with a balcony. Others are higher, many on stilts to provide parking underneath, many set sideways to the road, with gardens stretching between them. Broad boulevards make such neighborhoods most attractive.

If Tel Aviv is not a beautiful city, it can boast some beautiful buildings. In architecture as in painting, everyone has his favorites. Few can resist the charm of the Mann Auditorium, the home of the Israeli Philharmonic Orchestra. The auditorium was built in 1959, and with its tiered seating and modern acoustics, it is one of the finest music halls in the world, a pleasure to approach and a pleasure to sit in. It can accommodate three thousand listeners. Dov Carmi and Zeev Rechter were the architects, two of the leaders of the "new" architecture in Israel.

Neighbors to it are the Habimah Theater and the Helena Rubenstein Pavilion, an extension of the Tel Aviv Museum which is a five-minute walk away. The three buildings—the pavilion, the theater, the auditorium—are the cultural center of Tel Aviv and blessed by an adjoining public garden, the Gan Yaacov. The Tel Aviv Foundation for the Arts has commissioned appropriate sculpture for various public places. The cultural cluster mentioned is not the most conspicuous architecture in Tel Aviv nor the most exciting perhaps. The thirty-four-story Shalom Mayer tower is the most visible, a flat slab that could be found in any American city. At least it has the virtue of providing from its top floor a view that will show a visitor the sweep of the city, north, south, east and west and the countryside beyond.

One of the most exciting buildings in Israel is the Asia House, designed by Mordechai Ben-Horin, which swirls white horizontal bands upward to house

offices, embassies and a restaurant. The beautiful entrance presents a permanent exhibition of sculpture under a sparkling mosaic ceiling. Beside it, rising twenty-four stories in startling contrast, is the golden cylinder of the IBM building, a cylinder compressed to three curved sides. The firm of Yasky, Gil & Silvan designed this eye-catching tower.

Even as Israeli painters and sculptors have had so seek markets outside their native land, so it is with Israeli architects. The country has too many of them. They were in great demand during the years of expansion, particularly those decades immediately following the founding of the state. Public buildings and housing were both needed badly and quickly, and Israeli architects, trained both at the Technion in Haifa and in Europe, were kept busy at home. Construction today has slowed up somewhat, and hence the number of Israeli architects seeking commissions abroad. They have made their mark in Africa, Asia and the New World. In Nigeria the university campus is the work of Alfred Mansfeld in collaboration with D. Habvkin. S. and A. Rosoff have done two hotels in the same country. The largest work being done in that country by an Israeli architect is the planning of the new capital, Abuja, which will in time replace Lagos. The architect-planner is Avraham Yaski, a native of Russia who emigrated to Israel in 1935, where he went to night school in Tel Aviv and in time took his architectural degree. His designs are on the campus of Hebrew University in Jerusalem, and in the city of Jerusalem. His major work in Israel is the campus of Ben Gurion University in the Negev. Other Israeli architects have been called in by Ethiopia (Z. Enav, M. Tedros — Addis Ababa Post and Telegraph building and the Imperial Palace). In Sierra Leone, the House of Representatives is the work of Dov Carmi, A. Melzer and Ram Carmi. Other work has been done in Ghana. These are men who have won their commissions in international competition.

Most of the public housing and public construction in Israel has been commissioned through competitive submissions. Foreign architects did some buildings before the creation of the State of Israel, some of them quite attractive, but seen now, they stand apart from whatever it is that is developing in Israel. These were mostly done by private interests who chose their own architects, as in the case of the Rockefeller Museum, now within Israel's borders and part of the Israel Museum, which was designed by the American Abraham Harrison, whose firm did Rockefeller Center in New York City. The Rockefeller Museum is done in a semi-Oriental style, which Israeli architects have happily abandoned.

Costs are always a factor in bids, but something more than economics seems to have dictated the popular use in Israel of reinforced concrete, painted white or in bright colors in some places, and left in its natural state in others. To me, massive concrete, presenting plane against plane, with sheer-rising walls,

giving the impression of weight, strength and permanence, seems very Israeli. I cannot look at the Mechanical Engineering building at the Technion in Haifa, or the Negev center at Beersheba, but I think of the Western Wall with its massive blocks of stone. Such stone-cutting is beyond price in Israel today and unattainable, but poured concrete and reinforced concrete give a similar sense of strength, perdurability and vigor. Subliminally, the Western Wall, the wall of the Second Temple so sacred to Jews, the realized concept of an ancient architect breathing a *ruakh*, the spirit of the Lord, must have entered into the thinking of more than one Israeli architect.

One of the most powerful buildings in Israel is the Jerusalem Theater, designed by David Reznick and S. Pevzner. Standing before it, one can readily imagine looking at a synagogue of the time of King David or a Hebrew fortress declaring its immutability in the teeth of Time. Here as elsewhere in Jerusalem we find facing of Jerusalem limestone, the stone that has made the city golden. It doesn't necessarily go with every building that uses it, and some buildings on the campus of the Hebrew University, where its use was legislated, each the conception of a different architect, consort with it better than others.

At Haifa University, the Brazilian Oscar Niemeyer was called in to work on the new campus and its landmark, the Eshkol Tower, which dominates the three hundred-acre campus with its fifty buildings topping the great slope of Mt. Carmel. Not far away on the hill is the famous rest house at Zichron Ya'acov, owned by the Histadrut (Haifa is thought of as the labor city, the blue-collar city) and designed by Yaacov Rechter, which won the Israel Prize. Here the architect has met a condition that is an ongoing problem in Israel: building on a hill. Rechter traced the topographical contour of the hill with a sweep of curved concrete, painted white above to give an aspect to the building of rising in the air.

A unique building in Israel that stands apart from all architectural styles is the work of two American architects, Armand Bartos and Frederick Kiesler, created in 1965. It is the famous Shrine of the Book on the grounds of the Israel Museum in Jerusalem. Walled in by Jerusalem stone, the Shrine's roof in designed to resemble one of the covers or lids from the giant urns in which, in a cave not far from the Dead Sea, a Bedouin boy found the ancient scrolls of the Essenes. The great white disk slopes gently from its edges to a peak. Beyond it stands a black basalt wall, rising in opposition to the peaked white roof offering in color and in shape a stark contrast to the roof. The contrast reflects the basic conflict that the Essenses saw between good and evil, between darkness and light.

Beneath that roof, which many see as shaped like the popular concept of the flying saucers that every so often fly across the imagination of man, is

the scroll of the Book of Isaiah, which is a thousand years older than any previously known manuscript of a Biblical text. Enclosed under glass on a drum at eye-level, the text turns the interior, which lies below ground level, into one of the most sacred rooms in Israel. Having the room below ground level gives to the visitor the sense of entering a cave. The architects, again with great insight, have made the drum showing the text the circular base of a sculpture designed after the manner of a giant Torah scroll.

No building in Israel is more revered than Yad Vashem, the memorial on the Mount of Remembrance to martyrs and heroes, the victims of the Holocaust, the Jews who died defying the Nazis. Inside is an eternal flame, the ashes of the dead, and a mosaic floor in which are listed the names of twenty-one of the largest concentration camps of the Nazis.

The building is made of a fieldstone wall, surmounted by a wooden overhanging wall and a flat wooden roof. It was designed by three men, Aryeh Elhanani, Aryeh Sharon and Benjamin Idelson. Sharon and Idelson, recognized as one of the foremost architectural teams in the country, also designed the hospital in Beersheba and the Worker's Bank in Tel Aviv, among other structures. For many visitors the outstanding features of the outside of the building are the doors, designed by one of Israel's most famous sculptors, David Palumbi, whose death at the age of forty-two was a loss to the country and to art. His memorial is these doors and doors of the Knesset, also his work. His doors at Yad Vashem are a sculptural masterwork. They are made of iron, always a stark medium, and the choice of it was an exquisite touch. The design is artistically sure. Pointed forms of striated or scratched iron are laced horizontally and vertically in seeming random arrangements against the flat iron of the doors, offering grim excitement and improbability in blunt contrast to the bland, flat surface of the background. Both the abstract forms and the flat surface hint of an incalculable fate. The strident abstract forms at once suggest prison bars, instruments of torture, charred ruins and even prostrate victims. One knows on seeing those doors that beyond lies a chamber of tragedy, and yet, the whole — building, doors and dim interior — arouses immediately one's sense of compassion. We weep for ourselves as well as for the memorialized dead.

In remarkable contrast to this building and to the poured or reinforced concrete magic of others is the synagogue designed by Joseph Neufeld at the Hadassah-Hebrew University Medical Center at the village of Ein Karem in the Judean Hills, a couple of miles southwest of Jerusalem but still within the city limits. This is the synagogue that holds the magnificent stained glass windows done by Marc Chagall. To move from Yad Vashem to this synagogue is to move from the depths of tragedy to the pinnacle of spiritual hope.

The windows are twelve in all, one for each of the twelve tribes of Israel.

They dominate the square synagogue, which is built into the slope beside the hospital. The building is square with a facade of six squares of open stonework set three and three on either side of the central door. The windows rise from the roof in a clerestory, three windows to a side, set well back from the railing that rings the roof.

The windows are each eleven feet high and eight feet wide with a rounded arch at the top. Their beauty, of course, has to be seen from inside. They are Chagall's masterpiece, a magnificent, universal, religious monument, transcending, as great art must, all doctrinal dissent, political hang-ups, nationalisms and cultures. They are a blaze of luminosity, a pellucid presence that catches up the Jewish history of the children of Jacob and transforms it through color, image and composition to revive, as one critic said, "the frenzied epic of St. John the Divine." The comparison is apt for here mythological beasts fly through the air—the Lion of Judah stands before the walls of Jerusalem; David's crown tops the window which alone Chagall initialed; and the twelve tribes face each other in an eternal presence.

For the artist, the work never arrives at the perfection of the concept. Mayor Teddy Kollek tells us that Chagall was not happy when he saw the synagogue. He thought the windows too close together. One could argue that their magnificence is such that each deserves a temple of its own, and yet, standing in their presence, the observer knows that they have to be together, nudging each other perhaps, but indissolubly linked.

No synagogue could be different in style, shape or intent than that on the campus of Hebrew University designed by Heinz Rau. It is a white dome all but open to the air because of the great arches through which one enters. The synagogue is part of an extraordinary complex of buildings, without doubt the largest complex of public buildings in the Middle East. Mt. Scopus, on which it stands, is to the northeast of Jerusalem and rises 2,500 feet above sea level. Once again building on a hill gave architects unique problems. The university is on three levels, and its horizontal structures are marked by the use of Jerusalem stone. The synagogue benefited by escaping from the ukase. The Israelis were denied the full use of the university campus until the war of 1969 when they seized the ground. The many buildings on the campus, some better architecturally than others, are an exciting visionary complex yet to be completed, troubled like many institutions today by want of funds, worth a visitor's tour and some hours of contemplation.

The synagogue at the university—while it is extraordinary, eye-catching and inspiring, because it is a snow-white dome standing in sharp contrast to the buildings near it, because domes, whitened or painted, are common in the Middle East—does not strike the viewer as something from another planet. The synagogue at Mitzpeh Ramon in the Negev seems as unbelievable as it

161

is exciting. It is a pile of polyhedrons standing above the desert in a proclamation of defiance to the inchoate landscape around it, but seeming to take its strength from the landscape, as if the rocks and sands of the desert grew into these extraordinary figures.

The synagogue is the work of Zvi Hecker, who, while one of the most controversial figures in Israeli architecture, above all others seems to his compatriots to be approaching an architecture that is distinctly Israeli. For certain, it is found nowhere else, and he has used his techniques for apartment dwellings as well as for the synagogue at Mitzpeh Ramon.

Hecker has stated that the cube such as we saw in the synagogue at the Hadassah-Hebrew University at Ein Kerem, where the four-sidedness is broken only by the arches at the tops of Chagall's windows, is passé, that it is not as economical of space as his polygonal creations, which present apartment-dwellers with sloping walls. These may present a pleasant surface to lean against, but they can leave a man baffled as how best to hang his pictures.

Hecker studied at Haifa Technion under Alfred Neumann and later in Canada where a fellow Israeli, Moshe Safdie, came to international attention with a building called Habitat, which broke ground for futuristic housing. Safdie now divides his time between Israel, Montreal and Harvard University. At Harvard he holds the title of adjunct professor at the Harvard School of Design.

On his return to Israel from Canada Hecker collaborated with Neumann and Eldar Sharon on the Dubiner apartment house in Ramat- Gan, a Tel Aviv suburb, to create one of the most unusual collection of flats in the country, pairing polygonal design with cubes. Together with Neumann, he also did the Mechanical Faculty of Mechanical Engineering at Haifa Technion, which has been called an excellent example of morphological architecture.

For American visitors to Israel the memorial erected outside Jerusalem to honor the memory of President John F. Kennedy and his brother, Senator Robert Kennedy, takes on the aspect of a shrine. The building is circular with sloping sides and a flat top, designed to have the appearance of the stump of a great tree, truncated, cut short as were the lives of the brothers. Around the sides, sloping sixty feet to the top, are fifty-one columns or flanges, one for each of the United States and the District of Columbia. On the windows between the flanges are the seals of the states. The interior is stark, and in the center rises an eternal flame. The building tops one of the Judean hills and it is said it can be seen from Tel Aviv on a clear day. Surrounding it is the Kennedy Peace Park. One of the most impressive buildings in Israel, it is one of many eloquent reminders that the heart of all architectural concern in the country must ever remain Jerusalem.

Jerusalem

If I forget thee, O Jerusalem, let my right hand forget its cunning. Let my tongue stick to the roof of my mouth. . . if I set not Jerusalem above my chiefest joy.

The most beautiful artifact in all Israel is Jerusalem. The legend runs that God allotted ten measures of beauty for the world and of the ten gave Jerusalem nine, and only one to the rest. Jerusalem is the city of eternal joys and mundane sorrows. It has seen a dozen empires or kingdoms come and go: Babylon, Assyria, Egypt, Persia, Greece, the Seleucids, Rome, the Seljuk Turks, the Omayyads, the Crusaders, the Mamelukes, the Ottoman Empire, the British and the Jordanians. Those empires have swollen, burst and declined. Jerusalem remains, a treasure to the world.

For all Israelis the heart of Israel is Jerusalem. For the most intense Orthodox Jew, for the socialist and secular Jews in the kibbutzim, for the cooperative-minded Jews of the moshavim and for capitalist Jews everywhere, for the "new Jew" who would leave the God of Israel behind, forget the Zionist socialist dream and forge an entirely new national identity in a thoroughly independent Israel, Jerusalem is the omphalos of the world, the Golden City, the Holy and Beloved Place.

The Jews see the city as a work of art, numinous and unique, and they would do all in their power to glorify it. They would preserve its ancient sanctities, redress such impetuous novelties as have intruded, heighten the immortal aspects and make it accessible to the world. For the Muslim, Jerusalem as a sacred place ranks just behind Mecca and Medina. For the Christian, a thousand sites within Jerusalem are sacred to the memory of Jesus Christ; for the Jew the whole city is sacred.

Throughout its history, it has been frequently under siege. More than once it has been razed or destroyed. By one accounting it has been conquered thirty-seven times. For nineteen years, from 1948 to 1967, it was horribly scarred with a wall, uglier than the Berlin wall, cutting it in half. The Old City with its two and a half miles of wall — that beautiful girdle built by the Turks and today one of the city's loveliest features — was ceded to Jordan under the terms of the armistice that ended Israel's 1948 War of Independence. The other half of the city — the new city — was under Israeli control. During the nineteen years of Jordanian occupation, Jordan, in defiance of the terms of the armistice, added to the destruction the war had brought upon the old Jewish quarter of the Old City with its many synagogues. Again, in defiance of the terms of the armistice, Jordan denied Israeli Jews access to the Western Wall, causing all Jews great anguish, even those permitted to visit it. During those years, Israelis have charged, Arabs profaned it, a charge the Arabs deny. Not until 1967, however, when the Jews took charge of the entire city, having once again defeated Jordan, Egypt and their allies in the Six Day War, were the Holy Places of Jerusalem made available to all — Muslim, Christian and Jew — by order of the Israeli government. The Israeli victory was the thirty-seventh conquest of Jerusalem, and for the first time in more than two thousand years the wheels of history returned the Holy City to a government of Jews. Persons with a vision of history and a knowledge of the slow reduction of the kingdom of Israel by a succession of conquerors ending with the Romans, can readily imagine the emotional surge felt by the Israelis when once again Jerusalem was all theirs.

The siege by the Arabs, who refuse to recognize Israel's right to exist, expresses itself all too often in a terrorist raid from Lebanon, or by terrorist bombs thrown not at soldiers or military installations but at innocent shoppers at a busy pedestrian corner or children on a bus. But Israelis will tell you that they do not need the terrorist bomb to remind them that their country is under siege by the Arab world, for just south of Jerusalem is Dehaishe, a refugee camp of Palestinians, on the disputed West Bank. The border that set off the West Bank from Israel was the line that ran through Jerusalem. The plight of the Palestinians is tragic. Dehaishe was not established by Israel. Set up by Jordan, which didn't want the Palestinians settling there, it fell into Israeli hands when the Israeli army drove the Jordanians from the West Bank, back across the Jordan river, and occupied the West Bank. Israel claims that the West Bank is essential to its military defense against further attacks. Many Israelis have long been aware of the problems arising from the occupation of the West Bank. The riots in the first months of 1988, not only in the West Bank, but in the Gaza Strip and even Jerusalem, have emphasized in a tragic way the dilemmas that face Israel's ruling parties. Like a running sore, the occupied territories will trouble Israel until a peace treaty is signed.

The difficulties brought on by the occupation are part of the political-military siege that Israel is under and Jerusalem shares, a siege that brought the sting of tear gas to the top of the sacred mount, a siege that intensifies the second siege that Jerusalem endures, the siege from within the city itself.

The first conqueror of Jerusalem that history records was King David who, in 1000 B.C.E. defeated the Jebusites, who occupied the city, and proclaimed it his capital. The Jebusites were permitted to continue to live in it, but it became a Jewish city. David ruled for forty years; his son, Solomon, would reign for another forty. During Solomon's reign, the great Temple was built and the Ark of the Covenant holding the precious tablets given to Moses by God on Sinai were placed in the Holy of Holies, the heart of the Temple. In 922 B.C.E., on the death of Solomon, the Jewish kingdom was halved by contentious tribes into Israel and Judah, and to Judah fell the city of Jerusalem and the Temple. Jewish rule endured down to 587 B.C.E. when Nebuchadnezzar, who died lunatic, destroyed Jerusalem and the Temple and sent the Jews into exile in Babylon. Then it was that the Jews discovered how much Jerusalem meant to them all; they were the people of the Book and the heart of the book was the Torah and the city of Jerusalem. Fifty years later the Jews were returning to Jerusalem, and the building of the Second Temple began. Alexander the Great came next, and his rule was followed by that of the Seleucids. Against the last of the Seleucids, Antiochus IV Epiphanes, the Maccabees revolted because he had plundered and desecrated the Temple.

The victory of the Maccabees brought about the rule of the Hasmoneans, a Jewish dynasty, whose John Hyrancus extended to political independence the religious liberty that had been won by Judah Maccabee. Jewish rule again prevailed in Jerusalem until 63 B.C.E., when Pompey established Roman rule that was not to release its hold for more than three hundred years. In 70 C.E. the Second Temple was destroyed, the temple which had been refurbished to elegance and majesty by Herod, and a remnant of which—the Western Wall—today stands as a sacred shrine for the Jews of the world. For one stormy period of three years, Jerusalem was again the capital of Israel when Bar Kochba revolted against Roman rule. By 135 C.E. his revolt was done, Jerusalem further leveled and a new city built called Aelia Capitolina, named for the Emperor Hadrian. From 135 C.E. until June 1967, Jerusalem and the Western Wall were in alien hands. During that sweep of time, the Jews did not forget. Annually, and more than once in the course of the year, for two thousand years they cried out in anguish, "Next year in Jerusalem!"

In 1987 the twentieth anniversary of the Six Day War was celebrated with formal ceremony and informal recollections. But the twentieth anniversary of the liberation of Jerusalem found the Holy City again under siege—a triple siege—from within and without, although it was never more populated nor more prosperous. All Israel, as we have mentioned, is under perpetual siege by the Arab world. The rioting of the Palestinians in the Gaza Strip and the

West Bank is merely the most recent and the most severe internal manifestation. The new siege from without is the siege set by tourists, and the use they make of the city, in reverence or indifference, particularly the Old City, the heart of Jerusalem. Armed with cameras, curiosity and concern, tourists from all over the world and all parts of Israel breach the walls of the Old City.

Outside the walls, more and more buses storm the city year after year, while more and more private automobiles surround, approach and invade even the ancient precincts, penetrating the narrow, twisting streets like burrowing insects. Outside the golden walls, and on the approaches to the holy places sanctified by tradition and prayer, buses, delivery trucks and vans, automobiles and taxis battle for space. And in Jerusalem even today one must not discount the donkey, although the camel remains only for show. Such pressure of logistics distorts what might otherwise be the orderly growth and development of the city.

In the magnificent book *The Harvard Jerusalem Studio*, celebrated Israeli architect Moshe Safdie presents figures compiled by the Kennedy School of Government in connection with the study that predict an ominous future. Whereas at the time of the Six Day War the population of Jerusalem was 200,000, by 1980 it had doubled and by the year 2000 will have doubled again. This points to an urban sprawl that is likely to swallow Bethlehem unless sensible planning averts such an unwanted melding.

The same projection indicates that the half million automobiles in use in the city in 1980 will also have doubled by the year 2000. So far as tourism is concerned the figures jump even more rapidly. In 1960 about 277,000 tourists visited the city, but by the year 2000 experts expect more than four million tourists will visit the Sacred City. In 1980 more than two million visitors came. The congestion of buses, taxicabs and automobiles is already intolerable. The attempts of the Israeli government to solve the problems that such congestion presents deserve international support.

Such support as might instinctively come to Israel's assistance in protecting the Holy City is in part inhibited by the unsettled political position of the city and the West Bank. Whatever the rights or wrongs in the matter, the fact is that the problems arising from the very openness of Israel to visitors in its rule of Jerusalem do not win from the international community the assistance it should. Israel wants control of Jerusalem as the capital of the country. Others want the city made an international enclave.

The fanaticism of the Arab extremists puts part of the city under siege from within. The Jewish quarter in the Old City that was destroyed during the war and fell into decay and neglect under the Jordanian occupation has, under the rule of Israel, been beautifully rebuilt and restored. So attractive is it, that it has become a fashionable place to live, a case of gentrification, whereas in the 1940s it was a rather poor quarter. In turn, the Arab quarter

of the city is turning into a slum. With the return of Jerusalem to the Jews, the wealthy Arabs left the Old City; only the poor Arabs remained. The section has deteriorated rapidly. The Israeli government is eager to restore and rebuild in the Arab section, the northeastern quadrant of the Old City, but some Arab landlords who own the property but live elsewhere will not cooperate with Israel in improving conditions lest they be deemed collaborators. In the main, their stance is one of commercial self-interest.

For Mayor Teddy Kollek, whose performance as mayor of Jerusalem has taken on the quality of statesmanship, the problems are endless. Seeking the cooperation of the Arabs becomes exhausting. But not all his problems come from the Arabs. Within the Old City, the *Haredim*, radical Orthodox Jews, feeling a sense of propriety for the Sacred City, have been increasing in number and in an intransigence of their own. Their behavior indicates that they believe no one else has a right in the city, and others, Jews, Christians and Arabs, have protested that they are made to feel unwanted by the more aggressive haredim. Mayor Kollek has to face the conflicts of Arab with Arab, Jew with Arab, Jew with Jew, and has managed to preserve an uneasy internal peace. His constant task is to relieve the siege within and the siege from without.

Under his inspired mayoralty, the city's beauty has been enhanced. No one who has watched the walls of the Old City from the tower of the Y.M.C.A. building or indeed from a room in the King David Hotel can be other than thrilled to see the night lights go on illuminating the walls of the Old City and the shadows of the park area beside them. No one has walked on the walls without admiring the park belt encircling the city. Jerusalem by twilight or Jerusalem at high noon arises on man's vision as a city of beauty. The hills and the valleys, the desert in the distance have beyond historical resonances a natural beauty that the hand of man has heightened. Within the city are lovely parks such as the Liberty Bell Park, designed to honor the United States of America on its bicentennial, and many others. The Old City is, of course, the heart of it all, the jewel in the crown. Not all the new city is beautiful. Some of it deserves substitution. But the ancient churches and celebrated shrines have their own beauty and in some cases gorgeous natural settings. Most of the new construction has been done well: the university buildings, the hospitals and other constructions, such as the Hadassah synagogue with the Chagall windows, are beautiful additions to a beautiful city.

Much of the new city, including large apartment houses and skyscrapers, was built by Israelis when the city was divided. The architects did not, indeed they could not, think of the city as a whole. In most cases they built well but not in all, and disfigured the hillsides. City planners do not like the high-rise buildings that dot the landscape, preferring those structures that follow the ancient contours of the landscape after the fashion of the Old City. All that

167

is a minor matter compared to the concern for the future. All building now brings to bear talent, taste and concern. Under the British mandate Sir Herbert Samuel decreed that all buildings in the city must be faced with Jerusalem stone. That insistence has been followed in the main. The result has been to give the city a unity. Jerusalem stone is a beautiful stone and helps justify in a physical way the title of the Golden City. Some buildings have avoided the ukase, one with a most happy result. It is the synagogue on the campus of Hebrew University where the rule might well have been ignored to advantage on some of the other buildings there. The synagogue is a snow-white dome that lies on Mt. Scopus like a fallen sunburst. The ultimate fact is that Jerusalem has escaped the horrors that here and there blotch Tel Aviv.

That said, one has to remember that various factions within Jerusalem are fighting for their own interests — property owners, shopkeepers, developers, landlords and all those businesses that cater to the tourist trade. Jerusalem is not a museum but a vibrant, growing, modern city. All such commercial conflicts, as well as the ethnic conflicts, were taken into consideration in *The Harvard Jerusalem Studio*, about as thoughtful a gift as one could devise for those persons charged with the future of Jerusalem. Architect Safdie conceived the idea of such a study of city planning for Jerusalem, and Irving Schneider of New York City financed it. Not only the Harvard Graduate School of Design applied its expertise, but the Kennedy School of Government at Harvard did as well.

To anyone interested in the problems of urban development and redevelopment, Jerusalem can be irresistible. Safdie in his introduction writes:

> Jerusalem, a sleepy and provincial divided city in the 1950's, burst into a period of intense development after its unification in 1967 following the Six Day War, making it one of the most fascinating laboratories of urban development. All the ingredients were there: a historic city of world significance; a religious and sacred center for three of the world's religions, and a city supercharged with symbolic meanings; a complex physical setting of steep hills, valleys and plateaus on the watershed between the desert (aridity) and fertility; a diverse mix of peoples of different religions, races, incomes, cultures and life-styles; a city growing at the rate of 3.7 percent per year; with a population of 268,000 in 1967 heading toward 770,000 by the turn of the century.

Safdie cites, as one of the major problems attending the Old City, the rising tourist threat and intensifying traffic at the Damascus Gate, at once the most popular entrance to the Old City and the center of Arab commercial life. Here one can see any day the congestion of traffic, as tourist buses arrive and mingle with the trucks seeking to supply the Old City. Since automobiles can only enter the city at two of the eight gates, and then can only penetrate a short

way into the city, the problem of supplying the residents of the walled city is intense. The Harvard study offered the city several plans for adapting the great apron in front of the gate to provide for access and parking, both now quite randomly approached. The Harvard study offers various plans for other sections of the city. It has certainly pointed up the difficulties facing the city and highlights the possibilities of protecting the city from the inroads of the future.

Despite all the problems, which Mayor Kollek has said will take two hundred years to solve, Jerusalem remains as it has remained for six thousand years, one of the treasures not of Jew, Christian or Moslem only but of all mankind. It is not a museum, but of the many museums in Israel none can stand beside the treasures of the Golden City. The response of the Israelis to the aesthetic principle in all the arts can only raise the hope in the hearts of all men that that response is the most trustworthy guardian for its sacred treasures, including the Temple Dome, the magnificent mosque that rises over the stone on which tradition says that Abraham stood ready to sacrifice his son, and from which Mohammed rose on his flight to Paradise, said to be one of the most beautiful buildings in the world. Tragically, the area became involved in the early 1988 disturbances and was profaned by rebellious rioting and suppressive tear gas.

Jerusalem hence is a problem for the world, not for Israel alone. The tragic political division in the country, which leaves the government paralyzed at times, will generate further tragedy if Jerusalem becomes a pawn in the struggle for dominance. In the Jewish aesthetic sense and its moral aspirations lies the salvation of Jerusalem, and any well-wisher can only hope that that aesthetic sense will triumph over all political exigencies before a crisis develops, the resolution of which will elude all arbitration.

INDEX